Culture
in Another
South Africa

Acknowledgements

This book would not have been possible without
the generous cooperation of all the authors,
photographers, and translators of the resumées in
the various languages.

We owe special thanks to: Robert Dorsman, co-
worker in the Literary Programme of the CASA
Festival for translations and editorial assistance;
the graphic designers, Caroline Boone, Hanne
Leijesen, Lies Ros, and Rob Schröder; the workers
at Zed Books, especially John Daniel and Anne
Rodford, for their stimulating advice and practical
support.

We are also indebted to the city of Amsterdam
and the Committee of Recommendation
comprising, amongst others, the Mayor of
Amsterdam, the Governor of HM The Queen in
the Province of Noord Holland, former Ministers
of Culture and Science, the directors of the
National Ballet, and the Netherlands Opera; as
well as to the CASA Foundation, consisting of
artists and Dutch members of parliament, and the
staff of the CASA and AABN offices. For the
conference, Amsterdam was declared to be an
anti-apartheid city, and real significance was
given to this notion by the hundreds of AABN
volunteers, the hundreds of host families who
opened their doors to strangers, the drivers of
trains and buses who gave delegates free
transport, the Surinamese community which
supplied cooks, and the managements and staff of
all the large and small venues that did not charge
for performances. These ranged from the
prestigious new Music Theatre and the baroque
Municipal Theatre to the casual Paradiso.

Many donors made financial contributions to
the CASA Festival. They were the Amsterdam
City Council, the Dutch Ministries of Culture and
Development Co-operation, the European
Economic Community, the United Nations, and
various trade unions, local church communities
and town councils all over The Netherlands, as
well as some business corporations. Publication of
this book was made possible by a financial
contribution from the Directorate of Development
from the European Communities, the Ministries of
Development Co-operation and Culture in The
Netherlands, the Municipality of Amsterdam and
the Algemene Spaarbank voor Nederland (The
General Savings Bank of The Netherlands).

Willem Campschreur and Joost Divendal.

With special thanks to the SSP, Amsterdam

Culture in Another South Africa

edited by
Willem Campschreur
and Joost Divendal

OLIVE
BRANCH
PRESS

An Imprint of Interlink Publishing Group, Inc.
NEW YORK

Culture in Another South Africa was first
published in 1989 by Zed Books Ltd., 57
Caledonian Rd, London N1 9BU, UK, and by Olive
Branch Press, An Imprint of Interlink Publishing
Group, Inc., 99 Seventh Avenue, Brooklyn, New
York 11215, USA,

in cooperation with

Culture in Another South Africa (CASA)
Foundation
c/o Dutch Anti-Apartheid Movement, P.O. Box
10500, 1001 EM Amsterdam, The Netherlands.

Graphic design by Caroline Boone, Hanne Lijesen,
Lies Ros and Rob Schröder, Amsterdam,
The Netherlands.

Translation of chapters of Dutch authors by
Robert Dorsman

Typeset by EMS Photosetters, Rochford, Essex

Printed and bound in the UK at The Bath Press,
Avon.

British Cataloguing in Publication Data

Culture in another South Africa.
 1. South African arts.
 I. Campschreur, Willem II. Divendal, Joost
700'.968

ISBN 0 86232 856 X
ISBN 0 86232 857 8 pbk

US ISBNs
0-940793-36-9 pbk
0-940793-35-0 hbk

Back cover illustration shows the Renaissance New
Church in Amsterdam decorated with the ANC flag
during the CASA conference

Contents

Preface

In December 1987, Amsterdam, capital of The Netherlands, was host to 300 South African artists, a mix of exiles from all over the world and 'insiders' working and living in South Africa. They came as participants to the Culture in Another South Africa (CASA) Festival and Conference. For some ten days they exchanged views on the cultural infrastructure of a non-racial and democratic South Africa, free from all manifestations of the apartheid system, while also giving expression through plays, musical events, literary performances and art exhibitions to the vibrant and various aspects of that culture already developing inside and outside South Africa.

As the first exchange on so large a scale between exiles and non-exiles, between professionals and amateurs, between members of the democratic movement inside South Africa, non-aligned artists and the African National Congress, this was a gathering of major historical importance. As such, the production of a book reflecting the many aspects of that culture is a joyful evolution. It includes many contributions from the whole range of fields covered — prose, poetry, fine art, photography, journalism, music, theatre, film and video — as well as contributions analysing such topics as the prevailing ruling-class culture in South Africa today and the complex questions surrounding the cultural boycott movement. The most important papers of the CASA Conference are reproduced, preceded by a comprehensive account of the Conference and Festival.

The book also includes photographs, songs, and poems, many of which were especially written for the CASA Festival, all of which provide uniquely personal interpretations of the emerging culture of the 'other' South Africa. Together with the written contributions, these collectively constitute a tribute to all those artists, known and unknown, who in their life and work have contributed, and are giving expression, to the emergence of a non-racial and democratic culture, which will one day thrive in a free and liberated South Africa.

February, 1989.

The value of a conference

Introduction

by Nadine Gordimer

The value of a conference is in what you take away from it; what endures; in how much your thinking is invigorated — either confirmed or changed — and your actions directed by what has been experienced in those few days. A good conference is not what happens behind closed doors but what opens out from them.

I do not know what our comrades-in-exile expected from the CASA Conference. I know that for those of us who came from South Africa there was apprehension mixed with excitement, the kind associated with a meeting with members of the family one has not seen for a very long time, or has never met, from whom one has been parted by distance and by circumstances of living often beyond imagining. Exile makes strangers out of intimates. For the young among us — who had been children when these comrades were forced to leave our country — what would these legendary people really be like? For those of us who had known some of them, how much would they have changed inwardly — never mind the extra pounds round the middle or the grey hairs? What would their attitude be towards us?

There were basic tenets on which we knew we were at one. As expressed later in the *Preamble* to the *Resolutions* which came out of the Conference, we met 'in the conviction that a great responsibility devolves on artists and cultural workers to align themselves consciously with the forces of democracy and national liberation in the life and death struggle to free our country from racist bondage'. But how critical would the exiles be of our efforts, at home, towards creating the culture of another South Africa? Would we find our perspectives of the cultural struggle so far apart that they would not be able to understand our problems, and we should not understand theirs? Would we sit together and remain mentally apart? Would the South African regime, whose oppression has forced so many of our artists and writers into exile, be seen to have succeeded in producing another kind of apartness, depriving the community of arts, the family of liberated ideas?

10

What we found was a remarkable endurance of community in the arts. The joyous meeting between old friends, the embrace of new comrades proved to be not merely the euphoria of managing to meet in spite of the repressive laws, the years, the distances — although that was there, an achievement in itself. The exiles were passionately eager to ally themselves with cultural initiatives at home; to be informed about and understand our problems in circumstances there — massive population removals, crisis in education, State of Emergency, media censorship, to name a few — that have compounded in the exiles' absence. As for progress being made at home, the fact that our contingent of delegates prominently included representatives of trade unions' cultural organizations proved more convincing than any explanations of how cultural concepts have broadened, from possession by a well-meaning intellectual élite, black and white, to receive those of the masses who work with their hands.

This breaking of the old concepts of culture, so attentively pursued together by exiles and delegates from home, was surely the most creative, influential, and lasting result carried away from the Conference. In its pursuance there was so much that was fresh and lively; old analogies, worn formulations, would not do. And although there were no yes-men and yes-women among the comrades, opinions were challenged without rancour. Neither was there much rhetoric of the kind that at home so often fudges important issues. This vigorous tone was set by the addresses of Barbara Masekela and Pallo Jordan which, while immovably dedicated to the principle of a working-class based culture in South Africa, gave no encouragement to sloganeering anti-intellectualism. There was a sense of historical perspective, outside the customary political clichés, to set off boldly the continuity of the struggle for the workers — called up by history, called up by justice — to take a leading part in the defining of cultural norms and to enjoy the self-realization of the arts. There remain, with those of us who heard him, Pallo Jordan's striking parables of the cultural deprivation of the masses by the privileged, linked across the ages and cultures.

Odysseus having himself tied to the mast of his ship so that he might enjoy the song of the sirens without danger of succumbing to them, while his galley slaves, down in the dark, pulled on the oars with ears stopped against the music; an African legend of a woman whose lord allowed her to walk about only at night, so that no man other than himself could enjoy her beauty. And in emphasizing that the ruling classes have always tried to appropriate culture as exclusively theirs, there was established the implicit assertion that relevance to our struggle is not necessarily restricted to one culture or one age, nor should we limit ourselves to these. The tremendous empathy between Europe's audiences and our performers in South African dance and drama, and the amazing sound of a huge choir of Dutch people singing in African languages, were a vivid example.

Another basic statement to carry away came from Vernon February, when he said, once and for all: 'Apartheid did not produce our poetry. Our poetry began when the Khoi-Khoi played the flute to the first whites to set foot in our country'.

And when Alfred Temba Qabula of COSATU described the writings and play-making of factory workers and miners, continuity was alive before us. The CASA Conference was not just a reaction to apartheid; it was an affirmation that indigenous South African culture was *already there* before it was overlaid and discounted by a minority ignorant of what they were depriving themselves, as well as the people they subjected. It was *there* and has survived, an artery that all the blood-letting of the struggle has not succeeded in severing, and it carries the stream of other artistic modes and skills it has made part of its own, to nourish a culture that will discount nothing but nurture creativity in all its forms.

Those of us who came from Inside found a far greater understanding of the problems of the cultural boycott as experienced at home, than we had expected. It was an aspect of the Conference's deliberations that was much distorted in press reports and that perhaps still requires more explication to be understood correctly by the general public, and, indeed, by some of our comrades in South Africa. But we came home from Amsterdam with a clearer idea of the importance of the boycott as a tactic that must be constantly adapted to changing circumstances in the liberation struggle. We gained reassurance that it will not be used to hamper in any way creative ability by South Africans who subscribe actively, in their work and life, to liberation. The recognition of the liberatory force of progressive culture, *in itself,* with an emphasis on the fostering of the culture of the people, was confirmed beyond any doubt.

Those who now have the opportunity to read the resolutions and addresses given at the Conference will have some idea of the openness with which the enormous difficulties we face, as exiles and comrades-at-home, were presented. Issues were not evaded; weaknesses were not glossed over. Misconceptions peeled away, impractical ideas were abandoned, unconscious prejudices — sexism, for example — were vigilantly challenged. We learnt a great deal from each other. We came away with the immensely strengthening certainty that exile does not divide the community of the arts dedicated to the cultural force of liberation; Inside and Outside are one, working towards another South Africa.

And there was another assurance we took away with us. We had not thought at all about the third factor in our Conference: the city in which, and the people amongst whom, this meeting from Inside and Outside would take place. We had not realized how important this would be. As it turned out, Amsterdam and the Dutch people were not only the catalyst that brought us together, they were that essential element in the creation of a new, free culture in South Africa, the faith and belief in it of non-Africa, the support of those whose own abhorrence of racism does not let them rest while racism exists anywhere, those whose own freedom is taken as bringing responsibility for the freeing of others.

Art is at the heart of liberation; that was the lesson and message of CASA.

Now we enter history

Introduction

by Mongane Wally Serote

South Africa is no longer notoriously known for apartheid only. It is also now known for the courage, determination and resoluteness with which the oppressed of that country seek, cherish and fight for freedom. It is not only the fact that we have taken up arms and are ready to die and kill for freedom which has catapulted us onto the lap of the world. It is that, as we do so, as we seek to define freedom, we become part of humanity, because our history of struggle for freedom expresses the culture of normal human beings.

The rigour of our life against the high stakes of apartheid, as we seek the right to self-determination, is a clarion call to humanity, a cultural process to engage it in and to remind it of its duty to pursue happiness which is a normal condition of life. That is what human beings seek from nature; their interaction with nature for the betterment of their lives is an act of history which is also their cultural expression. The abnormality of apartheid lies in its having imposed on us a condition which requires that as human beings we had to reject life so that we can accept life. We have not known how it is to live as human beings. Apartheid is a negation of life; it exists to ensure that life is lived in the darkness of dungeons and survives because that condition exists; and, as the world knows, apartheid has been around for a very long time, in the broad daylight for everyone to see. History tells us that apartheid not only exists within the civilized centres of the world, but that it is a condition of the majority of people in this world. For this reason the world will, at this moment in time, be forced to look at the turbulent history of the oppressed majority of our country, so that it can know, can understand the slogan which walks our streets with a proud gait because its carriers are fearless of what ordinary people fear; and it speaks eloquently even from the mouths of little boys and girls who have hardly had the time to learn how to wipe their eyes and wash their faces, for they know death to be treacherously articulate in its speech to those of their age who have dared to seek freedom.

This slogan affects how we look at each other and at other people; it is a slogan which affects the way we walk the one-time dangerous streets which conspired with apartheid and their darkness as we lost life in them, where the rage of our existence instead of our living was expressed with amazing cruelty and fury.

Many of us have died senseless deaths in these streets which we made fearfully violent. This slogan has changed all this; it has changed our smile, laughter and gestures as we anticipate how the future will meet our aspirations. The slogan is *'Freedom or Death'*.

It is a slogan which, like the sharpest blade, has cut with extreme precision and ruthlessness, between the old and the young, women and men, black and white, leaving a very deep wound, leaving everything very bloody! It is our history which has put this blade into our collective hand as a people; this slogan is lived and died every minute of our life as we think and search for what it means to be free, and therefore, it is our contribution to the world to redefine the meaning of freedom. It is our will to be free, to become part and parcel of the world which wields this blade; we are creating new relationships among ourselves and between us and the world. The choice in words reads simple, but in deed it is profound.

It is as the South African Police and the South African Defence Force that the vigilantes and murder squads enter the townships and villages on a daily basis in the present time, to carry out their work in these dark dwelling places. We, the inhabitants: the children, mothers, fathers, the youth, after the glass has wailed, and wailed and wailed, after the fire has raged and raged, consuming bricks, fences and people, leaving behind a strange silence and the smell of gunsmoke, teargas, blood and shrivelled human flesh once more, we ask as we become aware of those that are no longer with us as we knew them — the maimed, the mad and the raving angry — does the world know that we want to be a free people? This question must be asked of the world, for indeed, the world has claimed civilization and this the world understands to mean that human beings have achieved the highest knowledge and ideals of life.

Included among the civilized is the white South African population which, after dark or in the early hours of the morning, is joined by those who, after their work in the dark dwellings, change their uniforms to become fathers, lovers, brothers and husbands. This is not a description of innocence at all; and that is why in the townships and villages, their ilk, who are black, were consumed by fire and we were shocked to hear the parlance of racists that this is 'black-on-black violence'. This is an indictment of the white master race. It is the definition of the collective responsibility of the white master race of the world; it must also be the process by which human beings rediscover conscience, which is colour-blind, which is capable of breaking conspiracy — for hope is unfriendly to fools — it is a process which also clings to life, or can, as the saying goes, render the subjects of God to madness in preparation for destruction.

It is our duty, as the oppressed, and as the subject of death for freedom, to remind our fellow human beings that love, compassion and knowledge, give us all a collective responsibility. And that therefore, as the strong men of the security forces of white domination go back to peaceful dwellings, their

knowledge of what they saw, heard, and touched in the townships and villages, some of which will be indelible on their minds and unforgettable in their lives, becomes a collective knowledge of the suburbs. It is in the name of this civilian population that the order was given and that black children and women and men, who can never be civilians because they are black and are supposed to have no army, are left with a silence which no one dare listen to. If this silence is replaced with the question of why the people's army, *Umkhonto We Sizwe,* kills white civilians or blacks whose corpses only become human at the raging fire of this army, we can only hope that in the same breath the question will be asked as to why the white army kills black civilians. Then, our wish to be free, puts the responsibility on us to give an answer to the question asked us. And the answer is that the ANC has never in its history considered civilian targets.

We may as well remind the world that the South African regime is illegitimate. That while we are not surprised that it maintains itself through terrorism, we are not expecting too much when we expect everyone to be outraged. In human terms, this illegitimacy of the white parliament made white South Africans emissaries for the dehumanization of Blacks. While on the one hand, this role of Whites had to be built on the destruction of the hopes, aspirations and normal life of Blacks, the hopes, aspirations and normal life of Whites could only be maintained if this state of Blacks was permanent. This could only be permanent if violence is permanent. That is to say, the only condition for Blacks to become human was if they could live the slogan: *'Freedom or Death!'* This is the condition which characterizes the lives of both black and white South Africans in the eighties. The oppressed majority can only enter into history through a blinding sound! We must agree that there is something uncivilized about this act, but that is only because, if free people are unable to accept that the freedom of others is theirs, and are prepared to obliterate this truth with fire, then in the first place, there is no such thing as civilization. We all live a culture of annihilation.

Apartheid, in so far as it refers to racialism, has been the inculcation of fear to both Blacks and Whites about each other. The laws of apartheid were a 'conscious act' on the part of white regimes to ensure that Blacks are subordinate to Whites; this has been achieved through a systematic despoiling of everything human from the Blacks, and the legalizing of the ownership of the land and economic means by white settlers through violence.

Hence, then, the collective responsibility of the oppressed majority in South Africa is to completely clean the streets and alleys of the townships; to absolutely clean the footpaths, fields and *kraals* of the villages; for it is in these streets and alleys, and in these footpaths and fields that we killed each other, raped each other, abandoned our children to a merciless future, as we acted out our worthlessness, and it seems, almost believed the meaning of why we deserved to be despised. We have been known as such and to be capable of this only. It is the very base of white power which taught us our responsibility. We saw the sweat of our brow water the roots of the tree of privilege of white people, from which

their power bloomed. We transformed, almost with bare hands, rocks into holes, digging for gold and diamonds and coal; we built, we produced and as they become wealthy, we become poorer. We had to ask, what is it that is so special about white people? It is incidental that there are white people and black people and this fact has been used to justify a crucial reality, that he who is superior owns power and rules those who are inferior; that is to say, the very fact of being White entitles a white baby to power and the very fact of being Black entitles a black baby to powerlessness. But then, politics is no power without an economic base.

This, then, is the crucial issue of the struggle for liberation in South Africa. White South Africans lived their lives in South Africa certain that they had the right to power; they used this to make certain that their black fellow country people lived their lives certain that it was their right to be powerless. Unnatural and abnormal as this is, it has been the basis for black and white relations, co-existing and as intimate to each other as a powerful hand is to the throat it is about to throttle.

Democracy demands that white South Africans obey the will of the majority — who are black; and democracy is a civilized criterion for life. Since white South Africans cherish civilization; and see themselves as part of and of it, their dilemma has been, how possible is it to give civilization to the uncivilized. The intimate relation between race superiority and economic power in South Africa and race inferiority and lack of power has bestowed upon the history of that country a collective responsibility to the world to answer the question: what is civilization? That is because there is no such thing as black history, history is human and history binds human beings together for life, for without it, there is no life. But that history has also asked of the oppressed whether they are part of civilization. When the world comes face to face with white South Africans, if that world is civilized, it must ask where are the black people of your country? But when black South Africans come face to face with the world, they ask: what is civilization, if to be part of it for us is to live *'Freedom or Death'*? This has been the only condition — and the history of struggle in South Africa absolves me — for us as a people to re-enter life, to re-enter history and culture.

This re-entering of history through such grievous means, by a people relegated to the backyards of the world by law and privilege gained through conspiracy and blood-letting, has been and must be a subject and an issue of great concern for cultural expression in that country and in the world. It is only then civilization anywhere and everywhere can mean progress. That is, it is a moment in history when there should be no backyards in any country, for, indeed, when the oppressed in South Africa have, through their lives, forced on the agendas of the powerful round tables of the world an item on apartheid, it is a moment when once more, the issue of colonialism, whatever its form and shape, must be examined with the sole purpose of it being destroyed once and for all. That is the role of the South African struggle for national liberation in our time.

A people's history, and thus their cultural expression, binds them with humanity. That is so because history is of the people, irrespective of who they are and what colour they are, and culture is their expression of their acting out that history. In South Africa, this truth is lived as apartheid is dying. To hold on to life, apartheid has to be a master at making death, and the more it senses its end, the more it devises more effective ways of making death — hence the oppressed accepting death to gain freedom. The dying expressions on the face of apartheid have become an inspiration for the oppressed to seek more effective means of eventually dropping it dead, no matter what the cost may be; this history of life and death acted with such intense conviction, great demand on people, has become a finesse with which the oppressed in South Africa have hurled themselves out of the storerooms of history and culture, and have forged friendship and solidarity with the peoples of the world. After all, as every human being knows, we all live for happiness, and hope does define it. The songs, the poetry, the novels, the films, the plays which came out of South Africa lately, are located within and bound by the aspiration of the people of that country for freedom, which must mean that, as everyone seeks and pursues happiness and its meaning, in this period of humanity's history when life is under such great threat, our pursuit of freedom, no matter what cost, is a culture of hope creating space for happiness which must restore that peace which we all so cherish.

When Europe declared Amsterdam the capital of culture for 1987, and the CASA Foundation and the Anti-Apartheid Movement (Netherlands) organized a Festival and Conference of South African Culture called *Culture in Another South Africa,* though the world tended to be blind and deaf to this, it was a historic moment! About 300 cultural workers, both from South Africa and those living in exile, met, the objective being to answer the question: how does cultural work become part of and enhance the struggle? Several resolutions were passed, which located cultural work within the aspirations of the oppressed: *'Freedom or Death'.* It was acknowledged at this conference that, as the masses have fought tooth and nail to organize themselves, so must the cultural workers. The organization of the masses, including those of white democrats, is a process of isolation of the apartheid regime and the objective of these organizations is to destroy apartheid and create a united, non-racial and democratic South Africa. The decision of the South African Cultural Workers in Amsterdam to organize themselves, to become part and parcel of the struggle for liberation, working hand-in-hand with the Dutch Anti-Apartheid Movement, was significant. Apartheid culture has been isolated in that country, where it had a free run not so long ago, and it was replaced with a life-and-death culture for democracy, coming from the backyards of South Africa into the international scene. There shall be more of these occasions; as the people have said through their historic document the Freedom Charter: *The Doors of Learning and Culture Shall be Opened!*

The challenges of the written word

A reflection on prose

by Njabulo S. Ndebele

This discussion is premised on the belief that an essential precondition to the establishment of a free and non-racial cultural community in South Africa is the adoption of an holistic approach towards South African society. This approach helps us avoid the traditional trap of evaluating the success or failure of South African society primarily from the perspective of the social behaviour of the white population. According to this traditional approach, derived as it were from the flawed concept of 'dual economy' in South Africa, there are two distinct societies in that country. One society is built around a traditional, subsistence economy, while the other is founded on a modern capitalist economy. The former is characterized by stagnancy, backwardness, technical primitiveness, and is black; the latter, on the other hand, is dynamic, advanced, technically modern, and white. The appropriate ascription of positive and negative values, of connotations of success and failure, is obvious, and so is it also understood that the legitimacy of assigning the attributes belongs unquestionably to the 'successful' white sector.

The fact of the matter is that, within a unified social structure tightly held together by a complex set of historical circumstances, the relative 'success' of one social sector is a function of the 'failure' of the other. This is more evidently obvious in a country such as South Africa. Previously, the traditional focus on white society assumed an identity between South Africa and white society. Now,

when we focus our attention on the black majority, we should not be thought to be exercising an arbitrary and reflex alternative choice, but we want to study and evaluate its structural situation within the total national context as a way towards focusing on the entire national entity. When we do that, we invest in a total national concern.

This position, which is a direct negation of apartheid's approach to things, has immense epistemological and political value. From this position we can assert that the relative technical achievement of South Africa is not, by itself, a sufficient index of social success. It has to be accompanied by an equally successful sociological environment. Without that, 'white' South African technical 'success' is merely a spectacular fireworks display. After the breathtaking brilliance, there is left only a lingering memory that will itself dwindle into the vast and largely indifferent historical time. The challenge of the future in South Africa is the creation of a common national spirit that promises the realization of a higher and historically stronger national potential. But this cannot be done without a comprehensive understanding of the condition, that this potential of the vast majority of the South African society can only be evaluated against the quality of life of the majority.

When we look at the history of prose in South Africa, we are struck by the discovery of the same kind of contrasts as those alluded to above. We witness, on the one hand the plenitude of writers, written materials, and readers (both specialized and general) and, on the other, relative scarcity. Yet, when we actually discover the effort by black South Africans to contribute to the history of the written word in South Africa, we cannot but conclude that we are looking at a vast potential decidedly held in check. We are struck by the sheer force of enthusiasm, of the desire to learn, to inform, to influence, to record, if only to affirm existence in history.

Before proceeding, let me clarify the perspective from which the subject of prose is approached in this discussion. Prose, for the purposes of this discussion, is understood in a very broad sense. It is understood to cover the entire range of writing in both fiction and non-fiction. This approach is helpful for two reasons. First, prose fiction represents only a fraction of the total prose output by black

South Africans; second, we will be enabled to grasp the extent to which literary culture as a whole is a feature of general cultural practice in South Africa. That way we can determine the extent of the development of that aspect of literary culture, as well as assess its role and impact in shaping general social attitudes. Because prose, in all its forms, is easily the most available form of reading, our resulting understanding should also give us a sense of the level of social and cultural development in South Africa today.

In the nineteenth century, I.W.W. Citashe wrote a poem that has become quite well known:

Your cattle are gone,
My countrymen!
Go rescue them! Go rescue them!
Leave the breechloader alone
And turn to the pen,
Take paper and ink,
For that is your shield.

Your rights are going!
So pick up your pen,
Load it, load it with ink,
Sit in your chair —
Repair not to Hoho,
But fire with your pen.

This poem records a painful attempt by the poet to come to terms with the ultimate reality of conquest. Africans had lost the battle over their land. There was no possibility of the kind of victory in war that would have any significant, long-term benefits for the defeated Africans. The poem signals a tragic realization on the part of Citashe and his contemporaries of a dramatic and incontrovertible end of an era. No more the heroic wars and battles of old. In their place new forms of struggle, new techniques of survival, had to be invented. What Citashe and some of his contemporaries recognized was the beginning of the effective marginalization of the African peoples of South Africa; of their functional consignment to the periphery of human history. They would be there, but

effectively invisible. Citashe's insight recognized at least one seemingly unavoidable implication: the written word, perfected in the isolation of the study, which itself perhaps represents a form of strategic marginalization, may be the only viable bearer of witness, the one last act that would provide proof of existence.

Depending ȯn the kind of ammunition chosen, firing with the pen took several directions. In this chapter we are particularly concerned with the ammunition of prose. In this regard, when Citashe wrote his poem, he may very well have been giving legitimacy to a trend that had already begun. Between 1837 and 1900, several attempts had been made by Africans to fire with the pen. These attempts took the form of establishing newspapers and magazines. Given impetus by the Wesleyan missionaries back in 1837 with a paper called **Umshumayeli Indaba**, African journalism in the Cape never looked back. By the end of the nineteenth century and the beginning of the twentieth, black South Africans had played a part in several newspaper and magazine ventures such as **Ikwezi** (1844), **Indaba** (1862), **Isigidimi samaXhosa**, **Imvo Zabansundu** (1884), and **Koranta ea Bechuana** (1901), to name but a few. The history of written prose in South Africa was well underway.

One of the first tasks of the missionaries was to ensure that those African languages that had no written script were reduced to writing. Having done that, the next major task was to produce competent African converts who would help in the translation of the Bible and other major religious writings. These two tasks were performed with a satisfactory degree of success. It was this crop of African converts that took up the challenges of the written word with great gusto. Beginning their apprenticeship in missionary presses, they gained enough experience to enable themselves to set out on their own. In South Africa, the names of Tiyo Soga, William Wellington Gqoba, John Tengo Jabavu, John Knox Bokwe, Sol T. Plaatje, and Azariele M. Sekese of Lesotho come immediately to mind.

The socio-political environment of these early writers was not free from tension. The history of conquest followed by an insidious process of discrimination (which was destined to become total) meant that our early writers could not be entirely

21

free from the ambiguities of their situation. A total immersion into the demands of Christian charity was not possible in a climate of increasing and consolidated dispossession. Their writing, therefore, was a mixture of Christian advocacy and protest, much encouraged in the latter by the support missionaries generally provided in defending the rights of the Africans from the rapacious onslaught of white capital. While reflecting the anthropological interest of their mentors in African customs, these early writers also saw their responsibility as assisting in the literary preservation of their way of life. Thus, many of Tiyo Soga's articles in **Indaba** 'were didactic and moralizing, although they had a typical humorous twist, but he also published recordings of oral art, fables, legends, proverbs, praise songs, and genealogies, of which he was an eager collector' (Gerard. **Four African Literatures**).

From this time onwards, black South Africans produced a steady stream of writing in both English and such African languages as Xhosa, Sesotho, and Zulu. Indeed, we witness phenomenal development of writing in African languages: Tiyo Soga translated Bunyan's **The Pilgrim's Progress** into **Uhambo lomhambi** about which A.C. Jordan has written: '(it was) almost as great an influence on the Xhosa language as the Authorized Version of the Bible upon English' (Gerard). Thomas Mofolo was later to follow with his classic novels. Although numerous other writings in African languages were published at the time, there is evidence that much of African writing may have remained unpublished. Much writing appeared in the newspapers, where considerable debate was generated, and many poems and short stories published. In this context, journalism helped create and consolidate the social sense of prose as a vehicle of learning, debate, and political assertion.

Below is a summary of the modes of prose writing black South Africans have produced in the last 100 years:

Books
Book production by Africans was more likely in African languages than in English. This is because the missionary presses were more willing to publish books in African languages than were the white commercial publishers who were generally afraid of taking such risks as publishing a book by a black author in a racist society. Publishing in African languages was later to be dominated by

Afrikaner publishers who produced largely for a school market. In this field mostly novels were published. Other kinds of books were generally lacking.

Newspapers and Popular Magazines

This has been the predominant method of expression in print by black South Africans. Newspapers have catered for a variety of literary forms: essays, letters, news, short stories, poetry. So have popular magazines such as **Drum**, **Bona**, etc.

Journals

By far the most famous of these has been **Classic**, founded by Nat Nakasa and Can Themba. The main professional magazines that have appeared with any regularity are those sponsored by the government for African teachers under Bantu Education. Beyond that, black scholarly journals remain a rarity.

Pamphlets

The strong tradition of political struggle in South Africa should be expected to produce a rich, endless supply of pamphlets. A history of pamphlets in the political history of South Africa has still to be written.

The above modes of writing generated various forms of prose. The span of forms is relatively broad. Random examples are given below. This outline needs to be fleshed out into a comprehensive history of black South African prose: a task that should be undertaken without delay.

Social/Cultural Criticism

Black South African writers have always sought to stimulate and to inform social debate. Frequently, they could not resist the temptation to wear the mantles of adviser, preacher, and guide; they tried in various ways to increase the common person's intellectual understanding of the socio-political illness of apartheid. In this effort they have attempted a range of subjects.

The Colonial Impact

Jacob Nhlapo's **Bantu Babel: Will The Bantu Languages Live?** (Johannesburg: The African Bookman, 1944), grapples with one aspect of how colonialism may affect African society. This anxiety has spawned discussion in several important directions. The focus has been:

Descriptions of African customs and mores

The disintegrating social fabric of African society
Religion and morality
The importance of education to social advancement and political struggle
The future of African art, music, dance, etc.
Advice of various kinds in facilitating acculturation

The Oral Tradition

The major thrust behind writings of the oral tradition has been the attempt to rescue it from total loss. There was a strong desire to record a passing tradition for posterity. Collections in the following areas are common:
Proverbs
Sol T. Plaatje, **Sechuana Proverbs** (London: 1916)
Praise Poetry
Z.D. Mangoaela's collection of the praise poetry of the Kings of Lesotho is a case in point.
Folk Tales

Political Writings

Naturally there is an established history of political literature. Several themes are common here:
Protest
Advocacy
Exposure and Indictment
Sol T. Plaatje, **Native Life in South Africa** (London: P. D. King and Son, 1916) performs all three functions above.
Courtroom testimonies
Some famous courtroom political dramas have been published in book form and make popular reading.
Nelson Mandela, **The Struggle is My Life** (London: International Defence and Aid Fund, 1978).
Steve Biko, **I Write What I Like** (London: Heinemann, 1979).
Historical ʾPolitical Documents
The Freedom Charter
SASO Manifesto
NECC Resolutions on People's Education

History

Biography

John Knox Bokwe, **Nisikana, The Story of an African Convert** (Alice: Lovedale Press, 1914)

Msweli Skota's **The African Yearly Register: Being an Illustrated National Biographical Dictionary (Who's Who) of Black Folks in Africa** (Johannesburg: R. L. Esson and Co., 1930)

R.R.R. Dhlomo on the lives of Zulu kings

Autobiography

A. Luthuli, **Let My People Go** (London: Fontana, 1963)

E. Mphahlele, **Down Second Avenue** (London: Faber and Faber, 1959)

B. Modisane, **Blame Me on History** (New York: Dutton,1963)

E. Khuzwayo, **Call Me Woman** (London: Women's Press, 1985)

The Diary

Very little of this kind of prose by black South Africans has come to light. Sol T. Plaatje's **The Boer War Diary of Sol T. Plaatje: an African at Mafeking** (London: Macmillan, 1973) is the only major example.

The Travelogue

Tim Couzens in his study **Widening Horizons in African Literature** notes the emergence of 'travel literature' in South Africa towards the end of the nineteenth century. These were descriptions of both local and overseas travel by Africans. This nascent form unfortunately does not appear to have developed towards greater refinement.

There is another example of travelogue that has a potential for development. This is Lesotho's *lifela*, a poetic form developed by Basotho miners in which they relate their experiences of travel away from home. They are a kind of folk biography.

Letters

This form of personal history has seen a recent effort by Chabane Manganye to bring together selected letters of Eskia Mphahlele published as **Bury Me at the Market Place**(Skotaville, 1982). As a prose form affording readers a special insight into the mind of influential people, letters are particularly invaluable in bringing home to readers the human dimensions of fame and heroism.

Journalistic Commentary

There are some particularly popular examples of this kind of prose. The lively journalism of such names as John Tengo Jabavu, Sol T. Plaatje, H.I.E. Dhlomo provides some examples of outstanding forerunners. More recently, there have been Can Themba, and the memorable Nat Nakasa's column in the **Rand Daily Mail**, 'The World of Nat Nakasa', and the current, provocative 'Just Jon' by Jon Qwelane in the **Sunday Star**.

Translation

As already observed, one of the earliest translations was of Bunyan's **The Pilgrim's Progress**, done by Tiyo Soga, published in Xhosa as **Uhambo lomhambi** (1867). Sol T. Plaatje translated Shakespeare's **Comedy of Errors, Julius Caesar**, and others into Setswana. More recently we have seen such masterly translations as **Lafa Elihle Kakhulu**, Sibusiso Nyembezi's translation of **Cry, the Beloved Country** which seriously rivals the English original.

Textbooks

Textbooks by black professional academics in various academic disciplines have been relatively rare. Major achievements have been in the field of African languages in which various books on grammar were produced. The grammars of Sibusiso Nyembezi (Zulu), S.M. Guma (Sesotho), and B.M. Khaketla (Sesotho) come immediately to mind.

More recently, though, some outstanding scholarly works have emerged, particularly from South African scholars in exile. We recall here the works of Eskia Mphahlele, Bernard M. Magubane, Sam Nolutshungu, Daniel Kunene, Lewis Nkosi, Harriet Sibisi, and Mokgethi Motlhabi, and others.

Other Kinds of Prose

Collections of jokes
Recipes
How-to/instruction manuals
The erotic
The arcane/mysterious/magical
Prose in these forms still exists largely in the oral tradition.

Fiction

Prose fiction has received much attention with numerous scholarly studies. The bulk of prose output is in this area in terms of the sheer number of books published in all languages. For a long time South Africa has been known in Africa as the land of the short story. Quite easily, in both the novel and the short story, the names of Thomas Mofolo, B.W. Vilakazi, A.C. Jordan, Alex la Guma, Bessie Head, Lewis Nkosi, Can Themba, and others loom large. It is not essential to document the history of fiction to quite the same extent as above.

Is there a common thread that runs through all these writings? This is not a question that can be answered casually. But there do seem to be some tentative outlines of a recognizable historical development. In this outline may be found the makings of an intellectual and cultural character that may typify a general South African outlook. It reflects a diversity of thought, feeling and preoccupation all of which indicate the nature and character of particular moments in the intellectual history of South Africa. Roughly, the history of prose reflects something of the following about the intellectual response of black South Africans to the drift of history around them:

1. The desire to learn, and to absorb new forms of experience and knowledge
2. The desire to prove ability and successful acculturation
3. The need to define an authentic self
4. The steady growth of self-confidence
5. Concerted protest
6. Defining the enemy (index of self-confidence)
7. Determined assertion
8. Celebration
9. Critical questioning and the quest for, and enhancement of, self-knowledge
10. The quest for the future.

These attributes of South African prose, manifested in the various kinds of writing over the decades, suggest that acts of writing and reading can be viewed as significant social phenomena, yielding clues to definite forms of social knowledge and insights that tell us much about how people have sought to make meaning out of their individual and collective experiences. We see a definite posing of questions and a groping towards answers and solutions within the

context of a vigorous, challenging, increasingly complex, and often extremely painful, historical development. The various meanings of that development through the testimony of prose remain largely locked up in the intellectual dungeons of apartheid.

With the possible exception of prose fiction, the history of black South African prose does not reveal much quantitative and qualitative development after the efforts of the illustrious pioneers in the various prose forms. Prose fiction developed much faster possibly because of the timeless, widespread social habit of story-telling. Other prose forms would require more conducive conditions under which to flourish. They would certainly call for more socially entrenched intellectual habits that can only result from a purposeful, free and intellectually more open society, as well as from levels of economic and social development that make leisure more possible. They assume a more comprehensive universal education, the kind that would result in the broadening of intellectual interest such as would be reflective of the complexities of a modern industrial society. Beyond that, since education in South Africa was not designed to encourage such critical thinking among Africans as would enable them to problematize their environment in creative and critically constructive ways, whatever nascent African intellectual tradition was there was decidedly left out of the African classroom. Thus, the problems of prose in South Africa reflect the problems of intellectual culture in that country.

Looking into the Future
It is crucial that prose be defined as broadly as possible. To do so would be to approach the study of literature, in general, from a more comprehensive perspective. Such a perspective, for the vast majority of the South African population, is an essential antidote to the divisive epistemology of apartheid culture. It emerges as the very essence of a new humanism. To make this possible, several measures should be attempted.

In this regard cultural education in the schools, colleges, and universities must become a much more serious and more creative undertaking than it has been up to now. As far as literature is concerned, it must be properly contextualized within the entire range of cultural activity. The various roles and functions that literature plays in society should be fully explored and understood and the discipline

studied from that emerging perspective.

What may be needed is a consolidated curriculum of cultural studies in which culture is seen as an elaborate system of social meaning, including books, film, television, newspapers, fashion, architecture, theatre, music, video, the magazines, comic books, cookery books, languages, art, etc., incorporating also the possibilities of modern technology.

A coordinated search for primary materials in the various categories has to be undertaken resulting in a comprehensive history of prose. In this regard, it is significant that Rev R.G.W. Shepherd, back in 1955, remarked how every week he received several manuscripts by African authors in the vernacular or in English (Barnet:9). It is highly likely that there are countless trunks hiding away all kinds of manuscripts.

Selected primary materials must be introduced into the national educational curriculum, from school through colleges, to universities. At the moment, very few South African writers of note are part of literary studies in South African schools. The inculcation, in children as well as in adults, of a democratic attitude towards linguistic plurality is an absolute necessity. An essential aspect of this democratic attitude is the necessary translation of much of the best writings of the world into African languages. This calls for the production of language-learning materials such as dictionaries, tapes, grammars, to facilitate inter-African language learning. There is a strong precedent for such a requirement. The early newspapers tended to be bilingual. There are some newspapers that carry on this tradition even today.

Publishing outlets need to be significantly increased within the context of a broad national publishing policy. The task is to provide a variety of reading matter with the intention of meeting as well as broadening the social interest of the average South African. It may be argued that at the moment there are books available in South Africa covering almost every subject imaginable. The privileged sector in South Africa may very well attest that much. But their books and other cultural amenities represent an isolated and restricted social interest. Here, we are concerned with the vast majority of South Africans who see no future in the privileged concerns of white South Africa.

29

The reading range of the average South African is most likely to be very restricted indeed. The availability of reading matter may vary according to whether one is in the rural areas (where there may be relatively very little to read) or in the urban areas (where there will be much to read). But reading in the latter case will also depend on a number of variables: on whether one is in a position to purchase reading material; whether one can have access to a library; or, whether one has the requisite standard of education coupled with a sufficient reading interest to want to read what may be readily available. The fact that there are such numerous reading variables in such a highly industrialized and technically advanced society as South Africa, and that consequently, for the vast majority of the South African population, it is difficult to predict regularity of reading opportunity, indicates the high level of intellectual deprivation in that society.

It follows that if the reading range of the average South African is limited, so also will be the range of his writing. The average South African who reads will read a newspaper. Black South Africans have produced very few books. It follows that the vast majority of South Africans are unable to retrieve information for a variety of purposes: refreshing memory; re-enjoyment of pleasurable passages; checking facts; or for research purposes, however casual that research may be. Newspapers are not easy to keep. After they have been read, the paper may then need to be used for a variety of purposes. The reflective capacity of a society will be greatly assisted by an enhanced capacity to retrieve information. The most easily available method of information retrieval will be through books. So publishing policies, and the particular area of book production and information retrieval facilities are not matters to be taken too lightly. The press must be allowed to flourish as an instrument for the encouragement of national debates through the written word. That way, an informed and critical public can be ensured.

All the above cannot be realized without extensive and well-coordinated literacy campaigns to ensure the spread of the skill of reading.

It is clear from the foregoing that the history of prose is inseparable from the history of society and the manner of its organization. The availability or scarcity of reading and writing materials is a reflection on the level of social development

(specifically on the distribution of opportunities for self-improvement) in particular societies.

Writing in South Africa has predominantly been influenced by the history of struggle. If, as has been briefly indicated above, it requires fresh energy and new directions, then that is also largely because South Africa herself requires new directions into the future. The possibilities to be offered by the long fought for, the long awaited, freedom in South Africa also promise the flourishing of a new intellectual culture.

The social basis of the development of prose is a sound democratic educational system (there, the writers will be trained): the growth of the reading public (publishing houses that coordinate their activities); a dynamic and committed press; the enhancement of social debate through the libraries, theatre houses, concert halls, etc; and the growth of a creative social imagination. All these promise the consolidation of social confidence in a viable future.

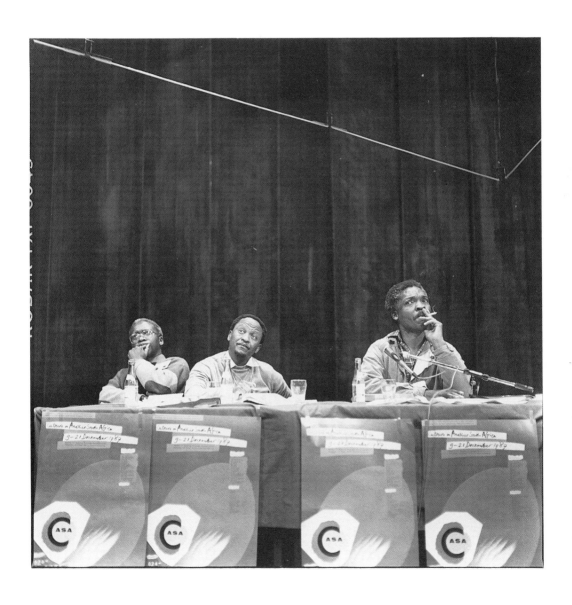

The **CASA Conference** consisted of various sessions. Behind the table the chairpersons on literature. From left to right writers **Lewis Nkosi, Njabulo S. Ndebele, Mandla Langa.** (Photograph by José Melo)

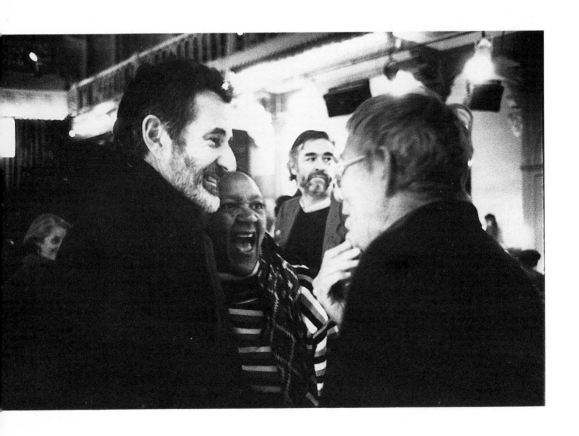

Reunion of three poets. From left to right: Breyten Breytenbach, Barbara Masekela, Marius Schoon. (Photograph by Pieter Boersma)

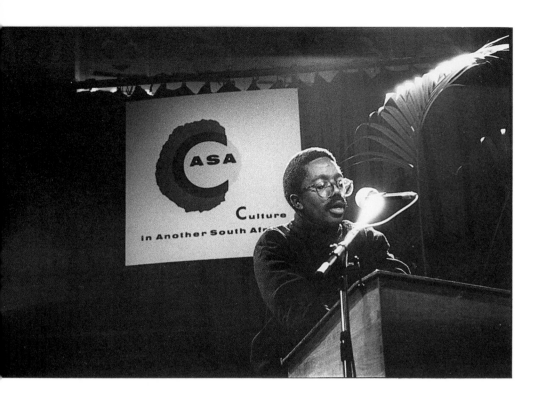

Johnny Matshikiza reads poems. (Photograph above by Pieter Boersma)
Nadine Gordimer reads prose. (Photograph below by Hugo Rompa)

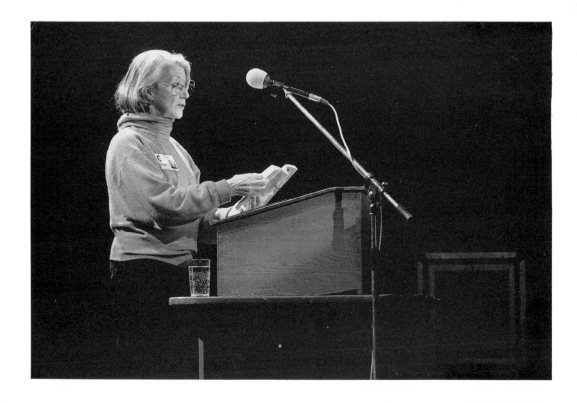

Poet Cosmo Pieterse, Master of Ceremony at the CASA Festival, during a back stage preparation.
(Photograph by Fran van der Hoeven)

Amandla, the cultural ensemble of the African National Congress. (Photograph by José Melo)

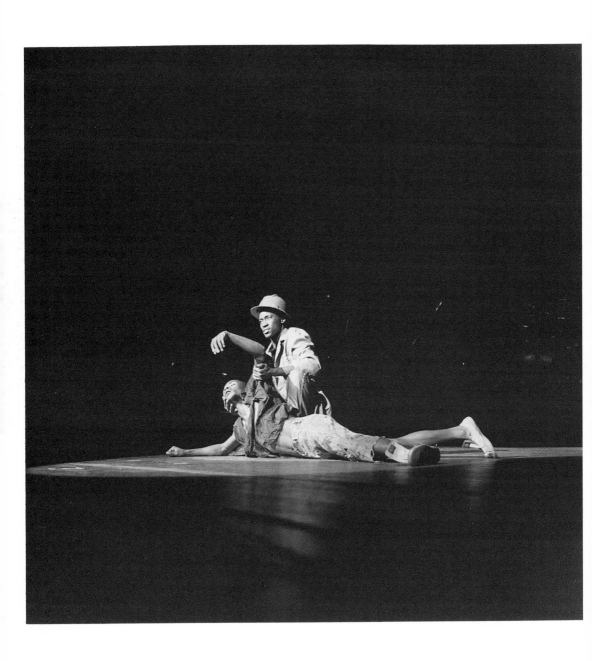

Amandla. (Photograph by José Melo)

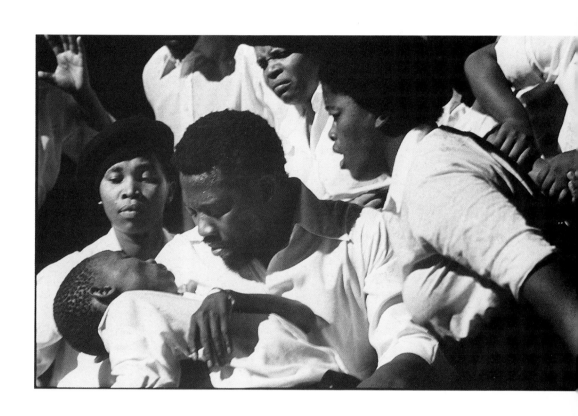

Amandla. (Photograph by José Melo)

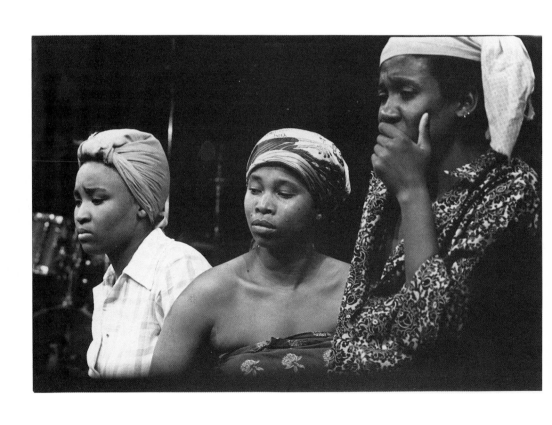

Amandla. (Photograph by José Melo)

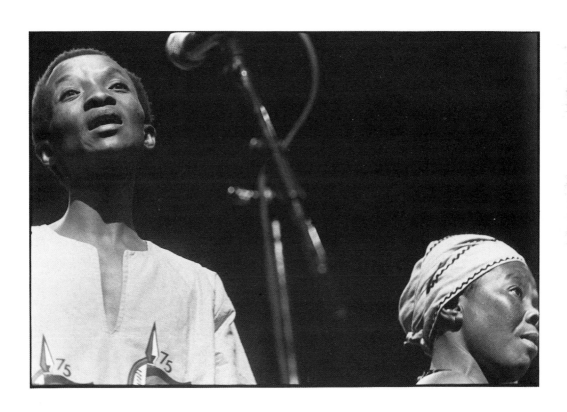

Amandla. (Photograph by José Melo)

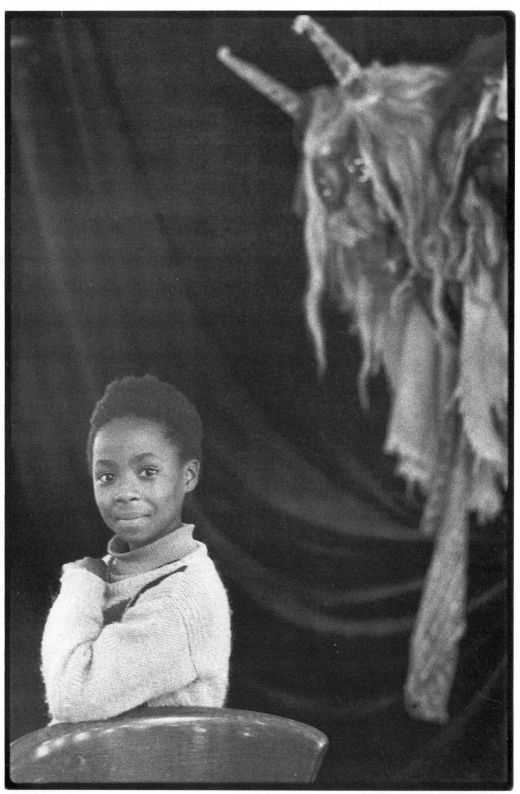

One of the children of the Student Youth Drama Society from Soweto: Nokwanda. (Photograph by Fran van der Hoeven)

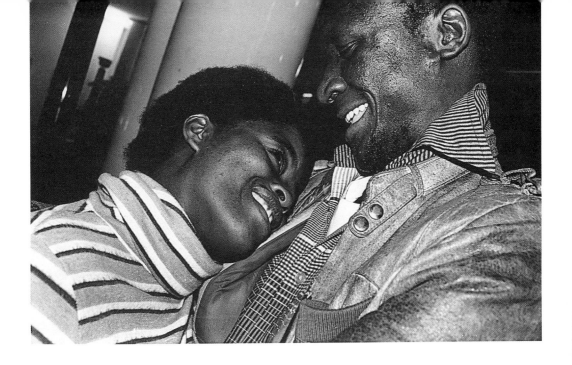

Break in the programme. (Photograph by Bertien van Manen)

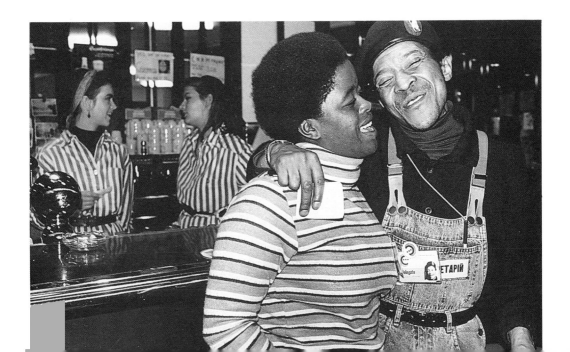

Mmabato Nhlanhla (above, right) replaced the late James Madhlope Phillips as the director of a specially formed CASA Choir of 300 Dutch people singing South African liberation songs. She was also the driving spirit of the CASA Fashion Show. (Photograph above by Bertien van Manen, below by Muriël Agsteribbe)

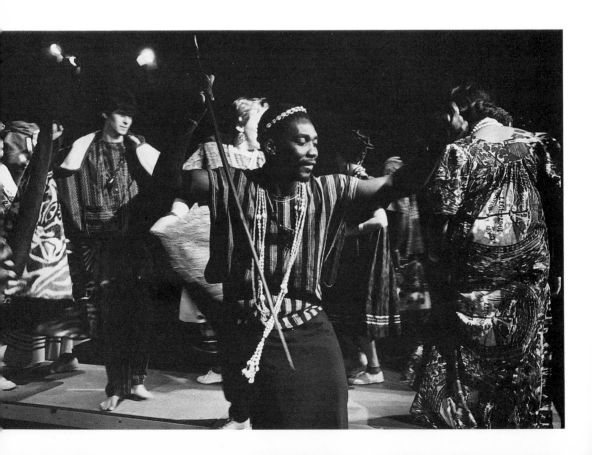

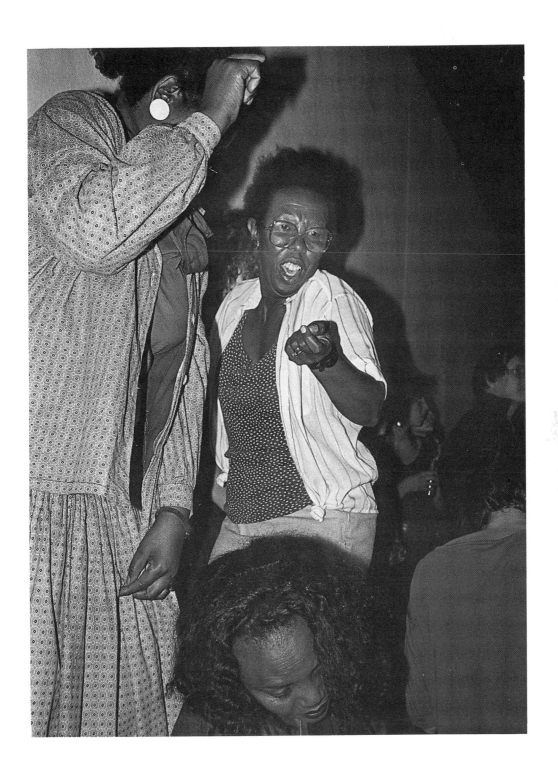

After work: dancing. (Photograph by Jan Voster)

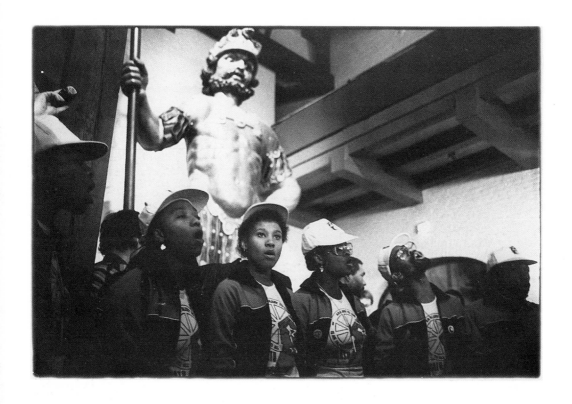

COSATU Choir Singers in the Amsterdam Historical Museum. (Photograph by Pieter Boersma)
COSATU Choir Singers. (Photograph below by Leo Divendal)

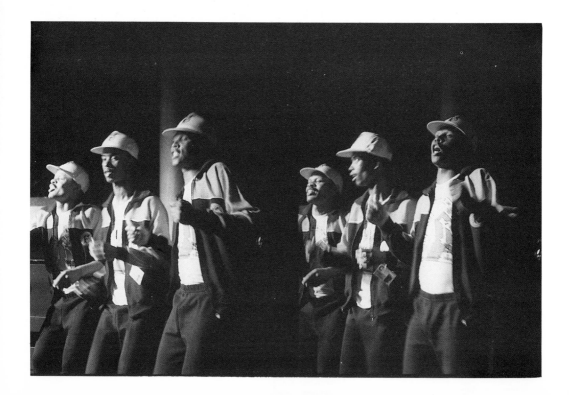

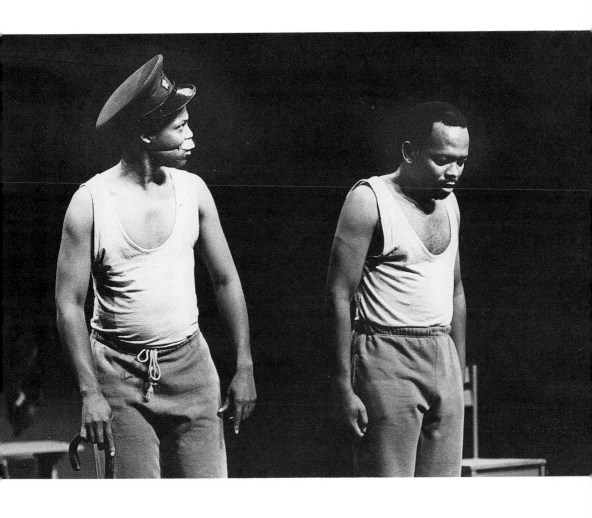

The Earth Players performing in 'Bopha!' (Photograph by Wilma Kuyvenhoven)

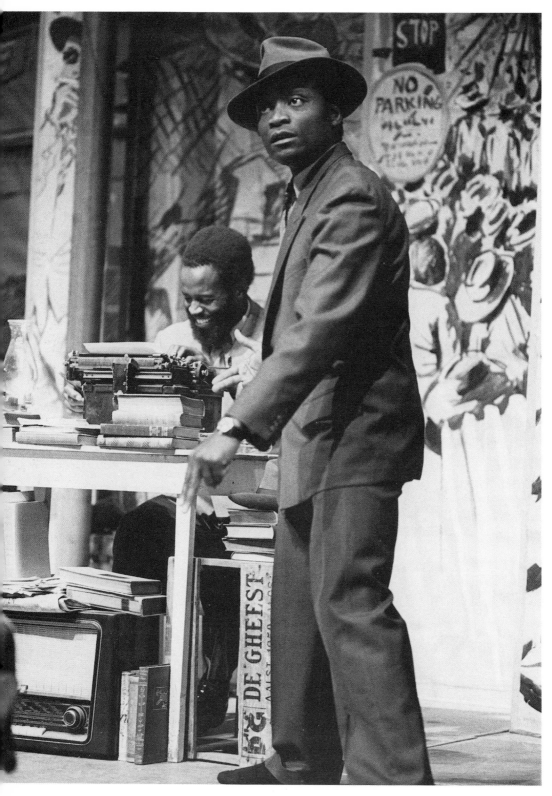

The Junction Avenue Theatre Company performing in 'Sophiatown' (Photograph by Wilma Kuyvenhoven)

The last bastion of freedom under siege

A reflection on theatre

by Anthony Akerman

Notwithstanding the reforms nervously conceded by the white minority government in an attempt to ensure its own survival, apartheid is still alive and kicking – harder than ever. South Africa has entered its third year of rule under a State of Emergency. Opposition groups have been systematically banned, censorship has been increased, what remains of the rule of law continues to be eroded away, unprecedented numbers of people have been detained without being brought to trial and the police force has become a law unto itself. In the past it may have seemed over the top to apply the emotive term 'police state' to South Africa; now it seems little more than objectively descriptive. It is understandable, therefore, that people outside the country are often surprised to discover that the theatre is able to criticize the system at all. It does not conform to their conception of what a police state should be. This may be a paradox, but South Africa is a country of paradoxes. The theatre has appropriated certain 'freedoms' for itself; these are limited, conditional and constantly under threat.

While theatre practitioners remain divided on the perennial question of whether theatre can be instrumental in initiating change in society, the government's mind is made up. The authorities have no doubts about the power of the written and spoken word. If this were not so, there would be no need of censorship in South Africa. Formal censorship has existed since the passage of the original Entertainments Act of 1931 and has frequently been invoked on the most ludicrous of pretexts.[1] In 1963 the Publications and Entertainment Act was passed and this was replaced in 1974 by the present Publications Act. Under section 47(2) of this Act, three of the provisions whereby a work may be deemed 'undesirable' betray a conviction that art can be the cause of social change:
(a) If it is indecent or obscene or is offensive or *harmful* to public morals;
(d) if it is *harmful to* the relations between any sections of the inhabitants of the Republic;
(e) if it is *prejudicial to* the safety of the State, the general welfare or the peace and good order. (My italics.)

This Act, in conjunction with older repressive legislation and newer provisions under the State of Emergency, puts a formidable arsenal of censorship laws at the government's disposal, and yet once again a paradox presents itself. By and large, writers do not appeal against bannings, as they feel that could be construed as an acknowledgement of the legitimacy of the system of censorship, but the Directorate of Publications appeals against its own previous decisions and has taken to unbanning some works. One can only guess at their motives for doing this, but it does suggest that they feel the passage of time has diminished the intrinsic harmfulness of such works as **Fanny Hill, Lady Chatterley's Lover** and **The Communist Manifesto**. This should not be interpreted as flexibility or leniency on the part of the authorities. Under the present State of Emergency it is even an offence to leave blank spaces in newspapers to indicate that censorship has occurred.

Although this climate is hardly conducive to artistic development, theatre survives, and even flourishes, in South Africa. It has been claimed that the theatre is the last bastion of freedom of expression left in the country. Has the theatre been exempted and, if so, why? Barney Simon, director and co-author of **Woza Albert!** remarked that censorship 'decisions are made from confusion rather than

conviction. And it is harder to ban a success than a near-miss.'[2] Jacques Alvarez-Pereyre qualifies this by saying that 'the emphasis in the last few years seems to have shifted from the message to the medium, or rather towards a greater balance between the two. For things can be quite as devastating when expressed in a humorous manner.'[3] Although the South African authorities have never been particularly strong on humour, do not laugh at themselves and resent being laughed at, this theory goes a long way to explain how a play like **Woza Albert!** eluded a banning, especially as the subject matter is explosive: Christ chooses South Africa to stage his Second Coming, as it claims to be a Christian country, is eventually arrested by the authorities, and at the end of the play, when he escapes from Robben Island by walking across the water, the police drop a nuclear device onto him!

Pieter-Dirk Uys is arguably the most successful and subversive satirist in South Africa. During the 1970s his plays often fell foul of censorship. When he began performing his one-man shows he made a point of getting to know the censorship laws better than the Directorate of Publications. He says the government writes his scripts and the Directorate of Publications is his publicity department.[4] He invites the censors to his first nights and when they tell him they cannot attend unless a complaint has been made against the show, he informs them that he is lodging a complaint himself. To date this tactic has afforded him a fair amount of leeway, as the Directorate of Publications is shy of publicity and prefers to examine potentially 'undesirable' works and objects in camera. This is something that Pieter-Dirk Uys and many theatre practitioners in the townships have turned to their advantage. They work without scripts and, therefore, have no text to submit to the censor for scrutiny. A consequence of this is the proliferation of 'improvised' theatre in South Africa. The existence of a play on paper can be a liability for a playwright. Athol Fugard's **Master Harold . . . and the Boys** and Anthony Akerman's **Somewhere on the Border** are both banned as 'books' and yet were both allowed as 'public entertainments'. This paradox approaches schizophrenia.

Clampdown

By the late 1950s an indigenous South African theatre had begun to emerge.[5] The jazz-opera **King Kong** (1959) put life in the black townships on stage in white

Johannesburg and Athol Fugard's **The Blood Knot** (1961) was the first play to confront audiences with the 'race issue'. These productions were seminal for a number of reasons; they confronted the facts of (political) life in the country at the time, they were the result of non-racial collaboration, they demonstrated that the South African vernacular was a valid and effective vehicle for theatrical expression and their success overseas gave those people committed to an indigenous South African theatre a sense of confidence. Although neither of these works received the blessing of the authorities, they were produced at a time of relative freedom of expression. In 1963 Edward Albee's **Who's Afraid of Virginia Woolf?** fell foul of the censor because it was deemed harmful to public morals. As the play was on a tour arranged for mixed audiences, many people speculated at the time that this was what the censor objected to.[6] After a postponement of ten weeks and some cuts in the text, the production was allowed to complete its tour. Two years later, the government amended the Group Areas Act to enforce segregation in all theatres. The times were characterized by a nationwide clampdown on all political opposition. By 1964 leaders of the recently banned ANC, like Nelson Mandela and Walter Sisulu, had been sent to Robben Island for life and many artists and intellectuals had gone into exile. Calls were made for the international community to isolate and boycott South Africa. The government had spared no effort in plunging the country back into the Dark Ages.

1963 is a significant date in South African theatre history. It marks the beginning of a more rigorous censorship under the Publications Control Board created via the Publications and Entertainments Act. The provincial Performing Arts Councils were formed and provided with state funding to present programmes of music, opera, ballet and drama. In the main their work has been unchallenging and, perhaps predictably, provincial. 1963 was also the year the playwrights' boycott began. For as long as it held firm, it deprived commercial managements and the Performing Arts Councils of some of the latest overseas hits. In 1965 the Copyright Act was passed, which made it 'legal' to pirate texts when foreign playwrights withheld performing rights on 'ideological or unreasonable' grounds. To their credit, most theatre practitioners respected the playwrights' wishes and did not take advantage of this odious piece of legislation. Although the effectiveness of the boycott is all but impossible to measure, it certainly did not

bring about the dismantling of apartheid. However, in the long term, it should be given credit for contributing to the movement that eventually swept away segregation in theatres. The playwrights' boycott, inadvertently, did South African theatre another favour as it gave a great stimulus to indigenous play writing.

1963 was also the year that a group of black actors called the Serpent Players presented their first production in the township of New Brighton, Port Elizabeth. They recruited Athol Fugard as 'scribe' and director and went on to produce work that has contributed more significantly to South African theatre than anything to have come out of the Performing Arts Councils. Their financial resources were minimal, but for a decade they produced work which they performed in the townships (where the Group Areas Act often prevented Fugard from attending performances) as well as in university theatres, which were 'private' and fell outside the provisions of the amended Group Areas Act. Their productions of Machiavelli's **The Mandrake** and Camus' **The Just** were memorable, but the pinnacle of their achievement was **Sizwe Bansi is Dead**.

Sizwe Bansi is Dead (1972) is a milestone in South African theatre. It was the result of a collaborative effort in 'play-making'[7] involving Athol Fugard and the actors John Kani and Winston Ntshona. The play walks the tightrope between poetry and propaganda[8] and succeeds in both areas. It was voted Best New Play by the London theatre critics in 1973 and the following year the actors received Tony Awards for their performances on Broadway. More significant than the international recognition the trio earned for their achievements was the influence this play subsequently had on South African dramaturgy. This is apparent in plays like **Woza Albert!** and Percy Mtwa's **Bopha!** Both plays manage to steer clear of stilted propaganda without losing their political impact. A striking similarity between these plays, apart from their small casts, is the simplicity of design. There is little else on stage other than the stock-in-trade of agit-prop theatre – essential props, costumes and a variety of hats. This sparseness has placed special demands on the actors and has resulted in a standard of performance that deservedly commands the respect of audiences throughout the world. When asked what the determining factor was in finding the 'style' for **Sizwe Bansi is Dead**, Athol Fugard said 'to survive for its first two years in South

Africa it had to be a play that you could put in a suitcase and carry around with you.'[9]. In recent years unsubsidized theatre in South Africa has demonstrated how much can be achieved with limited resources.

Market Theatre

It is doubtful if as much would have been achieved without an infrastructure of alternative theatres. The universities made a significant contribution, but the venues that effectively sustained this work were The Space in Cape Town, which was founded by Brian Astbury in 1972, and the Market Theatre in Johannesburg, which was founded by Mannie Manim and Barney Simon in 1976. The Space took advantage of a loophole in the Group Areas Act which made it possible to present controversial work to racially mixed audiences: it operated as a 'club' with a membership, and not as a public theatre. Plays by Pieter-Dirk Uys and Athol Fugard premiered there, as did Fugard's work with the Serpent Players. The Market Theatre, which has always been open to racially mixed casts and audiences, was initially the house theatre for The Company, founded by Barney Simon in 1974. It is also a receiving theatre for topical and socially critical productions from all over the country. It has become an important showcase for unsubsidized, independent theatre, as well as a launching pad for productions that tour internationally.

The Performing Arts Councils do not send their plays on international tours.[10] Not only would such a tour be unacceptable in terms of the cultural boycott, but it is inevitable that their work would be regarded as equivocal. That is not to say that nothing has changed within these bodies in recent years. In 1975, following a prolonged boycott, the Nico Malan Theatre in Cape Town opened its doors to all races. Other Performing Arts Councils have followed suit and now racially mixed casts, as well as politically controversial productions, are not altogether unusual. This is not in response to directives from above, but the initiative of a new generation of theatre managers and artistic directors.

Theatre in South Africa would appear to be thriving. There is no longer enforced racial segregation on stages or in auditoria. There has been a marked increase in the indigenous dramatic output. Plays are performed for and by workers within the labour movements and at political rallies. There has been an increase in the

number of festivals and awards to encourage new talent. A new generation within the Performing Arts Councils has started to flex its muscles. And now that television cameramen cannot send us reports of what is happening inside the country, there is a greater demand for 'anti-apartheid' plays. In the last year **Adapt or Die, Asinamali, Bopha!, District Six, Sarafina!, Sophiatown**, and **Strike the Woman** have all been performed on stages throughout the world.

This international recognition may well have given South African theatre a small measure of protection, but times are always changing. When **Somewhere on the Border** was performed in South Africa last year, it looked as though the Directorate of Publications had taken a back seat, but the authorities had other means of intimidation at their disposal. On the opening night in Cape Town military police arrived at the theatre and confiscated the army uniforms used by the actors as costumes and when the play ran in Johannesburg two of the actors were hospitalized by a gang of right-wing vigilantes. (Needless to say, the police never caught the culprits.) A performance of Michael Picardie's **Shades of Brown** was stopped at the University of Durban-Westville, because security policemen were sitting in the audience filming with video cameras. **Piekniek by Dingaan**, an award-winning satire on Afrikaner holy cows presented at this year's Grahamstown Festival by CAPAB, came under threat of internal censorship. The ensuing debacle resulted in the resignation of the director and the sacking of the head of drama. It has also put paid to the notion that any real artistic independence will be tolerated within the Performing Arts Councils.

The censor has also been considerably more active recently. In May 1988 both Heiner Müller's **Quartet** and Chris Pretorius' **Sunrise City** were banned. The Appeal Board, however, did lift the bans subject to certain restrictions.[11] Minister of Home Affairs Stoffel Botha recently insinuated that an open season would be declared on theatre because of 'a new tendency on the part of dramatists and producers to exceed existing norms and to openly challenge and shock the sensitivity of reasonable members of the community'.[12] He warned that censorship was an under-utilized weapon against plays 'focusing on themes of alleged oppression and police brutality, conscription, alleged social and political injustices and the like. Can the aims and purposes of such plays be anything else

than creating a spirit of discontent, unrest, civil disobedience, insurrection and in the final instance, revolution?'.[13] It is unlikely that any theatre practitioners would overstate their aims in such a crude manner, but now that Stoffel Botha has done it for them the last bastion of freedom of speech is under siege.

Notes

1 For further information see Anthony Akerman, 'Prejudicial to the Safety of the State: Censorship and the Theatre in South Africa': **Theatre Quarterly,** vol. VII no. 28, London, 1977.

2 'Kingdom Come', **The Listener**, 20-26 March 1982.

3 See Jacques Alvarez-Pereyre, 'Black Committed Theatre in South Africa', University of Grenoble, unpublished article.

4 In an interview on Dutch television, IKON, 29 August 1988.

5 For more information on theatre at this time see, **inter alia**, Robert Mshengu Kavanagh's 'General Introduction' to **South African People's Plays**, Heinemann, 1981.

6 Referred to in Russell Vandenbroucke, 'Chiaroscuro: a Portrait of the South African Theatre', **Theatre Quarterly**, vol. VII no. 28, London, 1977.

7 Fugard always speaks of 'play-making' rather than 'playwriting' when he refers to **Sizwe Bansi** and **The Island**, Russell Vandenbroucke, **Truths the Hand Can Touch**, New York, 1985.

8 Fugard's own description in **Notebooks**, Johannesburg, 1983.

9 Interviewed by the author in **Toneel Teatraal**, Amsterdam, December 1984.

10 NAPAC (Natal Administration Performing Arts Council) recently toured a production which only performed to invited guests at South African embassies.

11 Adrian Hadland, 'State vs stage. Stoffel's new war', in the **Weekly Mail**, 3-9 June, 1988.

12 Ibid.

13 Ibid.

Nkosi Sikelel' i Afrika

Lord Bless Africa
Let its Horn be Raised
Listen also to our Prayers
Lord Bless, Lord Bless
Come Spirit, Come Spirit
Holy Spirit
Lord Bless Us
We, thy Children

Enoch Mankayi Sontonga

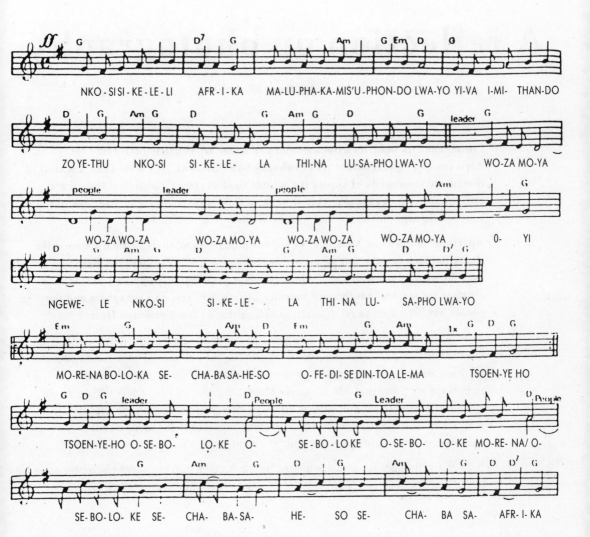

Apartheid — a vigilant witness

A reflection on photography

by Paul Weinberg

I intended this book as a documentary to show what life is really like for Africans. The government will probably ban this book. If I were them I would distribute thousands of copies for whites to show their children if they were concerned with eventual survival. (Ernest Cole from **A House of Bondage**, the first published book of photographs by a black South African).

Apartheid is violence. Violence is used to subjugate and to deny basic democratic rights to black people. But no matter how the policy of Apartheid has been applied over the years, both black and white activists have actively opposed it. It is in the struggle for justice that the gulf between artists, writers, photographers and the people has been narrowed. (Omar Badsha, editor of **The Cordoned Heart**).

These two comments are from two generations of documentary photography. They are in short the pre-1980's and the post-1980's. They share the common thread of all documentary photography to record the truth, but are different in one important way. Ernest Cole, formerly Kede, who changed his name to be granted 'coloured' status in pursuit of exposing apartheid before he fled the country, worked as an individual; Omar Badsha, who represents the more recent period, is a product of the collective movement of recent years.

A good starting point in the history of South African documentary photography is the 1950s. The influences of the picture magazines which had made their way

down to the southern tip of Africa combined with a decade of defiance and popular resistance. It was this combination which married culture and politics in a very vital way to produce **Drum** magazine. Through the influence of their first photographer, Jurgen Schadeberg, and later Bob Gosani, Peter Magubane and Alf Khumalo, these photographers gave life to the campaigns and people who made history. At the same time working from the inside and hardly known in his own country was Eli Weinberg, trade unionist and activist who recorded the political events of the time. Weinberg, who was involved in the ANC, was banned and under house arrest for most of his life. His book **A Portrait of a People** is banned in South Africa and his work has very seldom been seen. His contribution remains an indispensable chronology of the struggle against apartheid of that period. Photographs of the Defiance Campaign, the Congress of the People, the Treason Trial as well as his portraits of the popular leaders of the time, including Mandela, Sisulu and others, provide an invaluable resource in our popular history.

Drum

It is only 30 years later that a number of books that reflect that period are available for our consumption and scrutiny. **The Fifties People** is the most recent of such publications. Edited by Schadeberg, it is a powerful document of the period. Schadeberg himself, a contemporary legend, is now being dusted off the ledge and finding his way back into South African life after a long time away. Working in the mould of **Drum** ('live fast, die young and have a good-looking corpse') the work is reflective of that period. Music superstars of the time pose next to reportage of political campaigns. The amalgam is in an incredible mix which even 30 years later makes many modern picture magazines look weak.

It is important to note a difference in style and content between the **Drum** photographers and Weinberg. Weinberg was the serious recorder who looked at political events and people while the **Drum** photographers reflected the culture as well. As Schadeberg said, reflecting on that period at a documentary conference recently, 'we also went out to have a good time then'. Weinberg concentrated on making a political statement of the time, while the **Drum** period is characterized by a broad look at black culture, up till then disregarded by the white-oriented media.

Around at the time but to emerge only in the 1960s as a full-time photographer was David Goldblatt. Magubane, Schadeberg and Goldblatt remain the pioneers of the early period whose influence on the photographic movement has been profound.

Magubane still works in the reportage school of 'if you're not close enough, you're not good enough'. 'People should know how the underdogs live – even if I wasn't dealing with the underdog, but with the rich; people should know how the rich live' (interview 1987). Banned in 1968, Magubane is best known for his 1976 photographs and book on Soweto, after which he spent 519 days in detention.

Goldblatt on the other hand is a more traditional documentary photographer, characterized by his use of the portrait. His style, although original, has touches of Walker Evans and Paul Strand with flashes of Cartier Bresson. 'I am concerned to look at the world which I live in, trying to probe it, understand it, and use the camera for doing this and the occasion for doing this . . . I am concerned with the choices people make for themselves' (interview 1987).

Schadeberg falls somewhere in between the 'on the beat' reportage photographer and the considered documentary photographer. He was strongly influenced by the picture magazine formula of photojournalism adapted to a South African situation. Having studied in Germany before his arrival in South Africa he played a crucial role, not only as a photographer, but in his ability to pass on photographic skills. Struan Robertson, a contemporary and himself a documentary photographer, for whom Ernest Cole worked for a time, wrote of Schadeberg's work: 'The centrality of his role as instructor cannot be understated. Not only did he play the crucial role of sparking off a complete tradition of black photographers involved in journalistic and documentary work, but he also influenced many white photographers as well.' (**The Wooden Spoon**, 1987, thesis on documentary photography).

All three are still very active in photography. Schadeberg is currently working in film and still on 1950s material. Goldblatt, who works primarily for **Leadership** magazine, has devoted his recent energies to a portrait on the night riders of KwaNdebele and structures in and around Johannesburg. Magubane has his hands full as a staffer for **Time**.

Magubane and Goldblatt, and more recently Schadeberg, through their own photographic works have provided an invaluable reference for our documentary history. Goldblatt's work provides a sociological journey through South Africa – from the mine lifestyle to an in-depth look at the Afrikaans-speaking community. In **Boksburg** he looks at his own background while **Life Times under Apartheid**, with Nadine Gordimer, is his attempt to make an overt political statement. Magubane's affinity with his subject matter allows for a more spontaneous and organic political statement, in particular on Soweto – its poverty, its spirit and its resistance of 1976.

Afrapix

In contrast to the pre-1980s period, the post-1980s period is characterized by a collective approach to documentary photography. Its early roots can be traced to the cultural magazine **Staffrider** which was born after 1976, in response to the cultural renaissance that emerged then. The magazine gave rise to and stimulated voices up to then unheard, of poets, writers, artists and photographers. Most of the photographers at the time were working in isolation from each other. The new generation comprised Omar Badsha, Judas Ngwenya, Jimmy Matthews, Biddy Partridge, Mxolise Moyo, Lesley Lawson, and Paul Weinberg. They ranged dramatically in opinion and skill but expressed a deep interest in sharing ideas and skills. All, in their own way, had been documenting the horrors of apartheid resettlement, squatter life, migrant labour, poverty. Some of these photographers met informally in Johannesburg one day and the end result was the formation of Afrapix. From the start Afrapix had two very clear objectives – to be an agency and a picture library and to stimulate documentary photography.

The library that grew out of this meeting became an important resource for the alternative press and socially concerned groups. But the meeting point was fundamental to the seeds of a new kind of approach. In very simple terms this was that, collectively we can say much more than we can individually. Two years later came the formation of the Black Society of Photographers established in Johannesburg which had a short but important influence on later events.

In June 1982, the Culture and Resistance Festival organized by the Botswana Museum set the tone for the collective photographic movement. It hosted the first

collective exhibition to come from South Africa, bringing twenty photographers together for a first joint photographic statement. Participants learnt a new language – artists were not above the struggle for change but part of it. All people who worked in culture shared a common identity – the word cultural worker was heard for the first time.

There were black photographers who did participate but, by and large, it was met with a black boycott, emanating from the Black Society of Photographers whose line was no participation with white photographers. What is significant about this exhibition, which characterizes the documentary genre from this point on, is the range of skill and vision. Experienced photographers like David Goldblatt exhibited side by side with young and inexperienced photographers showing their work for the first time. Goldblatt has been the bridge between the generations.

From 1982, collective exhibitions became an annual event. Under the auspices of **Staffrider** they continued until 1987. In a special magazine highlighting the first exhibition called **South Africa Through the Lens** some of the thinking behind the exhibitions was reflected editorially:

'The camera doesn't lie. This is a myth about photography in South Africa in the Eighties that we will not swallow. In our country the camera lies all the time – on our TV screens, in our newspapers and on our billboards that proliferate our townships. Photography can't be divorced from the political, social and the economic issues that surround us daily. As photographers we are inextricably caught up in those processes – we are not objective instruments but play a part in the way we choose to make those statements. [The photographers in this collection] show a South Africa in conflict, in suffering, in happiness and in resistance. They examine the present and beckon the viewer to an alternative future. . . . Social Documentary Photography is not, in our view, neutral. In South Africa the neutral option does not exist – you stand with the oppressors or against them. The question we pose is how do photographers hit back with their cameras?'

A criteria was thus provided for an aesthetic, although this took a number of years to articulate itself in form and content. More importantly, a process had been begun whereby, year after year, more and more photographers were drawn into the collective exhibitions.

Another very important milestone soon after the Culture and Resistance Festival was the Carnegie Inquiry into Poverty and Development, set in motion in 1983. Unlike the Farm Security Project, its budget was conceived along amateur lines. In a very thorough way it put photo essays to record the poverty that underlies apartheid – resettlement, migrant labour, farm labour, squatter life, etc. However, in a significant break with the past, it also documented organization and resistance as a way out of the plight of poverty. This conceptualization is significant in the consciousness of the documentary movement at the time. An important process had been internalized which came out of a lot of questioning by photographers who photographed poverty. What is the solution to poverty and how does one portray it? It is also important to note the symbiotic relationship that documentary photography had by this stage with the democratic organizations in this country. The new generation had begun to articulate itself through work and ideas. Photography, they asserted, needed to go further – to take sides.

A number of photographers began to document the growth of the progressive movement, the labour movement, and present a comprehensive picture that had not been seen since 1976. It should be noted that, in these early days and even with the formation of the UDF, the presence of the international press was small. It was only when South Africa became a 'story' that interest was shown. And it was only when it became a 'violent story' that concerted interest was shown. It is for these reasons that the indigenous documentary movement has a depth to it that international photographers lack.

However, many of the photographers who did work for the international press came from the new generation and their impact has been remarkable. Professor Neville Dubow, Professor of Fine Art at the University of Cape Town, has suggested that the period of unrest of the past few years has provided powerful images that have helped to articulate the kind of violence South Africans experience. He cites two kinds of violence – structural violence and responses to this violence. Structural violence is the apartheid system itself and the responses range from militancy to victims of this violence. He has also noted the adapting religious rituals that reflect a violent society.

65

The Hidden Camera

It has been exhibitions that have provided the catalyst for a collective approach. In December 1987, Amsterdam hosted the biggest ever anti-apartheid festival. Under the title, **The Hidden Camera**, it attempted to draw parallels with the way camera was used as a form of resistance against the Nazi occupation of Holland. The exhibition drew a response from 32 South African photographers. It brought together the most coherent work from those photographers who had been on the frontline, as well as essays on different themes and communities.

The collective exhibition has had a profound effect on the traditional conceptions of documentary photography. It encouraged up-and-coming young photographers and provided them with an outlet. It stimulated the 'travelling exhibition' and a form that goes beyond the 'gallery'. The gallery is often a community hall, a church hall, a public meeting, a foyer, a union conference and so on. When COSATU held their 2nd congress it was accompanied not only by a wealth of cultural events but an extensive historical exhibition of the labour movement as well.

The travelling exhibition often coincides with significant cultural and political events, such as August 9 (Women's Day), or the History Workshop's Popular History Open Day. This new type of gallery is reflective of an attempt by the new generation to deal with inherent contradictions of photography. 'Critical culture' becomes a product for the 'converted' and the middle class, while the new gallery has begun to provide an alternative outlet to a popular constituency. One of the products of the collective exhibitions has been the development of an alternative and accessible archive, a resource that has helped the stimulus of popular and alternative forms of communication – posters, calendars and the alternative press.

The documentary photographer who goes out to record, research and make a statement is soon faced with the issue of taking sides. It is for this reason that the South African photographer has a clear role to play. The clarity of this role has provided an organizational base for photographers to come together to address inherent problems. One of the most pressing areas in need of attention is that of photographic education. 'Each one teach one', once a popular slogan for a now banned organization, is slowly spreading into the photographic fraternity. While it

should be recognized that community photography is in its infancy, increasingly there are workshops being offered by more experienced photographers to facilitate this process. Their focus is on community groups and the trade union movement. Workshops are run by the Centre for Documentary Photography, Dynamic Images, the Brotherhood, Vakalisa, and Afrapix. These organizations comprise the existing photographic collectives. These collectives exist for commercial, ideological, education or a combination of reasons.

Looking at the community photography movement, it should be noted that there are very few black women photographers. There are a number of white women photographers who in the last ten years have made a significant contribution to the documentary genre. This is clearly an area that needs urgent attention as highlighted by Nisa Malinga, COSATU's cultural organizer in the Durban area. Making the point in general she observed that women joined in organized culture reluctantly. The problem lay in the double-shift issue, which saw women at full pace at the workplace and then working at home. This left very little time for cultural activity.

The collective approach of the 1980s has helped generate a process that has dynamically challenged the contradictions of photography as practised in the capitalist world. The collective approach has brought amateur and professional, teacher and student together in an exciting fusion of ideas and cultures. This has spurred on a development of non-racial vision and consciousness. Regional and local structures are helping to concretize this collective movement. The Photo Workshop based in Johannesburg and the Cape Cultural Congress are emergent fora for an indigenous non-racial culture through which it is hoped photographers will continue to document, teach and organize to express this new vision.

While there may be encouraging signs in the development of documentary photography, there has also been a concerted attack on the media for the past two years. It is important to see this development in the context of the other. Ever since the apartheid government has been in existence, there have been media restrictions. With increasing resistance to apartheid, there have been increasing restrictions placed on the camera. Much of the law protects those in uniform in defence of apartheid. By law, any photograph of a policeman or soldier or their operation is illegal.

The period of protracted unrest (1984-1986) brought to the fore an interesting contradiction that the lower levels of the apartheid government had to deal with. The police and army were caught between attacking the press and the people. The state was caught between showing off its reform to the outside world and its undisguised repression. It was in this gap that the camera played its most crucial role. This period has recorded some of the most dramatic images to emerge from South Africa. To suggest that photographers had it easy is misleading. Whenever they could, the police and army, having dealt with the people, then dealt with the press. It was a period of continuous arrest, confiscation, harassment and even at times assault.

Propaganda

It was in this period that world opinion was truly altered irrevocably to take sides against the South African government. The State of Emergency allowed the state to shift its attack to the press and the camera, which had inflicted a lot of punishment on the image of the country and needed to be sorted out.

The camera was and still is, except for the government's own propaganda purposes, seen as an instrument of insurrection. Louis le Grange, Minister of Law and Order in 1986, went further and accused the television crews of inciting violence. The subsequent media restrictions have refined the attack on the media to the point where a documentary on children made by the BBC can be the number one news item for three days.

Journalists and photographers who now criticize the government or merely cover anti-apartheid events are seen to be 'media terrorists' who are a part of the conspiracy theory that all that is opposition emanates from Moscow, even when it is on your front door. The gap that 'reform' politics allowed has gone and the gap between the press and anti-apartheid organizations, the people and the press is no more. We are all enemies and they are moving in on all of us. The latest press register that came with the last State of Emergency of June 1988 is an attempt to control every single journalist's copy, every photograph that gets published and all film and video footage that is taken. Breaches of these regulations are punished with a R20,000 fine or a ten-year jail sentence without the option of a fine.

Registration means, in effect, all media workers become licensed government agents. All those who refuse registration live dangerously or have to alter their careers. In a more insidious manner, the harassment caused to media workers, in particular small agencies, has become alarming. Chris Qwazi, a photographer who works for **Port Elizabeth News** (PEN), had all his negatives stolen in one of the 'strange burglaries' that took place in agencies recently. The 'burglars' penetrated sophisticated alarm systems only to steal files and documents and to leave the cash behind.

At a meeting to discuss this press registration and the gagging of the press, Sheena Duncan, human rights activist, appealed to the audience to 'stand up for the truth and respond creatively to apartheid'. What does this mean for the photographers who have built the tradition of documentary photography of which news is an integral part? How do they begin to 'respond creatively'? It is clear that the 'frontline' photography of the last few years will not be done by the professional. It will be the community photographer, the worker photographer who will record this history. A recent photograph that was published by **The Namibian**, an anti-apartheid newspaper based in Namibia, may illustrate this new era. The photograph showed an 'alleged Swapo guerilla' who was tied to a Caspir (a police vehicle) being paraded around a village in Ovamboland. What is far more important is that the photograph was taken with an instamatic camera by an Ovambo villager who, as quickly as he could, dispatched the film to the newspaper's head office in Windhoek.

The working photographer will continue exploring metaphors and symbols in an attempt to find creative responses. Recent work has indicated a shift into more in-depth community photography and more personal searches in the community of the photographer. Under such restrictions the camera seems likely to turn its energies to popular history and oral tradition, as has been the case in the struggles of Central America.

Many photographers will face the possibility of harassment, and of restrictions on or banning of their creative products. At the first ever documentary conference held in this country, its organizer, Omar Badsha was detained on the day it was to

open. It nevertheless went ahead with the feeling that the war on the media is very close to us. However, there is one war that the documentary tradition has shown, not only in our country but throughout the world, that apartheid will never win, and that is suppression of the truth.

References

1. Omar Badsha (ed.), **The Cordoned Heart**, Capetown: The Gallery Press, 1985.
2. Ernest Cole, **House of Bondage**, New York: Random House, 1967.
3. Peter Magubane, **Soweto Speaks**, Capetown: Ad Donher, 1978.
4. Struan Robertson, **The Wooden Spoon**, thesis, 1987.
5. Jurgen Schadeberg (ed.), Johannesburg: Bailey's Archives, 1987.
6. Eli Weinberg, **Portrait of a People**, London: International Defence and Aid Fund, 1981.

Ntyilo-Ntyilo

(Bird Song)

I heard a sound from the bush.
I looked up, I drew near.
The sound I heard was
Ti, li, ti, li, ti, li.
Ntyilo, Ntyilo, Ntyilo.
That melody was beautiful.
I heard a voice from the bush.
I looked up, I drew near.
The voice said:
'There is trouble in the land.'
Tra-la-tra-la.
That melody was beautiful.
The owner of the voice
Was dressed in white robes.
The owner of the voice
Was dressed in red robes.
The words were
Tra-la, tra-la, tra-la.
The melody was beautiful.

Miriam Makeba

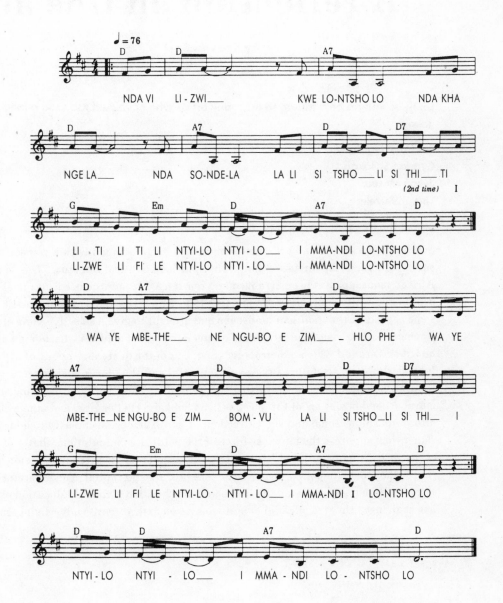

In the name of art

A reflection on fine art

by Steven Sack

Let these images be a tribute to the many artists who have died too soon and too young.

Empraim Ngatane,
Cyprian Shilakoe,
Julian Motau,
Thami Mnyele,

and to the freedom they longed for.

South African art, like all art, must of necessity be understood within a specific social context, in this instance that of the apartheid political structure. The South African landscape has been arranged and rearranged to suit the needs of racial capital and white supremacy. The images following this article are emblematic of some aspects of that political landscape and attempt to give a selective view of fragments of the visual culture found on the Reef, where gold was discovered and mined and around which a metropolis grew. Out of the dusty metropolis of Johannesburg, an artculture underwent a painful and slow birth, and has ironically found its feet in the difficult times of the 1980s. South African fine art, mural art and poster art of the '80s has been bold and challenging, and above all affirmative of personal and social freedom. It has developed a capacity to address rather than suppress the immense force of the political manipulations that characterize life in apartheid South Africa. It has offered an alternative vision to that of the other competing visual ideologies of state and capital. This liberatory visual culture has penetrated the iron shield of Christian National Education and has challenged the stranglehold of state television and corporate advertising. In

the streets as well as the art schools, galleries and museums, a critical and liberatory vision of and for South Africa has matured. This new artculture has had to negotiate the many complex forms of repression, denial and co-option, engineered in the name of 'civilized standards', 'racial purity' and 'corporate identity'.

A Critical Visual Culture

Art has had many definitions and it is made in the name of many visual ideologies, some more poetic than others. The poetry of the apartheid state has been one of severe faces, stampeding horses and more recently, modernist abstraction (the image of reformed apartheid). A public art tour through Pretoria is not without its sculptural shocks and surprises; one of the more recent surprises being a group of three lifesize bronze giraffe, grazing in the streets of Pretoria. The state has lavished a select group of white artists with major public commissions.

In terms of some of the more recent 'refinements' of apartheid policy, with the so-called new dispensation and the tri-cameral Parliament, art was defined as an 'own affair', meaning that the different ethnic groups were required by law to develop culture in racially segregated institutions and with varying degrees of state support or restriction. In this way, culture is carefully monitored and made available selectively so as to prevent the 'conscientization' of the masses. The state has constantly intervened in this process particularly as regards the more popular art forms such as posters, film and theatre and there has been censorship and control continually on the distribution of critical or 'protest' art. Cultural venues are controlled so as to prevent the free flow of cultural ideas and to monitor the accessibility of liberatory visual ideology.

Despite this policy, a vibrant and independent non-racial culture has been forged by artists and cultural activists working in alternative, privately organized venues – community centres and art centres. Many artists have made a significant contribution towards the development of a critical visual culture. This has been particularly evident in the Cape, where the lack of galleries as a mediating force has left artists free of the pressure or temptation of serving the needs of an intellectual middle-class. However, because of the limited access to venues and the stringent control placed on the media, images of direct political engagement have generally not been seen by very many people inside the country. In fact,

there are many people who have the perception that little or no 'political' art is produced, in particular by black artists. This has partly to do with the fact that activist artists have been forced to go into exile and that the galleries have not been viewed as the appropriate venue in which to display these images. Such images have been used within progressive organizational structures.

In particular parts of the country, art has consistently been used to reflect the socio-political environment, and as a tool in the development of progressive political organization especially in the production of posters and banners. The phenomenon of the 'people's parks' during 1984 was the strongest manifestation of a popular art movement that attempted to address issues related to environmental reconstruction and political conscientization. It is not surprising that this popular cultural upsurge was ruthlessly destroyed. In fact these parks with their rock gardens and tyre sculptures were viewed as potential 'ammunition dumps'. This would not have been the first time that art was put to military purpose. In times of war and shortage of materials in the West, steel and bronze sculptures and pieces of architecture have been melted down for weapons. In fact a common sculpture produced during the 'operation clean-up' and 'people's parks' manifestation was a cannon constructed out of the rear wheels and drive shaft of an old motor-car.

Political Landscape

When one looks at the official history of fine art in South Africa, it could be argued that many artists have worked with little awareness of the destruction being wrought by the apartheid regime. This art of dreamers, mystics and myth-makers has led to a rude awakening in the 1980s. Many artists have correctly recognized the need for an art of beauty, for a release from the harsh realities of the political domain. But this 'apolitical' art has, at times, been used against that very freedom that it seeks by being promoted so as to legitimize state power. For many artists the illusion of a South Africa of great beauty, and a romantic relationship to the spirit of Africa, sustained a never-ending fantasy and escape into mythologies and metaphors. Landscapes, wildlife and 'native' studies constituted the major concern of artists, followed by international modernism which also served to divert artists from the reality of apartheid. In 1976, the state could take an exhibition of traditional and modernist black art abroad and attempt to perpetuate the illusion of a benign enlightenment, a Garden of Eden.

The events of Soweto 1976 and the disruptions of the entire nation during the 1980s transformed the Garden of Eden into a political landscape, in which razor-wire and police roadblocks intruded upon the lives of everyone. Art too lost its innocence and it is probably true that almost every artist working during the 1980s produced work that reflected the harsh political realities that were experienced then by many whites for the first time, but had become almost second-nature to so many Blacks.

The great danger and challenge for artculture in our time is the problem of co-option. Although artists in increasing numbers and with greater effectiveness are producing a critical art, it is seen, acquired and promoted within white-controlled middle-class structures. As such, it is tolerated and manipulated to perpetuate the illusion of reform while the working class and the mass democratic movement continue to suffer constant repression.

A reflection on the development of fine art as a conclusion to this contribution is best shown with a number of illustrations, each with a story of its own, rooted in a far and recent past, sometimes already destroyed, sometimes found again in a different form: they give a far from complete, but nonetheless colourful impression of what the present has to offer and what the future holds in store.

The pictures contain fine art from inside South Africa, as it used to be or still is visible in the streets and elsewhere. From the limitations of a number of illustrations and the general framework of this book, it follows that the work of many well-known and unknown artists (living both inside and outside South Africa) is left aside: Thami Mnyele, Ben Arnold, Dumile Feni, Bill Ainslie, Gerard Sekoto, Louis Makubela, Gavin Jantjes and so many other fine artists from the 'other' South Africa.

Illustrations

Illustrations **1, 2** and **3** (photographs by S. Sack) were taken in Soweto during 1986. As one drives into Soweto on the Baragwanath Hospital highway, these three signs were the visual landmarks of the township landscape. They have all been removed and replaced with new signs. The advertising billboards in Soweto tend to dominate the landscape and become transient landmarks. They get woven into the social fabric and serve as literal and metaphorical indicators of the

underlying social forces. Within the context of the huge military presence in the township at that time (1985-86), the meaning of the *The Deadliest Doom Ever* sign (photo 2) takes on an ironic meaning, particularly with Soweto in the background. The Gilbey's Gin advertisement, located opposite the Baragwanath nurse's residence, and surrounded by the debris that litters the entire township, provides an icon to alcoholic addiction (photo 3). The *We Make Signs and Fine Art* painting, a piece of non-formal advertising which only managed to stay on display for a few months before it was removed, is a moving testimony to the fallen artist about to be devoured by a bird of prey (photo 1).

Illustration **4** (photograph by S. Sack): an advertisement in Braamfontein Johannesburg, contrasting the South African reality, the good time, **Coke is it** and the security **Peaceforce** that makes it possible and impossible. In the background is the Johannesburg to Soweto train.

Illustration **5** and **6** (photographs by Gideon Mendel): white kids in their white park (above); and **Only Poorman feel it** (down), a park made by youth during 1985 as a part of the 'Operation Cleanup' organized by UDF affiliates.

Illustrations **7, 8, 9** and **10** (photographs by Cecil Sols): **People's Parks** or **Peace Parks** that were built in 1985 in Mamelodi township, outside Pretoria. The public areas of the township were beautifully transformed. Grass, trees and flowers were planted and a variety of 'found object monuments' were made. Because these 'monuments' and 'signs' were mostly a celebration of the struggle, they were destroyed by the armed forces and conservative members of the community. Hence what had been an attempt to initiate responsible action on the part of the local citizens was maliciously destroyed.

Illustrations **11, 12** and **13**: black art has undergone significant growth in the 1980s. The educational opportunities have improved, although an enormous task remains, requiring external funding. These centres have evolved into an area of non-racial organization, in which equal partnership between black and white people is tested and negotiated. The prospects of diminishing resources, as the state delays the total elimination of apartheid and sanctions take hold, make the future of this embryonic art movement quite uncertain. There has been an important consolidation of a number of alternative art centres: such as the

Johannesburg Art Foundation, where Bill Ainslie has played a major role in facilitating and stimulating artists, both black and white; Fuba Academy, which after a number of years has established a matric programme for studies in Art, Dance and Music – Fuba also runs a gallery which, with the Market Galleries across the road, provides a varied programme of art and photographic exhibitions; Funda Art Centre, located in Soweto, where the African Institute of Art has established the 'Khula Udweba' (Grow through Art) Teacher Training and Child Programme; other existing art centres are the Alex Art Centre in Alexandra township, Mofolo Art Centre in Soweto, the Community Arts Project in Cape Town and the Community Arts Workshop in Durban.

Illustration **11** is of a teacher who participated in the pilot study for the Khula Udweba Programme, making her first ever drawing using sticks and black ink. Illustration **12** is of Richard Mabaso, then resident artist at the Funda Art Centre, and a participant in the pilot programme for prospective community-based art teachers. Since this pilot study, a two-year programme has been running, teachers are now being assisted in the establishment of neighbourhood programmes in Soweto and Katlehong townships.

Illustration **13** is of part of the mural at the entrance to the Fuba Academy in Newton, Johannesburg.

Illustrations **14, 15, 16, 17** and **18** (photographs by Larry Scully) are of a miners' compound that was destroyed in the 1970s. It is not clear who painted these murals, which are reminiscent of the murals found on the walls of rural black homesteads. Traditionally these would be painted by women, but women were not allowed to stay with their husbands in the compounds. However, when the mines closed, the hostels were used by various homeless people, and so it is feasible that the painting was done by a woman. These murals add some visual pleasure in what were appallingly overcrowded and severe living environments. Each compartment was the sleeping place for a miner and each dormitory slept sixty or more men.

Illustration **19**: a piece of sculpture by Michael Goldberg, entitled **Hostel Monument for the Migrant Worker** 1978.

Illustration **20**: the image of Samson was painted on the wall of the ICU (Industrial and Commercial Workers' Union) during the 1930s and is one of the few artworks that have survived from that era of working-class cultural action.

Illustration **21** is a work entitled **Detainee** by Paul Stopforth in 1978.

Illustrations **22, 23** and **24** are of a group of people who lived communally and formed a theatre company called the Junction Avenue Theatre Company (present during the CASA Festival with **Sophiatown**). One Sunday in 1978 everyone painted a collective mural. The dog perched on the box and a local meths drinker named Samson (seated while being drawn by William Kentridge) and who had a reputation for being an abortionist, were incorporated into the mural. On completion of the mural, a discussion was held on issues relating to culture and politics.

Illustration **25**: a work by Jo Schonfeldt, **Untitled**, an assembled sculpture in painted wood from the UNISA (University of South Africa) collection.

Illustration **26**: a functional postbox by Doe Molefe and son, owned by the Gertrude Possel Art Gallery, Wits University.

Illustrations **27** and **28**: drawings by William Kentridge.

2

3

4

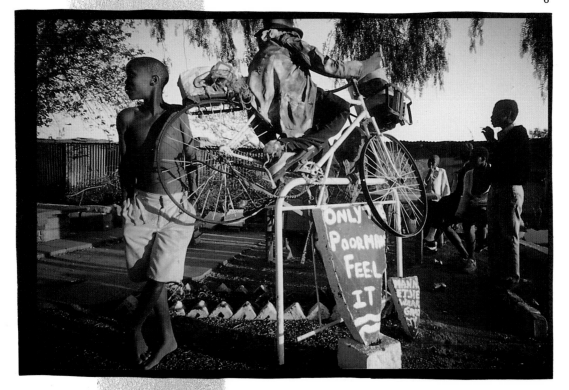

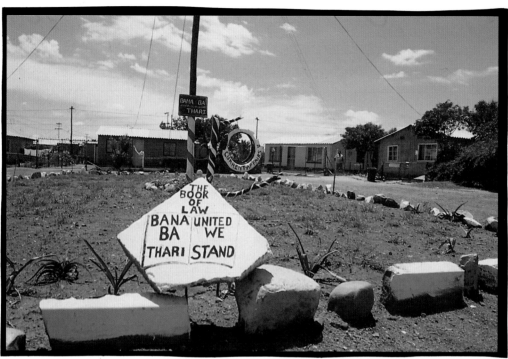

7

8

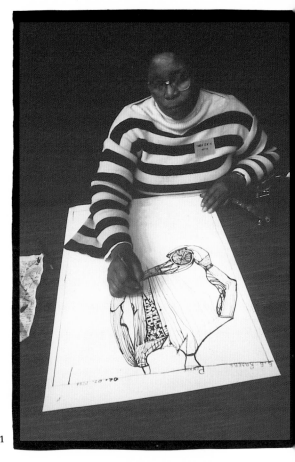

11

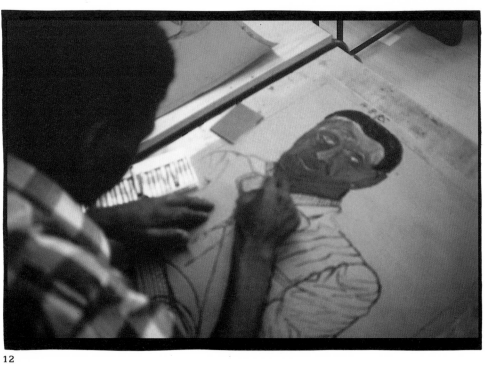

12

14

15

16

17

18

19

20

21

22

23

24

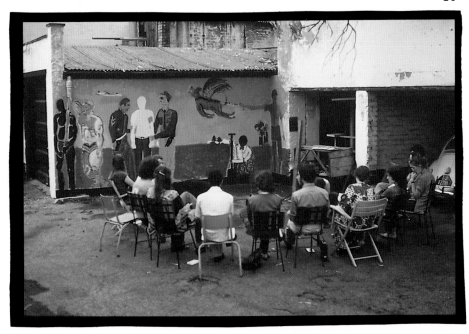

25

26

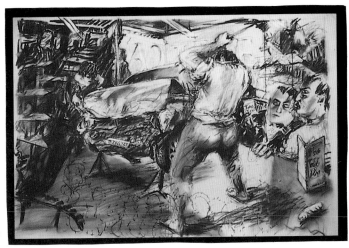

27

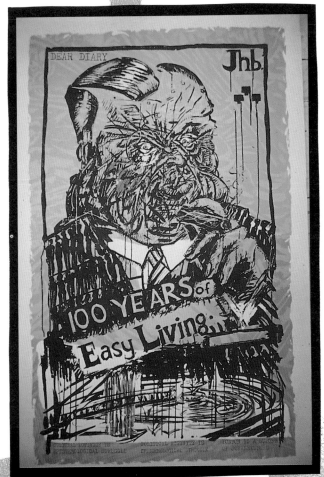

28

CASA Festival posters and papers. Graphic design: Frank Beekers, Lies Ros, Rob Schröder.

The Hidden Camera CASA Exhibition poster. Graphic design: Victor Levie.

The destruction of P. W. Botha. Viva Nelson Mandela! Poster and postcard, a present to CASA by Joost Veerkamp (graphic design) and Rolf Rolf Henderson (silk print).

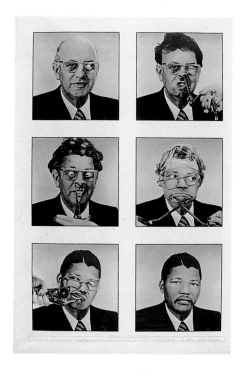

© Photographs by Sjaak Henselmans

Restrictions on the media

A reflection on journalism

by Mono Badela and David Niddrie

There is nothing, amid South Africa's vast censorship apparatus, preventing the country's media from publishing the information that a prominent prisoner has contracted a potentially lethal disease. Indeed, the fact that the prisoner was an internationally known figure whose seventieth birthday had just been celebrated by millions of people throughout the world would have made it a logical lead story for all South African papers, radio and television. Particularly as it was possible to establish that the ageing prisoner had not been hospitalized until he began coughing blood in his cell.

But when Nelson Mandela contracted tuberculosis in July 1988, the first newspaper to publish the fact was a British Sunday paper. This was followed by twenty-four hours' silence, after which the news was published by newspapers in Holland and Denmark. This was followed by a flurry of stories in papers and radio stations in Canada, the United States, Sweden and Germany. Only three days later did South African editors wake up to the fact that their country's best-known and most widely supported political figure might be dying.

Almost a week passed between the first worried rumours of Mandela's condition and the first press reports in South Africa. This 150 hours of silence speaks volumes about the state of the South African press.

Battered by years of government invasions into its right to publish – and three years of all-out assault – the South African media is a shadow of that which endless newspaper bannings, suspensions and seizures ago proudly claimed the title of 'the freest in Africa'. Whether that claim was ever true – and the rigour of the media in many unexpected corners of the continent suggests that it was not – is less of an issue than the fact that South African journalists, most particularly conservatives, believed it. Today they can no longer keep up even the pretence.

Under the leadership of President P.W. Botha, who sailed into office on a wave of 'reformism' in 1978, the ruling National Party has steadily tightened the screws on the media (and all other areas of social and political life) in South Africa until, today, it is often easier to understand what is happening in the country by reading the reports in several foreign countries, than by reading South African papers themselves.

It is possible to chart this decline through the steadily expanding State of Emergency restrictions on the media – restrictions which aimed first at blotting out public awareness of the mass, semi-insurrectionary resistance which characterized South Africa in 1984-85, by banning reports on events.

When this failed to stop enterprising journalists from seeking – and finding – loopholes in the sloppily drafted restrictions, the state empowered itself to suspend newspapers, the contents of which it disapproved. Finally, when this too failed to stop at least some of the truth from being published, the state in 1988 turned its attention to individual journalists – granting Home Affairs Minister Stoffel Botha (increasingly the personification of the assault on the press) the power to require journalists to register with the government, and to withhold registration from those individuals he felt did not conform with apartheid's view of acceptable journalism. In this he has been – temporarily – thwarted by an unexpected combination of journalists, editors, businessmen fearing such a blatant move would spark further sanctions, and Western diplomats similarly worried.

But it is a matter of time before this next logical step in the gagging process is enacted. Already there are reports that Botha, embarrassed and angered by his temporary defeat, is seeking another route towards the same objective.

Before outlining that route, it is worth returning to Nelson Mandela. Just a week before news that he had contracted tuberculosis, Mandela had unwittingly been the subject of a government-press conflict with P.W. Botha publicly demanding that the pro-government **Nasionale** newspaper corporation sack the editor of its biggest paper, the Johannesburg-based **Beeld**, because he used his newspaper columns to lobby for the release of Mandela. **Nasionale's** board of directors has not yet obliged, although its managing director, Ton Vosloo, has been one of the leading proponents, within the media, of further restrictions. We will return shortly to the persuasive Mr. Vosloo and his plans for the press.

For the moment it is worth remaining with the Mandela story. Although the South African press was among the last to pick up on the fact that he had contracted tuberculosis, South African journalists were not. It was a South African journalist working for **The Observer** in Britain who broke the story, and other South Africans working for various European publications who followed up. It is an indication, albeit a small one, that South African journalism - unlike much of the media - has not yet surrendered to Pretoria's demands for tame, 'responsible' (ie. uncritical) reporting.

The more important point, however, remains the first one we made. Although there was no ban on reporting Mandela's condition, no local publication did so - until well after newspaper readers throughout the world were aware of it. In seeking the reasons for this, it is necessary to look beyond the unremitting pressure directed by the government at the media (although that pressure forms a part of the broader picture).

Timid Animal
Briefly, the South African media can be characterized as follows:

An electronic media (radio and TV) owned or controlled through licensing by the government.

A 'mainstream' press of which well over 90% is owned by a cartel of four major newspaper groups - which also own the only non-government television channel (which in terms of its licensing contract is barred from running news). Because these papers draw their main revenue from advertising, and the people able to

afford the commodities and services advertised are mainly white, upper-income city dwellers, these papers cater mainly for white, upper-income city dwellers although most South Africans are neither white, well-paid (when they are employed at all – and up to 25% are not), nor city dwellers.

A small, struggling 'alternative media', made up of a handful of weekly and monthly publications, a half-dozen independent news agencies and not many more trade union publications. These media, and their journalists have been the prime target of government action.

The electronic media is almost exclusively pro-government. Until the late seventies, the mainstream press was either conservative (the Afrikaans-language papers) or liberal (the English-language papers). Those mainstream papers which tried to break this mould – **World** in 1977 and **Sunday Post** in 1979 – by covering news black readers were both interested in and which reflected their interests, were banned. These papers were not banned for committing any crimes – indeed they were never challenged in court. Rather they were closed for accepting a single principle that is anathema to the government: that black people were entitled to a role in the running of their own lives. They were also banned for attempting to assert their journalistic right to report on the views and actions of organizations – most notably the outlawed African National Congress (ANC) – which repeated surveys have shown have the support of the majority of South Africans.

This alone would not have turned the South African mainstream press into the timid animal it is today (or would be if it were not for individual courageous journalists). The **Rand Daily Mail**, a 'white' newspaper with a majority of black readers widely regarded as the conscience of the South African press, survived for a further five years, opposing apartheid to the end.

But the vast cost of apartheid had, by the mid-1970s – combined with an international recession to distort seriously the South African economy – contributed to the political explosion of 16 June 1976. The belated introduction of television to South Africa added to this to erode rapidly newspaper advertising revenue. Newspaper owners, happy to allow their publications to oppose apartheid while they remained profitable, moved sharply right as profits plummeted.

The last years of the **Rand Daily Mail** are the most vivid example of this. In early 1985, after sacking two outspoken editors in quick succession, the owners of the **Mail** closed the paper. A month later, however, the four major newspaper groups – among them the owners of the **Mail** – announced that the government had granted them a licence to start the country's first and only privately owned TV station. The deal had been brokered by Ton Vosloo. The mainstream papers were looking elsewhere for profits and – said opposition spokesmen – had traded the country's most highly regarded newspaper for those profits.

The process continued: in pursuit of profits, the papers steadily eroded the quality of journalism – cutting journalists' salaries (in real terms) year by year, until at one stage they were among the lowest-paid white collar workers in the country. 'If I need journalists, I can get them out of the gutter', one particularly notorious newspaper manager said at the time. As journalists' salaries dropped below those of policemen and teachers – both notoriously badly paid professions in South Africa – an entire generation of committed, assertive and progressive journalists were forced out of the papers. Some, like those who broke the Mandela story and those who went on to establish the tiny but vigorous 'alternative media', remained in the profession. Dozens of others moved out entirely – with dozens emigrating through the early eighties. Those who remained behind were, for the most part, too timid or too inexperienced to challenge their newspaper hierarchies and the state.

The explosion of political resistance that turned South Africa's black townships into a bloody battleground in 1984, turned the newspapers themselves into battlegrounds: young reporters, fresh from witnessing scenes of brutal repression in the townships, fought bitter verbal battles to get their stories into the papers against tough resistance from newspaper managements which feared that such stories would both terrify their predominantly white audiences and – more importantly – scare off their advertisers.

South African Euphemism
A steady stream of politically and economically motivated newspaper closures, combined with this newspaper management retreat to the right, created both the motivation and the opportunity for the establishment of the major 'alternative

media' initiatives – the **Weekly Mail**, **New Nation, South** and, belatedly, a Durban-based independent weekly newspaper due on the streets in 1989. These were, without exception, established by journalists alienated by the shifting priorities of newspaper proprietors.

These papers, outspoken, openly opposed to apartheid and unconstrained by the political conservatism of advertisers – most substantially foreign-funded – were among the prime targets of media restrictions introduced by the state with State of Emergency rule in most urban areas in 1985 and, from 11 June 1986, nationally.

The first time around, the state banned reporting on 'unrest' – a South African euphemism for manifestations of popular rebellion that drew in millions of people to challenge apartheid more fundamentally than it had ever been challenged before. Significantly it also banned reporting on the actions of 'security forces' in curbing this resistance. In the next 24 months it consistently narrowed down the space for reporting: when journalists found a loophole in reporting on the often brutal actions of South African soldiers and police, the authorities made it an offence to be present at an incident of 'unrest' or security force action.

When this failed to stop the coverage, the apartheid government granted Stoffel Botha arbitrary powers to suspend the publication of newpapers for up to three months for weeklies and up to six months for monthlies. After delaying for several months – it is still unclear why – Botha used these powers early in 1988 to close the Catholic Church – backed **New Nation** (whose editor, Zwelakhe Sisulu, has been detained for much of the newspaper's existence) and its Cape Town equivalent, **South. Weekly Mail** managed to survive for some months by tying Botha into a complex and interminable set of negotiations. With the new emergency regulations – each set lasted for 12 months – from 11 June 1988 Botha retained the right to suspend the papers, but appeared to be unkeen to do so because of the international outcry resulting from the action against **New Nation** and **South**.

The method he chose instead was to introduce a compulsory register of journalists – granting himself the power to arbitrarily de-register them, thus making it an offence punishable by up to ten years' jail to continue practising as journalists – 'committing journalism' as one South African writer described it.

The register was due to take effect in August 1988 and for much of July it seemed he would succeed. In drafting the regulations, Botha defined the requirement of registration as affecting only those undertaking 'news agency business', while at the same time exempting the national South African Press Agency, and 14 international agencies. Only the half-dozen independent agencies would be affected, he said.

The definition of 'news agency business' was so widely drafted, however, that it would have covered virtually every journalist in the country - thus empowering Botha to pick off at leisure those he felt were unacceptably critical of apartheid. It took little time for newspaper proprietors to realize the implications. Once they did, several of them - notably Harvey Tyson, editor of the country's biggest daily, **The Star** - threw their weight behind a 'Save the Press' campaign organized by journalists to head off the government register.

They succeeded in spreading sufficient concern among local businessmen - their sensitivity to government action heightened by the prospect of tough US sanctions under the Dellum's Bill, then about to go before Congress - that several national business groupings approached the government to warn of the potential consequences of such a direct attack on the press. Their warnings were endorsed by South African based diplomats of Pretoria's few remaining Western allies. Botha backtracked hastily - saying he would redraft the restrictions to exempt the 'mainstream' press. The retreat came too late: having been galvanized into action by the threat of a register, Tyson and others responded by saying that exemption - implying that those exempted would be acceptable to Pretoria - was just as bad. 'We would be labelled propagandists for Pretoria,' a statement by journalists warned.

In early August, Botha retreated further, dropping the idea of a register. For South African journalists it was a hollow victory. All they had won was the right to report within the confines of restrictions which do not allow them to be legally present at a political protest. The reality of their situation was driven home when police reacted to a protest by members of the Federation of Transvaal Women (Fedtraw) in Johannesburg by ordering the women to disperse - but detaining most of the journalists covering the protest.

Nor has Botha given up in his bid to bring journalists into line: in September 1988 he summoned to a meeting the media owners' organization, the Newspaper Press Union (NPU), now with Ton Vosloo as vice-president, to demand that they toughen up the Media Council - a voluntary body formed by the NPU as a watchdog over member papers. Formed in response to government threats in the early eighties to form its own version, the Media Council has operated as a mildly liberal defender of press freedom since its inception. So far media owners have resisted attempts by the government and by Vosloo to grant the Media Council disciplinary rights over non-members and - more sinisterly - to grant the Council powers to suspend and fine publications and journalists.

As we write, the outcome of the meeting is not yet known. What is known is that the government is holding out as bait the offer of commercial local radio station licenses - long championed by Vosloo as a vehicle to boost the advertising revenue of the 'Big Four' media corporations. Last time around, the 'Big Four' traded the **Rand Daily Mail** for the only non-government TV channel.

Nor is this the only threat hanging over the heads of South African journalists. Not satisfied with the powerful gag they already have on our right to inform, and South Africans' right to information, the government has threatened several further steps towards absolute media silence - among them a ban on reporting on 'political' trials until final judgement. At the same time, the country's highest court, the Appeal Court, has overturned a ruling by the liberal Natal courts which last threw out several clauses of the emergency regulations as they affected the media. Although this Appeal Court judgement is largely academic - the government had already redrafted the regulations in a way that they would stick - it is a further sign that we cannot rely on the system to defend us from itself.

Similarly there has been a growing recognition among journalists that the freedom they hold highest - freedom of information - cannot be realized in a society that does not recognize and enforce all other basic human freedoms. Journalists have thus engaged in a series of debates on how to integrate themselves and their struggle for freedom of information with the struggle for a free society in South Africa. And they have done so recognizing the need to retain an integrity and independence as journalists - heeding the warning voiced by ANC media official

Victor Moche during the CASA conference in Amsterdam: 'A sycophantic press is the most fertile breeding ground for tyranny.'

The CASA conference was, in fact, something of a watershed for this trend among journalists – bringing together media workers from all over the country and from the national liberation movement based outside the country to debate and begin synthesizing the views of different elements in the broad democratic movement on the role of the media. That process is still continuing, and will almost certainly continue to do so well into the post-apartheid era in our country.

Shaping the future

A reflection on film and video

by Barry Feinberg

To agree with Lenin that film is the most important of the arts is not to make an unduly subjective or partisan judgement; nor does this viewpoint imply any downgrading of the importance of other artistic disciplines. The judgement is based objectively on the unsurpassable size of the audience that cinema has at its command and therefore its enormous potential for influencing human behaviour. Of course, the impact of film has been greatly extended by the advance of television and video which has also served to increase the centralization of control over people's ideas and attitudes.

The state-controlled television broadcasting system set up in South Africa in 1976 'is today one of the chief means by which the apartheid system reinforces its ideology and hegemony'.[1] While television has become increasingly more pervasive than the cinema, film has played a clear supportive political role. Although South Africa's local film production is relatively modest – in 1984 there were only ten features produced – more than 230 films were imported from Britain and the USA. The total audience for those films exceeded 40 million in that year,[2] making the film industry a major accomplice of SABCTV in underpinning the interests of the apartheid regime and its collaborators.

In this connection, it is of interest to note that, despite its relatively small population, South Africa is currently the 11th largest foreign market for US film productions. In 1984 the distribution of US films in South Africa realized more than $11 million in rentals.[3]

Clearly the politics and profitability of US film enterprise in South Africa is indivisible. The film and video industry is a powerful weapon protecting apartheid. This has ensured that whites also monopolize jobs in the film and television industry. Consistent with the general discriminatory education policy of the regime, film and television education has deliberately precluded the training of Blacks. There has been not more than a token development of black skills and those few who have been trained, invariably as technicians as distinct from producers, directors and script writers, have mostly been absorbed by the state television system or by white production companies.

Increasingly during the 1980s:

'in order to respond to the growing hunger in the black urban areas for TV with a greater relevance to the black communities, it has been useful, even necessary, for the regime as an insulation against black radicalism to encourage the development of a stronger element of black surrogate participation in film and TV production.'[4]

There has also been a commensurate expansion in the number of films specifically produced for black consumption. 'Despite the questionable standards in many of the films the appetite to see films in their own vernacular by over 20 million people has very much created a "captive" market. Films are more often than not the only entertainment available in those areas, as television has yet to arrive.'[5] Because of the relative size of the national groups the black film industry appears to be growing at a faster rate than its white counterpart. In 1983, 15 films were released, in 1984 32, and in 1985 more than 50.[6]

Quite apart from the obvious commerciality of this burgeoning black film programme, it is clear that the content of the films is thoroughly sanitized according to the exigencies of the Board of Censors. Indeed, many of the films, particularly the earlier ones, have been overt vehicles for purveying 'traditionalism'. 'These movies usually start with a well-dressed, sophisticated migrant worker with a suitcase walking through the bush. Once he arrives home he progressively readapts to tribal life (even if he is city born . . .) is bewitched by sorcerers and spirits, and by the end of the film, he has taken to wearing skins, feathers and beads.'[7]

The Spirit of Revolt

A more recent genre of films for blacks, ostensibly less racist, deals with 'a self-contained urban black society . . . Causation is displaced from society to the individual. Crime, for example, is shown to be the result of greed rather than necessity. Unable to deal with the source of social conflicts – apartheid – this genre stresses individual solutions to individual problems. Collective action is necessarily a political activity and is thus avoided.'[8] Of course, it is only through political activity that the persisting and intensifying social and cultural inequalities and distortions can be uprooted. The defeat and dismantling of apartheid will not in itself create a democratic, non-racial and unified film and video industry but it is the prerequisite for such a development to take place in the future. And it is the film and video workers themselves who are best placed to help shape that future.

Film and video are certainly powerful weapons sustaining the system but they can also be powerful weapons when turned against it. The ANC and the liberation movement have always stressed the vital revolutionary role that cultural workers have to play in the struggle:

'We charge our cultural workers with the task of using their craft to give voice, not only to grievances, but also to the profoundest aspirations of the oppressed and exploited . . . Let the arts be one of the many means by which we cultivate the spirit of revolt among the broad masses, enhance the striking power of our movement and inspire the millions of our people to fight for the South Africa we envisage.'[9]

Recognition of the key role of culture has always been part and parcel of the ANC's strategy for an alternative South Africa. In July 1982 at the initiative of the ANC, a pace-setting conference on the 'Culture of Resistance' was held in Gaborone. Film and video workers from inside and outside South Africa featured prominently at this event and pledged to 'align themselves with the people of South Africa for the liberation of the country by contributing their special skills in a conscious and organized way in their communities and regions.

Almost exactly one year later, the establishment of the United Democratic Front consolidated on the broadest possible national level the growing opposition to the

apartheid regime. Films of the event made by community film and video groups were copied and fed back to supporters up and down the country. It was not long before footage of this historic occasion was incorporated into documentaries both inside and outside South Africa. The setting up of the UDF was a milestone in the development of non-media based film and video work in the country. Individual film and video workers inspired by the Gaborone conference were able for the first time to site their skills and commitment within a constituency of mass militant opposition to the racist regime. This organic relationship with the mass democratic movement gave great impetus to the growth of community video collectives, in particular, but also, to a lesser extent, to a few established independent film and video documentarists with an anti-apartheid outlook, who could now, for the first time, get assistance and feedback from clearly defined and accountable political structures.

Despite steadily intensifying police surveillance of the media, especially since the State of Emergency in July 1985, these two sources of film and video information on apartheid and the struggle against it have become increasingly organized and productive, albeit in circumstances of high risk to the producers. While community and worker-based video groups had their task clearly defined by the internal political and educational needs of the organizations comprising the mass democratic movement, there has been less scope for the much more complex and cost-intensive internal production of documentary films and videos.

Because of the state monopoly of the television network and the close control over cinema circuits, the largest part of documentary production has fallen into the hands of international TV companies. Not lacking in financial and technical resources, they produce or buy in films which, with rare exceptions, are not concerned with, or able to further the cause of, national liberation. Their lack of perspective on the central issues of the struggle has been exacerbated by stringent state laws prohibiting the taping and filming of 'subversive' material. As a result they have adjusted their focus away from depicting scenes of repression and resistance to productions involving footage of a less overtly political character. Not that the scenes of conflict were very properly contextualized; but they did provide for a mass world audience seering insights into the unbridled savagery of the regime's repressive apparatus.

Despite these weaknesses and difficulties resulting from the ongoing crisis of the apartheid regime, an unprecedented number of documentaries appeared on international television networks. The largest concentration has been in Britain where, despite the Thatcher government's consistent role as the apartheid regime's most ardent collaborator, more than 80 documentaries critical of apartheid were transmitted on UK television networks in the five years following the foundation of the UDF in August 1983, compared with 40 in the previous five years.[10]

ANC Cinema

The apparent liberalism of the British media is in part due to British capital's long-term concern for the future of its stake in South Africa. It is clear that change is necessary and in this regard legitimization of protest including recognition of the leading role of the ANC, however undesirable, is unavoidable. Conditions have, as a result, been created for positive interventions by the ANC and its supporters in some sections of the media. Most recently the attempted cover up by Botha's regime of its violence against children was exposed on BBC TV and its attempt to distance itself from responsibility for a growing list of political assassinations was effectively countered on a commercial TV channel. A ten-hour international transmission of the Free Mandela concert went ahead despite a flurry of hysterical objections from South Africa and its friends.

There is clearly much more that can be achieved in isolating the apartheid regime through the British and international TV networks, and this is a crucial task for the international solidarity movement in the sphere of video and film. There is also much to be done to help build an alternative film culture. At the Amiens anti-racist film festival in 1983, international cinematographers called for film workers to prevent the diffusion of their films in South Africa and to boycott products of the South African film industry. They also called for the setting up of a vast international support movement in unity with the cinema of the ANC. While this declaration has still to be fully translated into effective action, there have been important developments. International government and non-government funding is helping to provide professional video production facilities for the ANC, including the training of technicians.

As a result, not only have the ANC and related organizations like the International Defence and Aid Fund (IDAF) succeeded in producing their own films and videos,

110

many of which have achieved international awards for their excellence, but this climate of support has helped non-ANC cinematographers, most recently in the hitherto remote region of feature films, to make outstanding contributions to raising to unprecedented heights the levels of popular sympathy with the liberation struggle. Of even greater significance (if less dramatic), is the development of an anti-apartheid feature film production group inside South Africa. Its first production is currently being screened on the international festival circuits.

Building support for projects of this kind should not, of course, be confined to the solidarity sphere:

'With the financial and technical help promised by friends, the ANC will be able, for the first time, to make decisions about the form and content of its own films rather than be subject to the goodwill of independent film makers or the mercies of the media. At the same time, it will be possible to give urgent attention to the crucial problem of responding to the developing struggle in South Africa from the point of view of those involved, shooting relevant footage and ensuring that resultant films are distributed to the maximum effect both inside and outside the country.'[11]

In the same way that the Gaborone conference was inspirational for many individual workers in film and video, leading eventually to the consolidation of their commitment to a 'culture of resistance' so the 'Culture in Another South Africa' conference held in Amsterdam in December 1987 was a crucial next step in helping to unite film and video workers of similar ideas into a national organization. This organization could build an alternative film culture by, on the one hand, producing and distributing films and videos relevant to the mass democratic movement, and, on the other, organizing and training more skilled people. Quite apart from the obvious perils inherent in this project, these are not, of course, straightforward tasks. The chairperson of the newly established Film and Allied Workers Organization has pointed out that the immediate aim is to look for funding and in this key area FAWO hopes to forge international links and to play a practical and advisory role in facilitating help from potential overseas funders.

Notes

1 Feinberg, 'The role of social documentary films in our struggle for national liberation' **Sechaba**, November 1983.
2 **Screen International**, 15 June 1985.
3 **Variety**, (undated) 1985.
4 Feinberg, op. cit.
5 **Screen International**, op cit.
6 Ibid.
7 Tomaselli, 'Racism in South African Cinema', **Cineaste**, vol. 13, 1983.
8 Ibid.
9 Tambo, interview, **Rixaka**, no. 1, 1985.
10 Catalogued by IDAF, London, 1988.
11 Feinberg, op. cit.

Towards a survey

A reflection on South African poetry

by Cosmo Pieterse

I

Senzenina...
What have we done?
These are our people,
Why are they weeping?
Senzenina?

It is sung: at funerals, at rallies; it is written on banners and held aloft – at demonstrations, on marches, in meetings and in churches. The song has become poem. The poem belongs to people.

It is emblematic, this little 'poem' of the breadth and range of the breath and soul, of the spirit, the body, the voice and feelingfulness, the timbres and evocative wholesomeness, and self-questioning, life-involving, self-empowering force that invokes all our South African time and times, people and peoples, genders, organs and generations, as well as the millions of gestures and textures which constitute South African poetry now.

Now South African poetry is organic, committed, responsible: it is communication and it speaks to, for and from the people; it speaks out of experience, to the imperatives of mobilization, organization and action in the present, for the possible, full future. The pressures and needs that have, in part, produced this poetry are the simultaneous social, economic and political environment of an

apartheid milieu that enforces fracturing, and the opposite ('what have we done?') push and pull; the philosophy and will and movement that posit and repotentialize one country, one people, one humanity and one multi-faceted living freedom: These are our people.

The lexicon of this poetry is the experience of pain: 'Why are they weeping?'. It is also a lexicon that disturbs the status quo: **What** *have we done? What* **have** *we done? What have* **we** *done? What have we* **done**? Its vocabulary is militant but not militaristic, its diction is various, as that of its tonalities (collocated and contiguous, co-temporal and continuous) vibrate on many levels: the poem-song involves us in pain and tragedy and asks us to re-evaluate our history and our existence so that the becoming, the shaping of tomorrow's world will be ours: consciously, compassionately, humanely, actively, collectively ours, involving our best intellectual and finest emotional selves in the act of making, re-creating.

The visible etymons of the poem – the popular (anonymous?) song reduced to the rallying-call inscribed on the banner (or the page) are Bantu and Indo-European; the dural implications and allusions are the chorally repeated, plaintively elegiac resonance of 'Senzenina', as an intricate backdrop to the slogan that becomes its own epistemological and existential suggestiveness: 'These are our people!'

South African poetry, now, is verbal constructs that click. It is a variety of weaves of sound, of sound that is subtle and also direct, of words that are simple **and** complex, open, clear, direct **and** allusive, immediate and resonant, personal, individual (but not individualistic) and simultaneously overtly political, public and communal. This poetry uses tradition and innovation, vernacular and vehicular languages, standard and colloquial diction and idiom, the people's tongue ('*mensetaal*', '*tsotsi-taal*?') as playful irony, jocularly, and also in high seriousness, with, alongside it, a rhetorically rooted and flowering statement, analysis, philosophic probing and synthesis.

II

It is this South African poetry that can produce the multiplicity, variety and apparent difference that is really such a rich unity. It is a poetic that accommodates many. It encompasses:

Farouk Asvat, who writes about love and suffering, about individualism, snobbishness, pretence and pride, about human and environmental beauty and about opposing oppression, and who deploys metaphysical, lyrical and colloquial language, slang and standard diction, all with equal strength and ease.

Breyten Breytenbach, who uses many of the idioms of post-modernism, writing in Afrikaans and English, about prison, struggle, individuality and tomorrow's nation, with passion, power and drama.

Dennis Brutus, the eternal experimenter who is also the complete classicist, the activist-poet.

Stephen Gray, as prolific, as many-voiced, as intimate with the earth and the air and the activities of our South Africa as any one person – and his poems say: as all people – can be.

Keorapetse Kgositsile, whose verse is an incisive music and a vision that is global, reminding us of where we have been in Africa, in Africa South, in the African diaspora: where we are; whither we may be bound.

Mazisi Kunene, the sonority and reverberations of whose remaking of his own original Zulu poems into English versions are an indication of how tradition can be honoured and transmuted (and this is if one were to refer to merely one dimension of his *oeuvre*).

Don Mattera, James Matthews, Oswald Mtshali, Sipho Sepamla: we may be allowed to let the last four speak through a voice that may be said to represent the generation they belong to, the generation that has been chiefly instrumental in orchestrating the expressiveness of the new South African poetry.

Mongane Serote:
'The bright eye of the night keeps whispering
When it paves and pages the clouds
it is knowledgeable about hideous nights
when it winks and keeps winking' and later

'mini
mkaba
molefe
paul peterson
we ask luthuli
mandela tambo
how is a long road measured?'

'on the road,
fear pulsating near me as if it were my footsteps
i
looking always around me for my shadow' — then

'how can i forgive' . . . repeated
'but how can i forgive' . : . often
'can i forgive', and yet, though
'your dignity is held tight in the sweating cold hands of death
the village where everything is silent about dignities
i will say again
behold the flowers, they begin to bloom!'

These quotations come from **The Night Keeps Winking** (Gaborone, Medu Art Ensemble 1982) and **Behold Mama, Flowers** (Johannesburg: Ad Donker, 1978) respectively. Serote had published three volumes of poetry previously, in 1972, 1974 and 1975.

Between the earlier three volumes and the collections of 1978 and 1982 there had occurred the formative event, the second watershed in South Africa's recent history, namely the student demonstrations against 'Bantu' education, and the police shootings of Soweto.

Let us quote extensively from Mbulelo Mzamane's introduction to **Selected Poems** (Cape Town: Ad Donker, 1982):

'His (Serote's) poems about places, particularly his **Alexandra** poems, and his epic poems in **No Baby Must Weep** and **Behold Mama, Flowers**, grapple with the problems of squalor, violence, death, destitution, exploitation and the Black

people's quest for identity and a sense of community. Serote's identification with the problems of the Black community is manifested through his use of 'a profoundly compassionate authorial presence' in many of his poems. But he can also cultivate an artistic detachment through the use of expressions that are deadpan, which, far from sacrificing the emotional intensity of his poems, bring out most effectively the callousness, and the insensitivity of people.
He often employs township colloquialisms, through direct transliteration, in a manner which never detracts from the gravity of the situation evoked but rather reflects 'the lack of quality of the social (political and economic) milieu'. The simplicity and the affective tone of his language and what may sound like cliches are intended to make his appeal to the black community as broadly based as possible.'

Mzamane's entire introduction deserves constant reading and analysis: most of his insights strike one as eminently relevant and profoundly true: issues such as the need for dialogue within the oppressed black communities and for constructive self-criticism, the emphasis on the influence 'of Black Consciousness, as propounded by the late Steve Bantu Biko' and of the poet's seeing, depicting, conceiving of and articulating the vanguard role 'of Black women – downtrodden and degraded yet long-suffering and dignified –' in 'the Black people's struggle for liberation, in the manner in which Sembene Ousmane and . . . Okot p'Bitek handle women characters in their work'.

III

The last passage of our long quotation from Mzamane suggests two further, very important notes: first, women as self-actualizing makers of literary artefacts, and, next, two further aspects of the context for the evolution of South African poetry into its present many-voiced and thrilling integrity. Then also, we wish to note a minor disagreement with Mzamane who says towards the end of his introduction: 'Serote and his contemporaries are no longer writing for an alien audience – *unlike their predecessors, whom the protest tradition, the fact of exile and censorship had forced to write for an essentially non-black readership.*'

116

IV

It is certainly not our intention to isolate women who write poetry, but it must be noted that, as in other genres and spheres from Schreiner to Gordimer, from Makeba to Mbulu, women have stood in the forefront of the battle for human rights in poetry too.

In time and action, 1960 provides an immediate context for a new national voice and verse. The anti-pass campaigns, the police shootings at Sharpeville, Langa and Nyanga gave rise to an epochal poem in Ingrid Jonker's **The Child Who Was Shot Dead By Soldiers At Phillipi Location Near Capetown**, written in Afrikaans and allowed publication under the truncated title **Die Kind (The Child)**. The poem concludes thus (our translation):

The child who has become a man
Treks through the entire Africa
The child who has grown into a giant
Journeys over the whole world
Without a pass.

The contexts that Jonker involves in her poem include the restrictive South African reality of reductive, dehumanizing votelessness that pass-bearing spells and that the women who proclaimed 'Now that you touch the women, you've struck a rock' were determined to help overthrow; these contexts also include the decolonization of Africa – Gold Coast becoming Ghana in 1957; Nigeria's independence in 1960 – as well as the historical context of the trek of Afrikaners in pursuit of their freedom from the British Empire.

That voice of freedom to which this particular verse of Jonker's attests is carried on in the variousness of texture and tone, the declamation and demand and determination, the organization and freedom and attention that issue from what is unfortunately a fairly rarely read or seen volume **Malibongwe** (ed. Sono Molefe) that has at least a German translation (by Elizabeth Thompson and Peter Schultz; Weltkreis-Verlag, Dortmund; 1980). These are voices to which attention must be paid; as to the voice of a Gladys Thomas:

We, the mothers, don't sleep at night!
Sometimes we the mothers,
hear the cries of fourteen-year-old children.
It is us they want,
it is us they love,
Set them free to us,
THEIR MOTHERS!

(Prefatory poem to **The Wynberg Seven** 1987. Copyright G. Thomas, Capetown.)

v

The cries of the children issue from mouths that make shapes of a startling beauty and even greater potential out of the pain, deprivation, exile and death that their youthfulness has experienced so often, so vividly:

You can't stop me from fighting
fighting for my oppressed people
We shall take up the spears
of those who fall

You Can't by Jabulile Kunene

Mamma —
the gallows sucked life out of your son
like a thief that sneaked into a kraal
to milk Africa's cow into its mouth

Mother of a Spear (dedicated to Mrs. Martha Mahlangu, Solomon's mother) -
Patrick Mogopodi Mmusi.

These are my people
These are my ancestors
My blood! My everything!
To them
my life is dedicated
These are my people!
They shall be avenged.

These Are My People - Keneibe Saohatse

We shall overcome
injustice upon man by man
Remember 'Isandhlwana' victory
Spears and shields against
guns and cannons
Victory in Africa!

We Shall Overcome – Jabu Mahlangu.

These are taken from poems in a volume, **Mother of a Spear**, by students of the Solomon Mahlangu Freedom College, located in Mazimbu, Tanzania, published in Groningen, The Netherlands in 1982.

A cyclo-styled production from Mazimbu, **Somafco Pioneers Speak,** contains nine poems by primary school pupils. Here are snatches from **In Mazimbu** by the then 11-year-old Lentsoe Serote:

In Mazimbu/When I see the mountains/In Mazimbu/When I see the
fields/I think of my Mother land/I think of South Africa.
In South Africa/I see the mountains/In South Africa/I see the fields/But
these are only dreams/Dreams of my Mother land/

The first stanza of **Black Feet** by 12-year-old Sunyala Thom:

Black feet cover the floor/of the country's police stations/
Black feet cover the grounds near the stinking lavatory holes/
Black feet huddle together/to escape the rioting men/
Black feet dance the mad dance/called apartheid/

and the first of **Crying Child** by Barbara Marin-Rivas (12 years):

Crying child/sitting on the steps/of the house/He doesn't cry loudly/He
cries softly/He cries painfully./Small round tears/fall from his/eyes

The excerpts chosen do scant justice to the range of subject matter, sentiment, sensibility and sense, to the power and gentleness of the work of these young wielders of words, but they give a sense of how drenched the youthful poets are in experience and ideal, and how they wrestle with their medium and make it sing and say. Their work cries out for recovery and nurturing.

119

VI

1960-1976. Half a generation in time; in content a gestation and a regeneration; in context: 1960 anti-pass marches, Sharpeville shootings, continental African decolonization as far as Britain, France and Belgium go and in 1956-76, student uprisings against slave education, the Soweto massacre, the success of the anti-imperialist struggles in Angola and Mozambique.

Now, the freedom movements in 'Lusophone' Africa had had as part of their energy and mobilization the output of cultural workers, writers like Agostinho Neto, Antonio Jacinto and Noémia de Sousa, Marcelino dos Santos and Bosta Andrade; the political commitment of these poems in no way gainsaid their aesthetic dedication, and their immediate functions in no way precluded their lasting value.

Poems such as **Fourth Poem, Letter from a Contract Worker,** the Neto collection **Sacred Hope, Black Cry, Mamparra M'Gaiza** and Jorge Rebelo's **Poem:**

Come brother, and tell me your life,/come, show me the marks of revolt/which the enemy left on your body/ . . . 'Here my mouth was wounded/because it dared to sing/my people's freedom'/ . . . Come, tell me these dreams become/War, the birth of heroes,/ . . . mothers . . . fearless,/ . . . And later I will forge simple words/ . . . which will enter every house/like the wind/and fall like red-hot embers/on our people's souls/ . . . In our land/Bullets are beginning to flower.

This timbre, this scope, this sweep and finesse is available even in translation; these voices were heard by South African writers in exile and at home, as clearly as 'all' South Africans were hearing, heard, or were beginning to hear voices like those of Neruda and of the freedom songs, the voices of anonymous or recorded lyricists from the Kalahari, Namaqualand, the Karoo (cf. e.g. the work of the Bleeks and Laurens van der Post), the voices of praise-singers and traditional bards, orators in Sotho, Xhosa, Zulu, Tswana (of the works of commentary and translation of A.C. Jordan, Dan Kunene, Vernie February): over time, all these, and more, poured into, were poured over and made over by South African poetry.

Hence our disagreement with Mzamane: there may be changes in ostensible subject matter and differences in peculiar circumstances and particulars of

120

publication, but from about the mid-fifties, under the impact of South African conditions and events, the forms of struggle in constant growth and transformation, apparent power redistribution continent-wide, and deriving from the influence of diverse poetic outpourings, local and from other-where, traditional, indigenous and novel, unconventional, modern, there was a continuity that gradually became **more** encompassing and was made irreversible by the generation of 1976. The oneness, the integrity and continuity of this new South African poetry is, it is clear, a fundamental assumption and a truth of Feinberg's collection **Poets to the People**. Particularly instructive is a comparison of the 1976 (Allen & Unwin) and the enlarged 1980 (Heinemann) editions. That contact, that continuity is, it seems, borne out by a collection such as **Black Voices Shout**, an anthology edited by James Matthews, banned in South Africa, published in the USA (Austin, Texas: Troubadour Press, 1974) with an introductory note by Dennis Brutus, who says, *inter alia*, that these 'are new and distinctive voices (Serote belongs to an earlier generation, and Matthews to an even earlier): they are often uncertain and sometimes frankly prosy, but there is no doubt of their commitment'.

VII

Commitment does not guarantee excellence. It may encourage laziness. Brutus' evaluation of 1974 is one that is appreciative, unpatronizing, aware. That 'committed' laziness may become vapid, posturing, haranging sloganeering is the danger that we are alerted to by, for instance, the views expressed by Achmat Dangor in an interview in Canada: **Literature beyond the Platitudes** (Toronto: Southern Africa Report, July 1988).

'Protest literature had not gone much beyond protest. It was not enough to have a culture of protest', Dangor sees it being one of the reasons why the Congress of South African Writers (COSAW) was launched nationally in Johannesburg (July 1987). The theme of the launching conference gives the title to Dangor's interview, and at the launching Njabulo Ndebele warned 'against pamphleteering the future'. That this self-examination and self-criticism takes place without its developing into self-censorship or art-for-art's sake aestheticism, is (a) a sign of health, (b) an omen of greater growth and an augury of fine unfolding, and full, rich harvests and (c) attested to by the fact that (i) an oral poet, Mzwakhe Mbuli, was detained from January 1988 and was still in detention in June/July 1988 and (ii) that the

director of the cultural desk of the Congress of South African Trade Unions is also Vice-President of COSAW, and that he is a poet and a worker.

Dangor says, of literary endeavour in general:

The challenge to writers is to create, as cultural workers, new forms of writing that are accessible to people . . .

. . . almost 50% of the adult population cannot read. One of the most popular and successful literatures is that of Mzwakhe Mbuli who has developed the tradition of the oral poet and performs and records rather than writes his poetry.

VIII

Performing and recording poetry co-exists with publishing it; in South Africa magazines and publications like **Staffrider, Upstream**, the Mantis editions brought out by David Philip in Cape Town and the Beeton Saunders selection **Twenty-Three South African Poems** (Johannesburg: Ravan, 1979) are severally and together partly responsible for anthologies like the **Penguin Book of South African Verse** and (what is in many ways – paradoxically – a complementary but richer and more really representative volume) **The Return of the Amasi Bird** Black South African Poetry 1891-1981 edited by Tim Couzens and Essop Patel (Johannesburg: Ravan).

What these notes have essentially boiled down to is a semi-bibliographical survey; so we continue:

(**i**) an anthology of South African writing:
Somehow We Survive (New York: Thunder's Mouth Press, 1982); the choice of poems by a US editor is interesting next to those in

(**ii**) a South African reader:
A Land Apart edited by André Brink and J.M. Coetzee (London: Faber and Faber, 1986).

(**iii**) To complement these two, another broad view may be used, the best four anthologies of poetry from Africa, the compilations by Beier and Moore, Reed and Wake, Wole Soyinka and Keorapetse Kgotsitsile.

(iv) For yet another perspective, a rich contextualization and closer weaving together of the colours and contours of variously related poetics and systems, there is Frank Chipasula's **When My Brothers Come Home** (Middletown, Connecticut: Wesleyan University Press, 1985) which is unsurpassed for a steady look at and a panoramic survey of 'Poems from Central and Southern Africa'.

(v) Finally, three books of criticism that seem invaluable to at least one reader: Gordimer's **Black Interpreters**(Johannesburg: Ravan, 1973), Jacques Alvarez-Pereyre's **The Poetry of Commitment in South Africa** (London: Heinemann, 1987) and **Soweto Poetry**, edited by Michael Chapman (New York: McGraw-Hill, 1982).

IX

However divergent their audiences may seem to be, the poets who write

South African girls are more scantily clad . . .
South African men crack their voices like whips
Voices like whips . . .
But when, in bright daylight
Complacency slips
Their hands creep down to the guns on their hips.
South African men crack their voices like whips.

Mike Cope 'South African' in **Upstream,** Spring 1985;

and also

Haita, Joe let's hit the road
let's take the highway
out of the battle zones. . . .
Kom my bra, ek se moenie strik nie mamma
the road will rise to meet us;
the music is a road
which will not let us go without it

Wally Mondlane: 'Highway Blues' in **Staffrider,** vol. 7, 1, 1988

as well as, to conclude his **Makeba Poem**, Dumatude KaNdlovu's *Lelizwe Linomoya* repeated thrice, suggesting the interplay between *earth and sky/land*

and spirit/air/soul and hinting at the rallying call *Izwe Lethu* and the refrain in
Nkosi sikelela – *Woza Moya* – Come now/come back spirit, along with
Home/Where the sorrow is/ with two variations of agony and loss following this
initial 'couplet' of the refrain–chorus which ends with *home/where the music is*,
and later catalogues a number of South African music's individual 'giants' and
groups and anonymous **mbaqanga** (township jazz) creators and performers for the
poem to conclude its statement with

**'but home/
is where masekela is,
where the music is
where the heart is.'**

'Masekela Poem' in **Staffrider,** vol. 6, 1987:
such poets write within the same single new full tradition from an integrated
(however differing) experience for another South Africa.

This tradition is that of the categorical implosive, of the subsuming of seeming
antinomies, apparent dichotomies, ostensible opposites into a dialectical synthesis
which can transform and interrelate the previous existences and genres so as to
re-create out of music and song and narrative and action and conflict and tension
and lyricism and satire that entire new world of resolve, will, desire, dance,
recital, ritual, rightness, death, transsubstantiation and life: people and peoples,
peace, freedom, fulfilment, belief, deed, beliefs.
Let us listen:

**Why/my friends/in a land/
whose multi-colour wealth bloomed/
in a blinding flash**

Are we confronted and confounded here by mixed metaphor and ineptness: or is it
rather – and this can be proved with an analysis of word after word and the
meaning – the high and deep meaning of the phrase and the sentence which sing
and think on, which state and analyse, re-live and reveal a reality, deconstruct
that ugly past-present:

Dappling the air which glitters with gold/for whites/while blacks toil/ . . . ask any worker:/the miners whose sight like a chameleon now changes the colour of their stare/now for the light and then for the darkness

. . . .

I smile/for every day so many people in the world agree/that our bloody battle is just . . . i smile/for war shall have taught us/and Africa shall have taught us/and the world shall have taught us/that equality of a people/is a firm foundation for progress . . .

Serote, **A Tough Tale** (Kliptown Books, London, 1987) pp. 11-12 and 47-48.

We readily absorb the choral, symphonic effect of the repetitions, and we do not need (for the sake of superficially examining this extract) the knowledge of the fact that the dedication commemorates, memorializes the blood of those who died in Southern Africa for South Africa's freedom, to be able to experience the tensions, the multiple meanings of *bloody*: pejorative, angry, frustrated, gory, determined, sacrificial, calling for heroes, leading to death, enabling and enhancing life; we note how that *bloody* co-exists with *smile*: sadistically? No, for the *bloody battle is just* and this war in South Africa like others in Africa, in the world teach, instruct, educate us, humanize into the knowledge of social equality – global equality! – as a *sine qua non* for peace and progress; new energies, released in the peace thus finally achieved, lead to further creativity, wholeness, development.
And the dance goes on, with people . . . singing.

X

Temba Mqota, in a short article which is a tribute to Vuyisile Mini, says, in dealing with **South African Freedom Songs** that they 'are the songs of a New Africa, they cannot be crushed'. In one way the offspring, in another sense the moving simultaneous image of that music, South African poetry now, functioning with all its directness, rich and various vividness of voices, is to be found dramatized and recited – e.g., by the Amandla Cultural Group in shows, concerts or manifestations – is declaimed or chanted, is spoken or read, is published: at

125

homes, funerals, rallies, public readings, on record; to small groups or vast assemblies; abroad, at home.

What Mqota says about the revolutionary song is true of this new (post-1950) South African poetry: its 'content and form not only express forcefully the mood and feelings of the South African freedom fighters but . . . it also unites black and white in the expression of their common aspiration for a free South Africa'.

1956: Hey Strydom,/Wathint' a bafazi, way ithint' imbokodo uza Kufa'.
(Hey Strydom, now that you have touched the women, you have struck a rock, you have dislodged a boulder, and you will be crushed.)

Naants'indod'emnyama
Verwoerd* Pasopa† naants' indod' emnyama
Verwoerd*

* Later 'Vorster'
† **Pasopa — pas op :** Afrikaans = 'beware'.
(Behold the advancing Blacks, Verwoerd. Beware the advancing Blacks, Verwoerd)
(Translations in parentheses by Mqota)

These songs – one imagines listening to the rich baritone of the late Vuyisile Mini when he led mass Congress meetings in song because, as is likely, many will – do – remember James Madhlope Phillips as the resonance of his leading a group in song or rendering a solo: 'an inspiring event in itself.'

That spirit informs the continuing movement of South African poetry. It is found in the change and continuity of the music and the poetry of Abdullah Ibrahim (Dollar Brand) in the music and committedness and lyrics of **Ekaya** (Home), in the deliberations and decisions of cultural workers at CASA to create a real people's Culture in Another South Africa.

South African poetry, that healthy sound, weeps, and smiles and it makes. It is informed with history; it is there to help shape history.

The aloe and the wild rose

Abdullah Ibrahim (Dollar Brand)

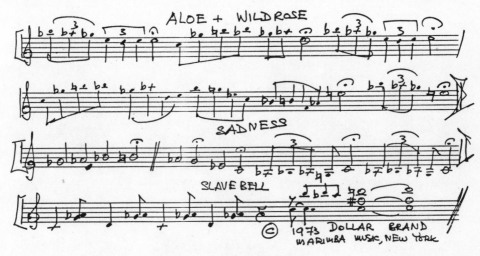

in the darkness
i met HIM
of the night
with ARMS FULL of
LOVE LIGHT

Carry one — said HE
INTO THE VAST NIGHT

Alright i said
just guide me
with
YOUR LIGHT dollar brand

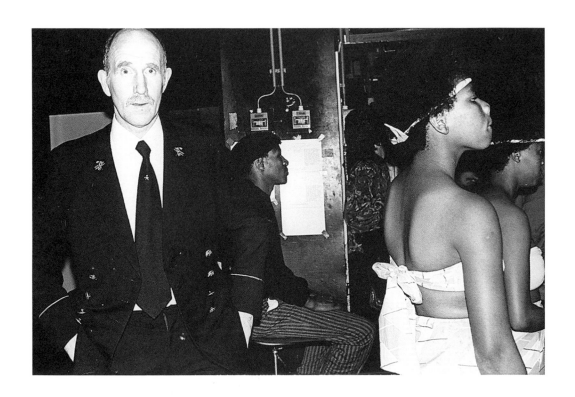

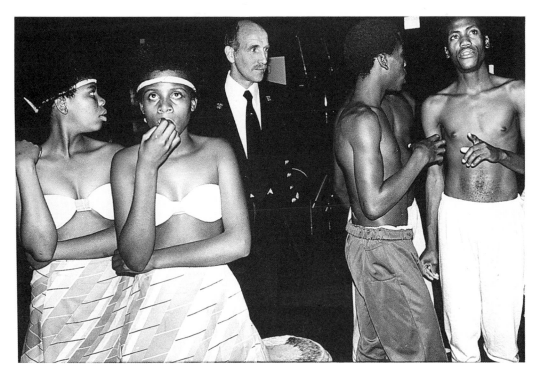

Members of the musical group Zakhene backstage. In the middle a fireman of the Music Theatre.
(Photograph by Bertien van Manen)

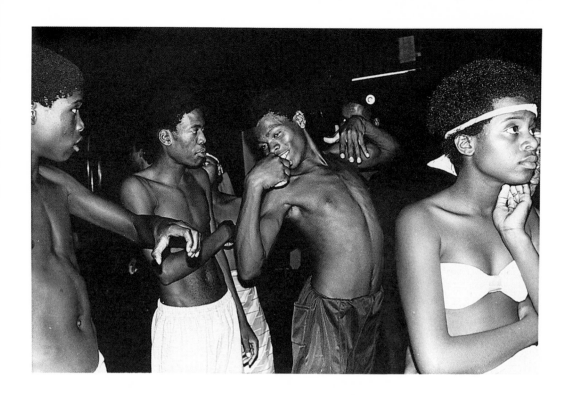

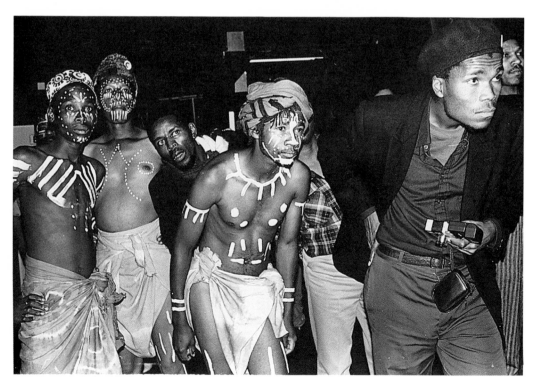

Members of the musical groups Zakhene (above) and Ntsikane backstage.
(Photographs by Bertien van Manen)

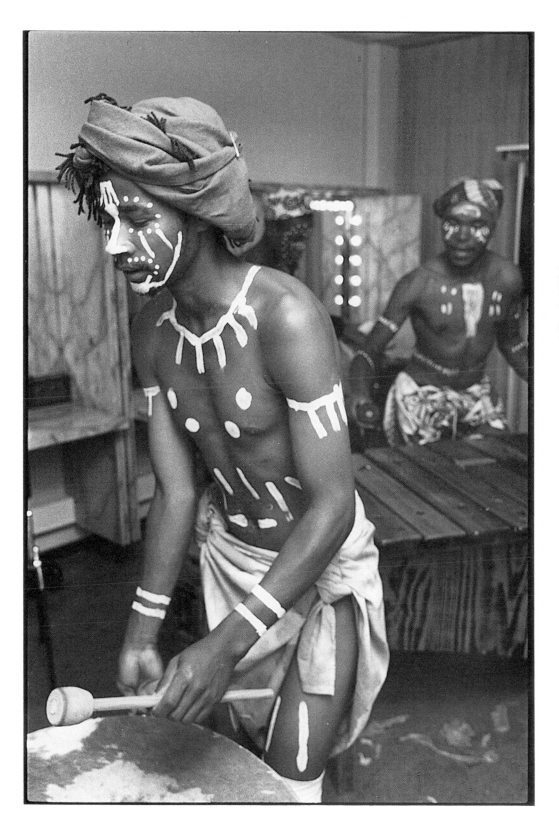

Ntsikane: last rehearsal. (Photograph by Muriël Agsteribbe)

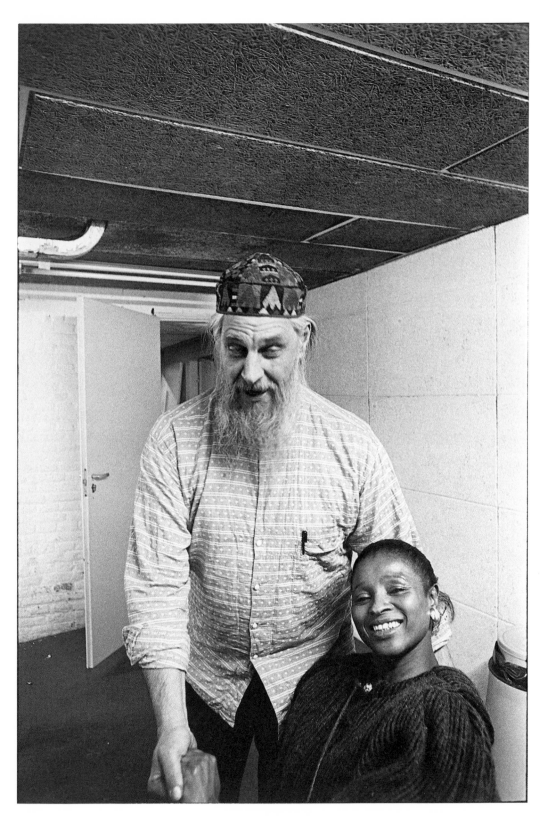

Pianist Chris McGregor and singer Pinise Saul backstage. (Photograph by José Melo)

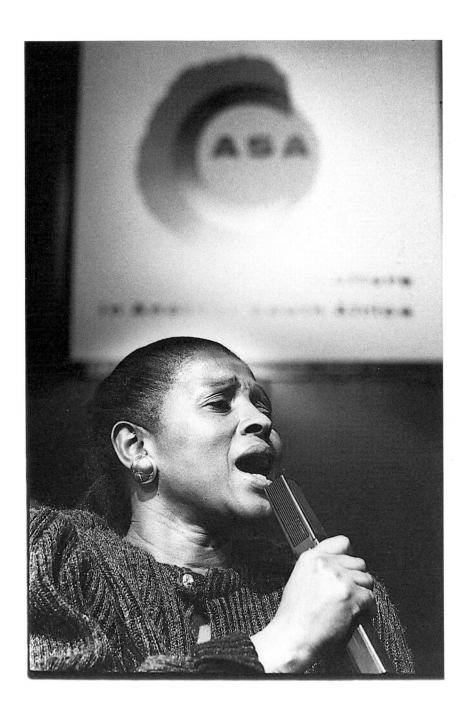

Singer Pinise Saul. (Photograph by Pieter Boersma)

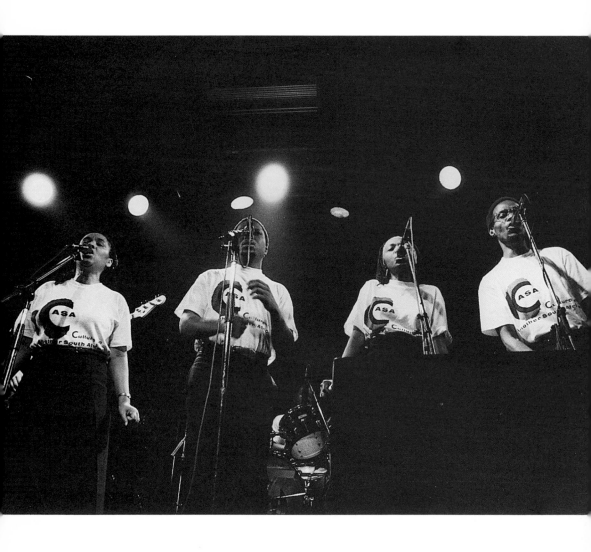

The Thami Mnyele Quartet, named after the fine artist who was murdered in Gaborone, Botswana by South African commandos. (Photograph by Inge Goijaerts)

Saxophone player Ntemi Philişo, leader of the Jazz Pioneers just before a performance.
(Photograph by Bertien van Manen)

On drums: Dutch Kopa of the Jazz Pioneers. (Photograph by Fran van der Hoeven)

Saxophone player Isaac S. Ntsamai of the Jazz Pioneers. (Photograph by Fran van der Hoeven)

On bass: Ernest Mothle of the Jazz Pioneers. (Photograph above by Paul Weinberg)
Jazz Pioneers. (Photograph opposite by Inge Goijaerts)

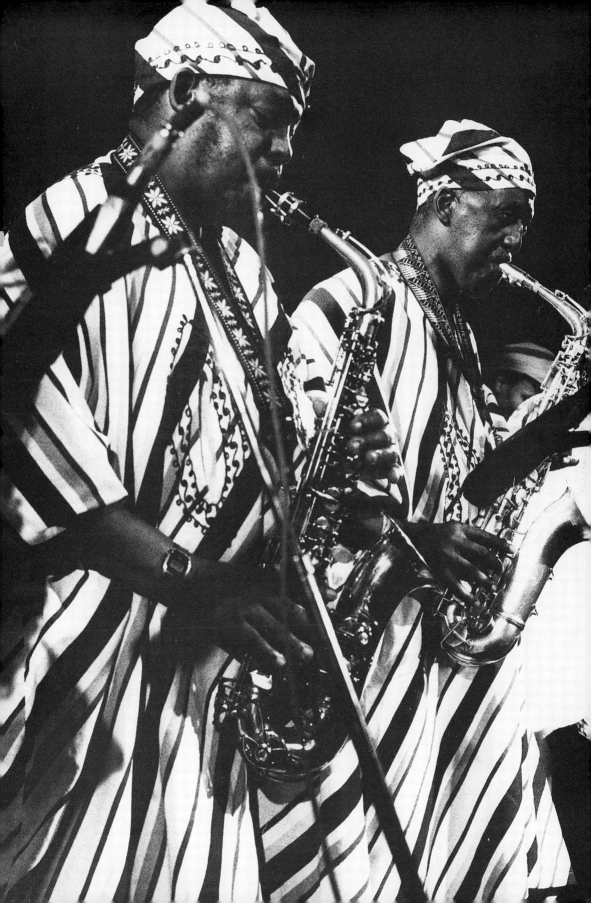

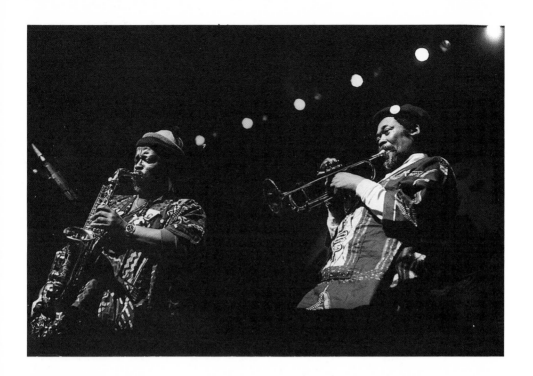

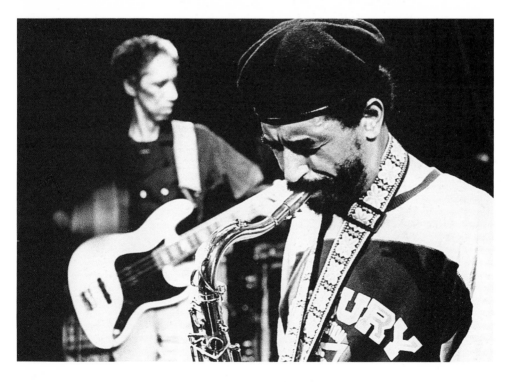

Dudu Pukwana (of Zila, left) and Denis Mpahle. (Photograph top by Jeeva Raggopaul)
Basil Coetzee with Sabenza. (Photograph above by Arnold van West)

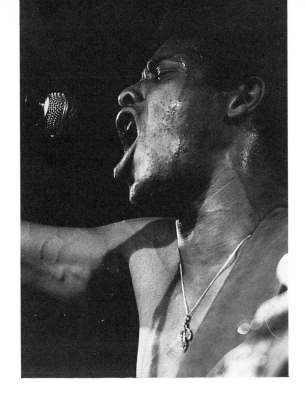

Mac McKenzie of The Genuines. (Photograph above by Arnold van West, below by Paul Weinberg)

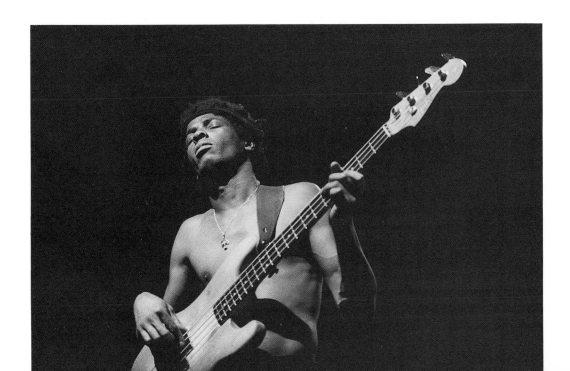

Denis Mpahle and Amandla trumpet player joining other musicians in jam session.
(Photograph by Leo Divendal)

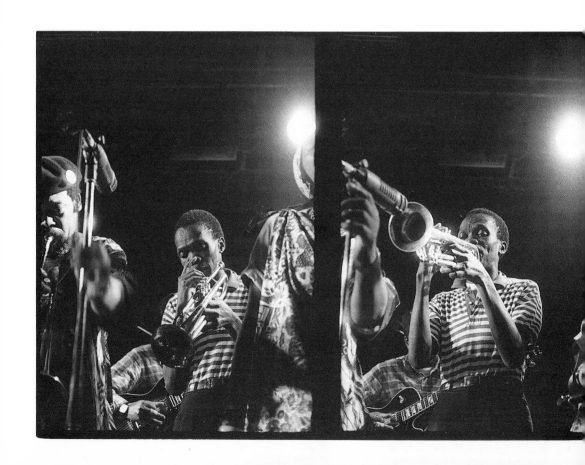

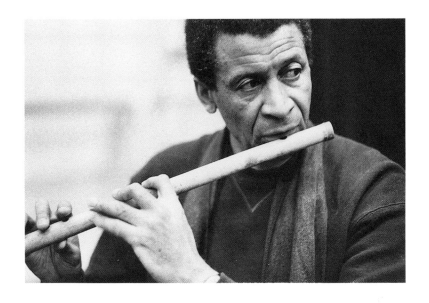

Abdullah Ibrahim (Dollar Brand). (Photograph by Fran van der Hoeven)

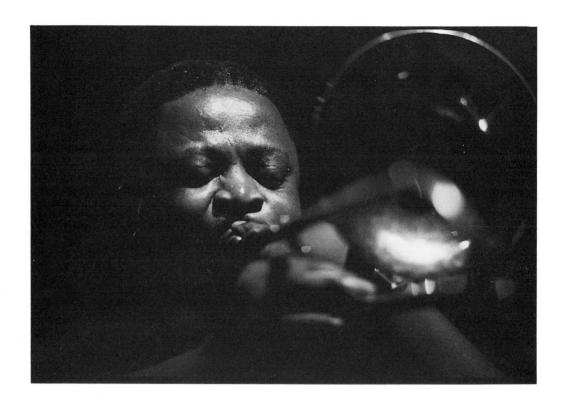

Jonas Gwangwa, trumpet player and composer. (Photograph by Paul Weinberg)

The melody of freedom

A reflection on music

by Jonas Gwangwa and Fulco van Aurich

Riot policeman Erasmus shot seventeen-year-old Mngcini 'Big Boy' Mginywa from Grahamstown at a funeral because, he told the judge, the people 'were singing in their own language and this causes riots'. Mngcini died in hospital. Fear seems to reign among the defenders of apartheid. Fear of revolutionary songs, fear of South African jazz, fear of **mbaqanga**, fear of **guma**, fear of all those kinds of non-biased and authentic South African music expressing the pride and the intransigence so characteristic of black South African musicians. This article deals with that struggle for a black South African musical identity against the poison of apartheid, and against the exploitation of white promoters and record companies, against the divide-and-rule policy of South African radio. It deals with the pioneers of township jazz, brass bands, **marabi, kwela, mbaqanga,** the variety show and the dilemma South African musicians face of whether or not to make use of valuable sounds from overseas (such as American bebop), without being swamped by them.

Naturally, it is impossible to give a complete profile of the rich diversity of South African musical styles (and sub-styles) within the scope of this article. We shall, therefore, briefly sketch a number of them. Those taking an interest in the history of South African music will soon observe that, from the very first moment the Europeans set foot in Southern Africa, attacks were made on the authentic,

146

traditional music of the African peoples. Vasco Da Gama may have been delighted when he was received on his arrival in December 1497 by a group of Khoi musicians playing five flutes at a time, but the colonial invaders tried to get a grip on African music, that was then, as it is now, fully integrated in everyday life, playing an important role at wedding ceremonies, funerals, initiation rites and daily work. Even in the early stages of the colonization the oppressors realized that, unless they were able to break the cultural fibre that gave the black people their sense of pride and cultural identity, it would be a difficult process to administer them politically and exploit them economically. Thus it was that, at certain stages in South African history, some folk songs, usually sung at funerals or in war, were either discouraged or banned.

Industrial Melting Pot of Culture

The late 19th century mineral revolution created a black proletarian melting pot of various African ethnic cultures and traditions, soon manifested in a variety of song, dance and instrumentation. During leisure hours miners gave performances, the cultural content of which was a blend of African melodies, and a demonstration of their exposure to a variety of cultural influences, including that of the Malay slaves and the colonizers themselves.

By 1900, African slums and shanty towns, built particularly around the mining compounds, had become so widespread and African culture so diversified, that a typical urban cultural tradition was born, woven around the means of survival in poverty and from police pass raids.

The conditions of the emerging proletariat were horrific. The one escape from everyday misery was the **shebeen**, where illicit alcoholic beverages were sold. The **shebeens** also played a significant role in the development of urban African musical culture because various urban songs were performed there. They became the working space for the unemployed musicians, who could in this way avoid working for white bosses.

Marabi

As the call for modern, urban music became louder and louder, there emerged a circuit of semi-professional musicians, from virtually every African population

group, typically city dwellers, bringing together all kinds of musical styles in one urban African style – the **marabi** – a familiar rhythm, a mixture of African polyphonic principles. It was in the **shebeens** where **marabi** was born. **Marabi** was the cultural interpretation of African music in an urban environment and played with western instruments. And rough it was; soon there came into existence a **marabi** parties culture, which by far surpassed the **shebeen** entertainment. The meaning of **marabi** is not exactly certain, but some of the more common explanations like 'to fly around' do justice to the tough living conditions of the urban Africans in those days. **Marabi** (played among other instruments on banjos, guitars, tambourines, concertina and bones) was a form of protest against exploitation and an escape from everyday misery.

Later on **marabi** was also played on organ, by, among others the renowned Boet Gashe from Queenstown, nicknamed 'Little Jazz Town'. The great significance of **marabi** was its multi-ethnic character, diametrically opposed to the oppressor's ideology of divide-and-rule. **Marabi** was more than music, much more the expression of a new cultural development among the growing urban proletariat.

The high point of **marabi** culture came with the emergence of the big band jazz of the Jazz Maniacs, founded by Solomon 'Zuluboy' Cele in 1935, together with Wilson 'Kingforce' Silgee. In 1944, this 'Father of African Jazz' took over the leadership of the Maniacs after the death of Cele. In an interview in 1982 (during the conference on 'Culture and Resistance' in Gaborone) Silgee said:

'We were the most popular band. I knew **marabi** beat and **Zuluboy** was a **marabi** pianist. So we put that beat into our music. That's why we had a bigger following. The roots of the black people, we had them in our rhythm. **Marabi** used to happen over weekends when the girls were off, the domestic workers were off. It used to take place from Friday night until Monday morning'. The Jazz Maniacs stood their ground well into the 1950s when the **mbaqanga** became popular and the band could not join in.

Sophiatown

If the **marabi** was especially loved among black (unskilled) workers, the black middle class developed an interest in American jazz. Partly due to World War II, the import of American jazz stagnated (there were jazz movies) and there was a

148

gap in the market which was gratefully filled by South African musicians. Singers like Dolly Rathebe from Sophiatown became hugely popular with their arrangements (not copies, but versions with their own African arrangements) of successful American jazz tunes. Increasingly jazz became an inalienable part of black South African music, manifesting itself particularly in the ethnic and cultural melting pot of Sophiatown, the legendary, demolished suburb of Johannesburg.

In 1955 jazz lovers formed the Sophiatown Modern Jazz Club, which on Sundays organized a number of jam sessions, led by Pinocchio Mokaleng, in the Odin Cinema, in which leading musicians like Mackay Davashe, Elijah Nkwanyane, Kippie Moeketsi, Ntemi Piliso (saxophone player in the current African Jazz Pioneers) and many others took part. In Sophiatown for the first time in South African history black and white jazz musicians could meet on such a regular basis on a common platform, a unique and typically Sophiatown fact. From these jam sessions emerged a very successful, star-studded band, the Jazz Epistles, featuring among others Kippie Moeketsi (alto), Jonas Gwangwa (trombone), Dollar Brand, now Abdullah Ibrahim (piano), Hugh Masekela (trumpet), Johnny Gertse (guitar) and Makhaya Ntshokr (drums). They laid the basis for a period of modern South African jazz, which was developed further in the 1960s. Jonas Gwangwa and Hugh Masekela were members of the only African high school jazz band ever formed in South Africa – the Huddleston Jazz Band, which was based in St. Peter's Secondary School, Rossettenville, later closed by the government.

Under a wide interpretation of the pass system, musicians were classified as vagrants. A black musician could only be semi-professional, for they worked in the daytime and performed after hours. For instance, the father of **mbaqanga** music, Zakes Nkosi, worked for Gallo, not as a musician, but packing records in their storeroom. Spokes Mashiyane, the international penny whistle star, who gained world recognition, similarly worked for Trutone Records until he was released by Union Artists. The penny whistle became one of the symbols of black South African music. Its origins date back to the pre-colonial period of South African history, when herdsmen made instruments out of reeds. It became popular in the 1950's, thanks to the film **Magic Garden**, in which it was played by Willard Cele.

White Greed

In the meantime, black musicians, however talented and successful they were, still had to fight with their backs to the wall for an existence with a regular income. The problem was that they could rarely obtain permits to perform as professional musicians throughout South Africa, and therefore they were almost always in the hands of white promoters, who served entirely different interests (namely filling their own pockets) than seeing to the interests of the musicians. Black musicians were neither permitted to join a white musicians' union, nor to form their own interest group, giving them no chance to take a stand against the record industry. And that was no luxury, because it was not until the end of the 1950s that copyright and royalty arrangements were introduced, which was only to the greater honour and glory of the record companies. In order to earn a living, the black musicians often had to turn to other odd jobs or hire themselves out as studio background musicians. In 1952, the white promoter, Alfred Herbert, set up the African Jazz and Variety Show in the Windmill Theatre in Johannesburg, for an exclusively white audience. Herbert shamelessly exploited black musicians (among them many stars), but a lack of alternatives forced them to appear in his productions. In itself, the regular payment and the guaranteed artistic freedom to develop a programme themselves, in addition to the professional running of the shows, were attractive factors for the artists. What was truly crippling, however, was Herbert's tendency to remove from the shows the authenticity of the African stage companies in order to make them 'suitable' for white consumption.

In **Makeba: My Story** (London: Bloomsbury, 1987) Miriam Makeba writes about those days:

'It is 1956, and I am twenty-four years old, when African Jazz and Variety begins a tour that will last eighteen months. The troupe travels from city to city, playing to white audiences and, once a week when my people are permitted into the theatre, to black audiences. This is always on Thursday, when the domestic workers are given the night off.'

Trevor Huddleston, Anglican missionary and anti-apartheid activist, formed a positive exception to white greed in the promotion of black music. In 1954 the then Union of South African Artists organized a farewell concert for Huddleston, who was on his way back to Britain. With the proceeds of this concert (with 200

musicians performing!) the Union could make a start with the payment of royalties to black musicians. Between 1957 and 1966, the Union organized the sensational township jazz concerts at Dorkay House for multi-racial audiences, featuring, among others, Letta Mbulu, Dolly Rathebe, Tandie Klaasen, the Jazz Epistles, the Manhattan Brothers and the Jazz Dazzlers.

In Dorkay House there was theatre as well, like the musical play **King Kong** (1958), a non-racial production – black musicians and actors, a white producer, director, musical leader and scriptwriter – which was a gigantic success throughout South Africa, running in London for a year as well. Among the cast: Miriam Makeba, the Manhattan Brothers, the Jazz Dazzlers Orchestra and ten-year-old (!) Lemmy Mabaso, who attracted wide attention with his **kwela** songs on the penny whistle. **King Kong** also met with overseas criticism: the show was said to be amateurish, and less of an outspoken political statement than was expected from the land of apartheid. Not entirely justified, because **King Kong** was actually a disguised indictment against apartheid and would in South Africa have been attacked by the censor.

Mbaqanga

In addition to jazz, **mbaqanga** (the name derives from Zulu, meaning something like 'steamed maize bread') has become a style which has given South African music a direction. It is a blend of various styles, of which American jazz, the **marabi** and the **kwela** are the most important. Founded in the 1950s, **mbaqanga** soon took on a political dimension. Songs such as **Azikwelwa** ('We won't ride') supported the bus boycott of 1957 in Alexandra, while the removals in Sophiatown (which started at the beginning of February 1955 and took five years to complete) were sharply criticized in **Bye, Bye Sophiatown** and **Asibadali** ('We won't pay rent'), songs which were promptly banned on radio by the SABC, although black disc jockeys tried to get them on the air anyway. **Mbaqanga** became the pride of the urban blacks in the townships.

Michael Xabu (who gave the name **mbaqanga** to this type of music), Zakes Nkosi and Elijah Nkwanyane formed the cornerstone of the **mbaqanga**. Ntemi Piliso and his All-star Band, Gwigi Mrwebi and the Cool Six, the Harlem Swingsters, and others were the main contributors in the development of **mbaqanga.** The vocal groups were the Skylarks, featuring Miriam Makeba, Abigail Kubheka and Mary

Rabotapa. Dorothy Masuka composed the all-time hit **Nontsokolo** and the Manhattan Brothers recorded various songs composed by Mackay Davashe.

Around 1960, the **simanje-manje** music (in Zulu, meaning 'now-now') emerged, a variation of **mbaqanga,** rendered, among others, by Mahlathini and the Mahotella Queens who were a great (commercial) success in South Africa, and the surrounding countries. In addition to Mahlathini (Simon Nkabinde), musicians like guitarist John Phuzhushukele Bengu were renowned **mbaqanga** interpreters. Groups like Ladysmith Black Mambazo with their internationally well-known **ificathamiya a cappella** music and the Afro rockgroup Harari owe much of their inspiration to **mbaqanga.** Many **mbaqanga** performers seem to take refuge in the interpretation of adapted traditional music and dance patterns and to avoid any semblance of criticism of the apartheid regime. Some hairsplitters mistakenly call **mbaqanga** the musical equivalent of 'Bantu education'. In **Music in the Mix** (Johannesburg: Ravan, 1981), Muff Anderson points to the political anaemia of groups like Steve Kekana and the Soul Brothers, but she does speak of a proud, authentic, African music. Philip Tabane, guitarist and founder of the famed Malombo band (which started as the Malombo Jazz Men in 1960 with, among others, drummer Julian Bahula who now has his own band in London) is a clear example of this.

Festivals

Many talented jazz musicians did not succeed in acquiring a recording contract. They often depended on **ad hoc** formations and festivals like the Cold Castle Jazz Festival and incidental gramophone recordings. We are referring here to jazz celebrities like Gideon Nxumalo, pianist, who gave piano lessons in Dorkay. In 1961, the festival award was won by the Jazz Epistles and in 1962 by Mackay Davashe's Jazz Dazzlers, featuring Kippie Moeketsi. In 1963 the credit went to the Blue Notes with the 'heavy' cast consisting of Chris McGregor on piano, Dudu Pukwana (alto sax), Mongezi Feza (trumpet), Johnny Dyani (double bass), Louis Moholo (drums) and Nick Moyake (tenor sax).

Jazz within South Africa's borders went through a difficult period in the 1960s and the 1970s. The resistance against apartheid, under the leadership of the African National Congress, had experienced a heavy setback: the ANC was banned, Mandela and other leaders were detained, hundreds of political cadres

were forced underground, leading jazz musicians fled into exile and some jazz celebrities died an early death, like Gideon Nxumalo and Mackay Davashe (early 1970s), Mongezi Feza (1975), Kippie Moeketsi (1983) and Johnny Dyani (1986). Pallo Jordan of the ANC portrayed Dyani in the ANC cultural journal **Rixaka** as a passionate musician, who 'made his own distinctive contribution to the contemporary cultural climate of a healthy cosmopolitanism, reflective of the recognition of the university of aesthetic values and the need for humanity to share its common cultural heritage'.

A difficult period or not, South African jazz succeeded in maintaining its own authentic position and power. Perhaps the fusion with other musical styles, like the **mbaqanga, kwela,** American jazz, soul and (sometimes) funk has been its salvation. A telling example of this is Dollar Brand's album **Mannenburg** of 1974, featuring Basil Coetzee, which received a jubilant reception inside and outside South Africa. David Coplan comments on the lesson to be learned from this project by South African musicians: 'An authentic syncretism in tune with the cultural reality of black experience is potentially the most creative and marketable direction that contemporary black music can make.'[1]

Traditional sounds with **mbaqanga** influence presented in the jazz fashion of stating a theme – improvised solo – have become popular amongst musicians all over the country. Young saxophone players like Barney Rachabane, Mankunku Ngozi, Duke Makasi, and Mike Makgalemele, guitarist Alan Kwela, the group Sakhile and trumpeters like Dennis Mpale and Johnnie Mekwa, and many, many others, have come to realize that our traditional music can be performed in a concert or night-club setting in any part of the world and be a resounding success.

White Poverty

Apartheid divides South Africans in racially separated population groups, and so it divides musicians. Black musicians are hindered as much as possible in order to prevent them from building their own musical styles and musical careers. Strange as this may be, it is precisely the black community that has produced the most interesting and most powerful music, in spite of considerable opposition; the contributions from whites in the development of South African music remains poor. Naturally this justifies the focus on the development of black musicians and bands (of which Coplan's words above are an expression), although this Black

Consciousness approach is rather one-sided and out of step with the mixed tradition of jazz and the rise of mixed bands such as Juluka (later Savuka) led by Johnny Clegg and Sipho Mcunu. In the **Weekly Mail** percussionist Mabi Thobejane of Sakhile said about Johnny Clegg's work: 'We can do this music thing on our own with a pure black African race'. A sad affair if we recall that, for years, both Clegg and Mcunu were barred from Radio Bantu because of the very fact that a white person like Clegg had succeeded in learning Zulu and had acquired Zulu dance and guitar patterns, and has in recent years more and more openly made a stand against apartheid.

There has been very little politically relevant 'white' music, that is before 'Soweto'. At the beginning of the 1960s white youths, particularly students, developed an interest for protest and folk songs from the USA, songs which, no matter how innocent most of them were, the regime regarded as a threat to the apartheid regime. **We Shall Overcome** (Pete Seeger) and **'Blowin' in the Wind'** (Bob Dylan) attracted a lot of attention from the Security Branch who raided record stores in Johannesburg for copies of these records. In **Music in the Mix,** Muff Anderson quotes from an article in **The Star** from May 1965: 'Johannesburg folk singers will be avoiding these songs [at the Wits festival]. But they can hardly ignore the enormous new treasury of American folk songs coming under the heading of "struggle" and "protest".'[2] **The Star** signals self-censorship among white folk singers, and, at the same time, it exposes itself as having no idea of the political situation in the black music scene of those days. 'There are no records of similar songs written in South Africa since the Nationalists came to power. But it is more than likely that among the Africans there must be a number which are linked with political changes.'[3] Under the influence of the 1976 uprisings by black pupils and students in Soweto and other places, and white students organizing solidarity actions, the necessary musical protest did emerge through the alternative circuits, but its range was limited. Thus Simon, a White from Cape Town, remarks about the South African punk music of the close of the 1970s: 'The music reflected the disillusions of the white youth in relation to white society. It offered no alternatives, nor did it make any attempt to bridge the gap between white youths and the black townships.'[4]

Apartheid is Money

The lousy, virtually rightless financial position of black musicians in the 1950s (the Sophiatown period) has already been mentioned. Since then the situation has improved only marginally. In addition to performances, musicians have to make a living through recordings and airplay. But here the bands with a strong political profile meet a barrier on the part of Gallo and EMI, the latter the biggest record company in South Africa with an annual turnover of approximately 100 million rand. Together, it is estimated they control 90 per cent of the market. Sometimes the bands found a successful alternative circuit through independent labels like Shifty Records, and explicitly political records then found a substantial market through African record stores by word of mouth publicity. The South African recording industry invests very little money in South African artists; cheap productions are the norm. In 1980, for instance, only R2,000 was spent on a record by the very successful artist Steve Kekana, while annually R100,000 is earmarked to retain foreign artists and their labels. Furthermore, the companies (WEA and CBS in addition to the two already mentioned) tend to release a great number of albums in small pressings rather than small packages in larger quantities. Black musicians are paid per session (for instance R5 per hour), the credits usually go to the producer and the record company. A star earns approximately R150 a week. A group like Mahlathini and the Mahotella Queens will spend an entire week in the studio and record dozens of songs, supported by constantly changing backing vocals and side musicians. The records are then released in small numbers (a few thousand) and distributed to every record store of any importance with ever changing names on the covers, but in fact always the same band. These records cost the record company next to nothing, but yield big profits.

The apartheid record business takes good care that the artists released by them do not express themselves in political terms. Steve Gordon wrote in the **Weekly Mail** (6.11.87): 'Airplay being essential for sales and profit, the record companies have learned that apart from the need to clear the statutory Publications Control Board [responsible for censorship of cultural products, eds.], their product should also be tailored to suit SABC programme formats.'

The white radio stations (The English Service, the Afrikaans Service, Springbok Radio, Radio Five, Radio Good Hope, Radio Highveld) do not broadcast black

music. Through black stations, however (Radio Zulu, Radio Xhosa, Radio South Sotho, Radio North Sotho, Radio Tswana, Radio Venda-Tsonga), the regime does make propaganda for white culture in order to poison the black communities. In addition to **mbaqanga** there is a lot of disco music to listen to, but not of course music involving politics. A secret programming board, exclusively white, decides what is permissible on radio. Lyrics involving issues of sex and social or political affairs are shunned like the plague. In **Music in the Mix,** Masekela concludes bitterly: 'Look at the Manhattan Brothers, and all those other people from the **bundu** who came in to record for them. The Manhattan Brothers are paupers today. . . . Spokes Mashiyane sold millions and millions of those breakable 78s, and he died of sclerosis. . . . Dorothy Masuka made Trutone; she had a record called **Nontsokolo** that just sold for years and years. She's in Zambia now, penniless. Nancy Jacobs had a hit with **Meadowlands** when the mass removals were going on. I'm sure she hasn't got any bread.'[5] Answering why the single **Afrika** was not played on his station, the boss of Radio Five said that 96 per cent of all local music was not broadcast by Radio Five.

Apartheid Propaganda

Pretoria seeks to do anything to use South African music to spread the poison of apartheid. Record companies are in step (does not every record say for which population group the music is mentioned – 'Zulu jive', 'Xhosa jive'?). But in 1986 the Bureau of Information started a project of its own, which turned out to be a miserable failure: **Song for Peace.** A number of black artists were approached, and thousands of rands were promised. Most of them refused, but some did fall into the trap. Steve Kekana, Abigail Kubheka and Blondie Makhene defended their participation. Kekana said that this was a serious opportunity for black South African musicians to promote 'racial conciliation', and that he preferred that money was invested in 'peace' instead of 'rubber bullets and teargas canisters.' When angry residents of Soweto set fire to his house, Kekana said his participation had been a 'mistake'. 'I hope people understand that I would never do anything to sell out any black person' (**Weekly Mail,** 27.3.87). Among the refusers was ex-Beaters, ex-Harari, now going it alone Sipho Mabuse, who has been criticized quite often for his slick, commercial music. Mabuse also refused to perform during Johannesburg's centenary celebrations.

People's Music

The CASA conference in December 1987 was not only an inspiring musical get-together and a temporary reunification of musicians from 'inside' and those in exile, but gave direction to the role that progressive musicians have to play in the struggle against apartheid. In the Resolutions of the CASA conference we can see that 'there has developed a vibrant people's music, rooted in South African realities and steeped in democratic values, in opposition to the racist music associated with the apartheid regime.' Casa brought many of those militant and courageous musicians into the limelight. For a while Amsterdam 1987 resembled Nancefield 1897, Rustenburg 1910, Queenstown 1935, Sophiatown 1955, Soweto 1960, London, New York and Stockholm of the 1970s; above all, Amsterdam was the South Africa of today. The African Jazz Pioneers, Bettina Schouw, The Children from Soweto, the COSATU choir, the Genuines, Zila, the Thami Mnyele Quartet, Sabenza, Arekopaneng, Abdullah Ibrahim, Ntsikane, the Amandla Cultural Ensemble, an avalanche of sounds against apartheid, and it did not matter whether you were white or black, came from South Africa or had been in exile for years. This was South African music for you, the way it was meant to be, without apartheid having a grip on it any longer.

Basil Coetzee of Sabenza says about people's music:

'Our sound has jazz influences, yes. It also got traditional influences. A traditional township sound can be developed musically. I think there is still a lot of work to be done with township music, and I am not for one minute going to believe what a lot of people say, that it doesn't exist, or it's a lot of crap. . . . I think a lot of musicians are becoming aware of themselves culturally. They have become aware because of the political events, because of the system. This growth of political consciousness gives musicians new freedom, a freedom to play what they want to.'

The Genuines, who established such a surprising fusion of rock and Cape **klopse** in their **guma** music, proved Coetzee's statement true, because they sing about **Mellow Yellow** *en die teargas en die purple rain en die pyn* and also about **Oh ho ho die struggle!**

Amandla

The Amandla cultural ensemble performs the revolutionary songs and dances of South Africa, employing most of the music types found in the country from choral music, **ificathamiya, kwela** and **mbaqanga**, to African jazz. All its songs carry a political message. As such it symbolizes an important concept of revolutionary artistic creation. Confronting colonial ideology, it rejects the ethnic particularism of apartheid, and stresses ethnic integration and a post-apartheid future that will be a bouquet of inter-connected ethnic cultural flowers. The dialectic in this revolutionary perspective on cultural change raises consciousness from the narrow past to a broader future.

According to M. Skota, while never losing sight of the need to entertain, Amandla has adopted a strong political position as an integral part of the ANC. For example, it has advocated the total isolation of South Africa.[6]

Film Score

George Fenton and Jonas Gwangwa composed the music score for Richard Attenborough's film, **Cry Freedom,** the story of South African freedom fighter, Steve Biko. Acclaimed internationally and nominated for awards, including several Oscars, a Grammy, and the Ivor Novello Award, the score combines a unique mix of traditional South African music with Western classical music. The London Symphony Orchestra played gumboot dance rhythms on strings whilst stamping the same rhythms with their feet – a truly fantastic sound. The finale had 90 mixed South African voices with orchestral accompaniment singing **Nkosi Sikelel' iAfrika.** This song, the recording of which hit the British pop charts, was composed in 1897 by Enoch Mankayi Sontonga. On 8 February 1912, when the African National Congress was formed, this composition was sung and adopted as the national anthem. Today, it is the national anthem of Tanzania, Zambia and Zimbabwe, and has been adopted by SWAPO of Namibia.

Notes

1. David Coplan, **In Township Tonight**, New York: Longman, 1985, p. 193.
2. Muff Anderson, **Music in the Mix**, Johannesburg: Ravan Press, 1981, p. 112.
3. Ibid.
4. Simon (a pseudonym), **Muziekkrant Oor**, Amsterdam, 18 June 1988.
5. Anderson, op. cit., p. 37.
6. M. Skota, **African Communist**, 104, 1986.

The struggle against cultural racism

A reflection on ruling-class culture in South Africa

by Patrick Fitzgerald

This article originates neither as an academic paper nor even as a conference presentation. As such the methodological presentation as well as the political perspective inheres in no specific collective moment. The thoughts expressed constitute thus one particular bundle of impressions within the spectacular flux of this field over the past ten years.

This text should therefore be taken as impressionistic; but at the same time one hopes the impressions are not wholly arbitrary. They ought to represent some 'chewing of the cud' of ruling-class culture, especially retrospective to the Culture in Another South Africa (CASA) manifestation held in Amsterdam in December 1987 and the gains cemented there for democratic South African cultural life.

In the first instance, one must raise the question of what is meant by 'ruling-class culture'. Two obvious interpretations present themselves, both with their own particular force and both apparently related to particular analytical viewpoints in regard to South African social reality.

First, we might take ruling-class culture in South Africa to define generally the international capitalist culture of the non-racial bourgeoisie. This would include the drive towards acquisition of private property, extreme consumerism, the following of international cultural fads in dress, music, film, etc; the commoditization of personal relationships; and, in general, the breaking down of traditional culture in favour of the bland new world of orchestrated cultural imperialism. All of this hand-in-hand with the creation of a local ruling class characterized by economic, political and cultural loyalty to the world imperialist centres. This kind of emphasis would normally go along with the perspective which regards class as a specific determinant over-and-above race in all instances and tends to stress the necessity of continuous class struggle and the incorrectness or danger of national or populist struggle.

Now, in the (admittedly caricatured) standpoint described above, particular importance is normally placed on the aspect of ruling-class culture as a mechanism of social control by international (and sometimes local) monopoly capital. Without doubt, some moments of truth are well-developed in such a hypothesis. At the same time, however, certain fundamental insights into the concrete nature of the particular character of ruling-class culture in South Africa are entirely missing. In fact, exponents of our first position, in its bare form as above, are often caught in a bifurcated trap with two strategic dead-ends and sometimes find themselves oscillating wildly from the one dead-end to the other. These are the related cul-de-sacs of cultural ultra-leftism and cultural extreme-nationalism.

In the former case, we find that an ultra-leftist stress on undifferentiated class struggle without due weight given to national democratic struggle leads to a demand for 'socialist' or 'proletarian' culture to be developed. However the content, specificity and functional origins of this 'socialist' culture are invariably opaque. It is as if an assumption is operating whereby successful class struggle automatically generates a viable 'socialist' culture, as if culture and cultural reproduction is not itself a labour process which must deal with the objective materials coming down through the heterogeneous and complex cultural history of a region, a country, a nation.

Indeed, typically one finds that the intellectual aristocrats of workerism know little and are little interested in practical cultural organization and struggle. Their idea of socialist culture is abstract, or even worse, riven with Euro-centrism whereby the models of socialist culture of the European socialist movement are undialectically imposed on our own all too different circumstances.

Sometimes, however, they also engage in another solecism, typified by the other fork in our strategic cul-de-sac, cultural extreme-nationalism and the romanticization of the ethnic and pseudo-ethnic. In this view, ruling-class culture is conceptualized as an alien imposition on the authentic culture of the people. The overthrow of the system and oppressing class forces will allow this false capitalist culture to be peeled away, revealing an authentic working-class-cum-indigenous culture ready and willing to blossom.

Again here, there is present a tremendous over-simplification in regard to how culture works, the impact of capitalism and settler-colonialism on South Africa, and the interpenetration and irrevocable transformation of cultural processes into new forms.

Essentially, the above perspective of an 'evil' capitalist ruling-class culture oppressing an 'authentic' peoples' culture, which is temporarily dominated but fundamentally intact, rides roughshod over the painstakingly real historical processes by which the oppressed have grappled with, transformed and appropriated elements of colonial culture. It does not let us into the social engine-room of the reproduction of South African cultural reality which, today, shows up the bitter contestation for even those cultural areas and arenas which may previously have been monopolized by the ruling class. As such, it leaves us strategically and tactically blind.

Much or most cultural production in the present conjuncture in South Africa cannot be simply packaged into democratic and non-democratic containers and shipped into contemporary political theory in neat analytical bundles. On the contrary, cultural expression, with its pulse so close to the emergent processes of social debate and transformation, participates in the manifold contradictions of our South African situation.

The Internal Colonialism

We have discussed so far the first possible interpretation of ruling-class culture, namely, the international capitalist culture of the non-racial bourgeoisie. We have introduced some comments on the ultra-left workerist and the extreme-nationalist variants of this general position. We have further identified the common tendency of both variants totally to over-simplify historical cultural processes and to see cultural discourse as a convenient (or inconvenient) epiphenomenon of particular theories of class struggle.

There is, however, another common and often-used meaning in the South African context for the term ruling-class culture. This is to understand by ruling-class culture the culture of the white group, as opposed to black or African culture. Variants of this position range from the somewhat calcified positions of contemporary Black Consciousness to Marxist positions which regard the situation in South Africa as one of internal colonialism.

This latter position understands that in South Africa a situation of pure class struggle has not yet been reached as classes within the white power bloc still act in concert to preserve white hegemony whilst, at the same time, different class strata in black society still share an overriding common interest in national liberation.

As such, the relationship between the white power bloc and the oppressed majority, whilst undoubtedly a historical product of the processes of capitalist penetration and capital accumulation, is more adequately conceptualized as a colonial relationship. Therefore, we have the situation where the ruling bloc actually includes (white) workers, whereas the oppressed group contains (black) business persons, professionals and agricultural capitalists.

In fact, the framework outlined above is of much more use to cultural activists in terms of the understanding of ruling-class culture. Whereas, while there is a growing aspect of international capitalist ruling-class culture as represented by a non-racial bourgeoisie in our society, its articulation and political influence is still severely circumscribed and constrained by the unresolved national question in South Africa. Historically, the most relevant and politically important

manifestations of cultural struggle, influence, conflict and synthesis have indeed occurred between the two blocs, ie. the white ruling bloc and the black oppressed.

In terms of a practical political understanding of cultural struggle, past and present, including the cultural mechanisms apartheid has employed to bolster and shore up social control by the (white) oppressor group, the characterization of the ruling class in terms of the hegemonic balance within the white bloc is of great value. The whole idea of internal colonialism is of immense benefit to any conceptualization of South Africa's cultural history, as well as to strategies for the development of a democratic and dynamic South African culture in the present context of anti-fascist struggle.

Frequently, certain methodological problems arise in the application of theoretical constructs engineered for the politico-economic level to the cultural sphere. Cultural positions cannot simply be extrapolated in a mechanical way from correct economic and political positions. Thus, we should always proceed with extreme caution when using these deceptively familiar analytical tools to explicate the nuances of cultural reality.

Specifically, it should be noted that, in the case of the internal colonial thesis, heuristically useful as it is, certain germane considerations must be kept firmly in mind.

First, that the European culture which was imposed by imperialist violence on indigenous South Africa has within it both a progressive and a reactionary tradition. Of course, as is typical of the colonial experience, the most reactionary aspects of European culture have predominated in interactions with the oppressed; however, notable trends to the contrary exist in each case, most especially in ours. It is false to believe that all experiences of this other culture have been negative.

Second, it is also the case that the original European culture which constituted the initial colonial situation has been transformed beyond recognition, and in many ways has became recognizably non-European (meaning in this case 'not of Europe'.) Some of this change is, of course, a refinement of reactionary European culture to include aspects of world-wide imperialist culture, especially accommodating the influence of the United State of America. Another part of this

change, though, has been a significant restructuring of the colonial culture by indigenous reality and by the inhabitants of this reality. What we see in South Africa at present is a white culture no longer European (or even 'Western') but not yet fully African.

Third, and strongly related to the above, the categories, tools and tropes of colonial culture are no longer the sole possession of the inhabitants of the white ruling bloc. Far from it, many aspects, values and techniques originating here have been mastered, appropriated and resynthesized by inhabitants of the oppressed group. This has happened to such a large extent that the intellectuals of the ruling bloc can no longer manipulate their inherited cultural categories without taking into account the extent of participation and transformation wrought by the efforts of the oppressed.

Fourth, and very importantly for organic intellectuals originating from the oppressor bloc, these transformations of the inherited structures of cultural colonialism come as a greatly liberating phenomenon, allowing them a certain escape from the straitjacket of decaying ruling-class culture and giving potential access to democratic culture both in South Africa and internationally.

Fifth, unlike economic and political practice within the ruling bloc, numerous aspects of cultural practice within white society are either implicitly or overtly anti-apartheid. This applies most significantly and spectacularly to the practice of formal artistic production, i.e., writing, theatre, music, graphic and plastic art, dance, film-making. Within these disciplines it has become increasingly evident that almost all artistic production above a certain level of mediocrity is highly critical, and often openly critical, of the present social and economic dispensation. This indicates that the Gramscian concept of the state has lost the justificatory and propaganda services of a significant echelon of artists and intellectuals.

It is difficult to think of any other social practice in ruling-class South Africa where the leading practitioners have so decisively deserted the regime and denied the state apparatus their services as ideological apologists for apartheid.

The list of points above, while by no means exhaustive, is intended to show the dangers of mechanical applications of relevant social theories to the field of culture. In terms of the complex day-to-day reproduction of society, culture plays

a complex and intricate role – in some instances serving to bolster mechanisms of domination and exploitation and in other instances serving emancipatory purposes.

Whereas the theory of internal colonialism has proved the most useful available in terms of conceptualizing South African social reality, we should beware of simply equating the mechanisms of social and economic domination with those of cultural domination. Actually, the terrain of cultural struggle is different to that of other forms of struggle (as those forms also differ among themselves) and is sometimes in advance of and sometimes behind other struggles. In order to engage in effective cultural struggle, we must be able to identify the specifics of the state of art and culture in various areas and disciplines.

Although the account above is extremely general, it is intended precisely to clear the way for much more specific cultural analysis. The question must be very sharply raised as to how the various communities in South Africa will contribute to the democratic culture presently being built in our country. This bears on the question of nation building and the undoing of the present internal colonialism.

As Cabral has stressed, the act of national liberation is an inherently cultural act, as well as a political one. In our case, however, we have to look extremely critically at the culture of the ruling bloc so as to differentiate the reactionary and racist elements from those other aspects which may contain the seed of democratic reconciliation under a people's government.

Infinite Surprises
In the sense above, we have not made any consideration of concepts such as white Afrikaner culture (as opposed to broad Afrikaner culture) or white English-speaking culture (as opposed to broad English-speaking culture in South Africa). We have rather attempted to clear away in advance some of the clichés and prejudices which often adhere to these (often vague) terminological constructs.

Instead, we have argued that, at this important conjuncture of cultural struggle, we need to look at what exactly we understand by ruling-class culture with new eyes. We need rigorously to identify the reactionary and racist elements of white culture in South Africa and unrelentingly expose and isolate such elements. At the

same time, we should encourage and cultivate that side of white culture which is either mobilized on the side of democracy and progress or is capable of being thus mobilized by means of our own efforts.

Culture is a field capable of infinite surprises. Breakthroughs can sometimes be made on the cultural level which precede and engender political successes. Although sometimes the deadweight of cultural prejudice hangs around the neck of all efforts at social emancipation, at other times cultural and artistic expression provides the means of bringing about fundamental and vital shifts of consciousness. Cultural activists have continually to grapple with these extremes of stagnation and excitement, especially in the South African situation where the future South African culture is at stake. Because of this we need to redouble our efforts to tear out of the moribund hands of the monstrosities of apartheid all the means of production of repressive cultural apparatus and ideology. In the situation of political, social, moral and cultural bankruptcy which apartheid has now reached, decisive cultural action by the progressive forces may well yield spectacular results.

By avoiding dogmatic cultural formulations and by promising the preservation and development of all culture constituted on grounds of non-exploitative human relations, the democratic forces in South Africa will seize the high ground in the struggle against cultural racism. By bringing into the light of day the outstanding cultural achievements of our people, collectively and individually, and demonstrating at one and the same time how far we have gone and how far we still need to go, we can inspire further effort and work towards a truly liberated and democratic culture.

This also implies that democratic cultural forces need to embark on a long march through the institutions of cultural reaction – not merely to occupy such institutions but to transform them fundamentally. Here we need immense efforts to build expertise and skills in all art-forms, crafts and cultural disciplines so as to decisively break the ruling-class grip on institutional artistic and cultural production. (By institutional culture we include the entire gamut of socio-culture activities from television through education to industrial design and publishing.)

167

In the case of popular cultural forms which have been forced to survive over and against apartheid hegemony, these should be encouraged, funded, documented and granted access to the facilities previously reserved for establishment cultural activity.

Indeed, the ending of ruling-class culture in South Africa must go together with the demise of ruling-class economic and political power. However, within the shifting and uneven times of struggle, cultural activism will at times seem to lag behind and at others seem ahead. It should be noted, nevertheless, that the final demise of ruling-class culture will not occur overnight – the ending of apartheid and establishment of national democracy, for example, will not guarantee the extinction of ruling-class culture which will return in other guises. Defeat of ruling-class culture in its 'white' form may lead easily to its reincarnation as the élite culture of the non-racial bourgeoisie. Only if viable and dynamic democratic alternatives have been established in each cultural area and discipline, can we then ensure that the progressive South African culture even now struggling to be fully born will prosper and flourish.

Then we will see a true sharing of the riches of human culture in a non-racial non-sexist, non-exploitative South Africa.

Towards new cultural relations

A reflection on the cultural boycott

by Conny Braam and Fons Geerlings

In the history of the relations between the West and South Africa, the position of the African population has not been taken seriously. From the very beginning, from Jan van Riebeeck onwards, immigrant farmers, traders, investors and scientists have contributed to the subjection of the Africans. The colonial conquest of South Africa comprises a succession of land robbery, war and attempts to annihilate the indigenous population and their culture. The colonizers tried to supplant the existing indigenous culture with one emphasizing a radically different social harmony, based on social differentiation with regard to class, colour and nationality – a new harmony based on the control of the majority by the minority, on the degradation of the many and the elevation of the few.

Relations between the West and South Africa have until recently been dominated by the consolidation and extension of the economic position and the ideological views of the white minority, a group regarded as the bearer of western civilization, as a vanguard on the African continent, expressing humanist values, an outpost of western morals and standards.

It is interesting to exemplify the relations between the Netherlands and South Africa in greater detail. These relations were aimed for decades at a strengthening

of the position and power of the Afrikaners, the whites of Dutch origin, reflecting a racist view based on the Bible.

The majority of the African population were not regarded as partners, not even in the Cultural Treaty between Holland and South Africa, signed in 1951. They were dealt with rudely as a negligible factor, but, at the same time, they were seen as a potential danger because of their numbers.

In the third quarter of the 19th century the leading Dutch politician and orthodox Calvinist Abraham Kuyper was an exponent of the Dutch view. Kuyper was an advocate of the Boer cause and supported their policy. He beseeched the Transvaalers that:

'they be found on the height of the high task and holy mission that await you in Africa. . . . It is [in Africa] that thou, men of Transvaal, as pioneers of Christian civilization, art called upon to play such a highly important role. Having crossed the Vaal river already from the sea and having penetrated beyond the Zoutpansberg, thou shalt have to carry the banner of honour higher and higher.'[1]

Kuyper's attitudes included significant attention to the possibilities for Dutch industrialists. He called upon South Africa to become 'the frontline for Dutch trade, a new . . . field for investment of the overflow of our forces and for the placing of Dutch products and capital.'[2]

In this climate the founding of the **Nederland-Zuidafrikaanse Vereeniging** (the Netherlands South African Association) in 1881 was not surprising. Already several years earlier, **Die Genootskap vir Regte Afrikaners** (The Foundation of Right Afrikaners) had been founded in South Africa. The initiators advocated that Afrikaans be elevated to the status of a 'literary language'. This initiative was a reaction to the ever-increasing British influence. At the dawn of the 20th century the **Afrikaanse Taalvereeniging** (Afrikaans Language Foundation) was established followed in 1909 by the **Suid-Afrikaanse Akademie vir Wetenskap en Kuns** (The South African Academy for Arts and Sciences). One year later Afrikaans was recognized as the second official language (along with English) and in 1923 Afrikaans was given full parliamentary rights. This settled an important cultural dispute in favour of the Afrikaners. In the meantime far-reaching developments had been set in motion. In addition to the mainly culturally

171

orientated Foundation of Right Afrikaners, the **Afrikanerbond** (Afrikaner Foundation) came into being in the second half of the 20th century. Initially founded as an electoral association, it soon became an effective political lobby. The **Bond** was both the precursor of the later **Nasionale Party** of Malan, Vorster and Botha, and possibly of the even more sinister **Broederbond.**

Slowly an intricate complex of political and cultural institutions developed under the leadership of Afrikaners. Once they came to power in 1948, they gained control over public life, including cultural policy. Soon education and training facilities for the black population and facilities for black artists were restricted and censorship and pass laws introduced to reduce freedom of action and expression. Likewise African culture was affected through the tightening of the homeland policy which aimed at separation of the African population in tribal groups in order to hamper political and cultural unity of the population. In the view of the regime, culture had to be restricted and expressed along traditional tribal lines.

Oppositional Culture

However, no matter how damaging and oppressive this view was, culture could not be destroyed and resistance could not be abolished. As early as 1912, the first national resistance movement on the African continent, the **African National Congress**, was founded in South Africa. Throughout its history the ANC has attached great importance to culture and education, not only because several artists were among the founders of the ANC (poet **Walter Benson Rubusana** and writer **Solomon Tshekisho Plaatje,** for example, but because of the value assigned to the education, conscientization, and mobilization of the resistance of the Africans.

The intensification of apartheid policies in the 1950s was accompanied by the development of the resistance. Simultaneously there was a revival of oppositional culture. Pen, pencil and camera were brought to the defence of rights. Artists gave expression to the resistance. The regime hit back hard. Writers and poets were arrested. With the banning of the ANC and the PAC in 1960 after the massacre at Sharpeville, many artists were forced to take refuge elsewhere.

At a time when the South African government was using education and culture more and more openly as instruments of oppression, the Netherlands government entered into a cultural agreement with South Africa. Through the Cultural Treaty ties were established with the white minority, without any attention being paid to the African population. According to Dutch cabinet ministers Rutten and Stikker, the Treaty would lay a 'profound basis for the maintenance and enhancement of the cultural and intellectual relationship with the Union of South Africa'.[3] How the Treaty was to be used was clear from the accompanying text. 'In the spring of 1952 the commemoration of Van Riebeeck will again provide an opportunity for an enhancement of the strong ties of friendship between the two countries.'[4]

Soweto Uprising

In the 1970s the Dutch Anti-Apartheid Movement initiated a campaign to abrogate the Treaty – an artificial dialogue between the wrong partners. What had been established initially at the level of governments was finally stopped in 1981 through pressure from below. The notion grew in The Netherlands that the Treaty, used mainly by apartheid propagandists, and its underlying policy of dialogue, was pointless. Holland now principally rejected the apartheid policy. The events in South Africa itself were, of course, of crucial significance for Holland's modified stance. Angola, Mozambique and later Zimbabwe were liberated. This development gave impetus to the resistance in South Africa, which had seen a revival in the 1970s with strikes by workers in Durban and subsequently with the Soweto uprising.

Though unrest among students and workers occurred during a period in which people were rediscovering their own history and culture, a renewed interest emerged from the Black Consciousness organizations, which later orientated themselves more explicitly to the ANC. It was significant for the Soweto uprising that the spark was caused by the forced introduction in schools of Afrikaans. This attempt to impose upon Blacks a different culture and embed them even further in a system of domination was rejected on a massive scale.

The fact that Afrikaans, akin to Dutch, was regarded as a language of the oppressor, was a hard blow in Holland and it undermined the notion among politicians and policy makers that Dutch culture could be a force for good with the Afrikaners in South Africa. It became clear that the Cultural Treaty could be

broken, and the cultural boycott of apartheid in South Africa was advocated even more urgently. But, at the same time, the question was raised as to how cultural relations with the resistance movement could be realized. The debate about the cultural boycott had to be changed; it had to be made more qualitative, after having been advocated for almost thirty years.

Huddleston

It was in 1954 that an English priest working in Sophiatown, a Johannesburg township, wrote an article in the British **Observer** newspaper, in which he stated: 'I am pleading for a cultural boycott of South Africa'. His appeal provoked tremendous controversy – and controversy has surrounded the cultural boycott ever since. When Trevor Huddleston made his call for a cultural boycott, he was moved above anything else by the seeming indifference of Britain and much of the international community to the ruthless imposition of the policies of apartheid being pursued by the Nationalist Party. South Africa was still an accepted member of the international community and could play its role in the United Nations and the British Commonwealth. Huddleston's call had a double effect. It was the first concerted attempt to bring home to one section of the international community – artists – the real meaning of apartheid. But it also represented a powerful signal to the white minority that its racist policies were unacceptable to the outside world. Within two years, the members of Equity, the British actors' union, were able to adopt what was in effect an instruction to their members not to work in any theatre in South Africa. The Musicians Union later took a similar decision and the effect was visible when, in 1964, the Rolling Stones called off a tour of South Africa. Writers were drawn into the cultural boycott in 1963, when 40 playwrights announced, at the initiative of the British Anti-Apartheid Movement, that they would refuse performing rights for their plays in South Africa if they were performed along racially discriminatory lines.

The American Committee on Africa took a strong stance in favour of the boycott and in 1965 presented a star-studded list of 65 performing artists and actors who joined together to sign the **We Say No to Apartheid** pledge. Signatories to the declaration included Harry Belafonte, Leonard Bernstein, Sammy Davis Jr., Arthur Miller, Sidney Poitier, Nina Simone. They went one step further than their British counterparts, by pledging themselves to refuse 'any personal or professional

association with the present Republic of South Africa, until the day when all its people — black and white — could equally enjoy the educational and cultural advantages of this rich and lovely land'. Although some artists did not keep their pledge, great artists like Harry Belafonte have held the banner of the cultural boycott high through the intervening years.

Blacklist

The cultural boycott was launched thanks to the efforts of solidarity groups and artists' organizations, and was intensified internationally in the decades ahead. Thus, in 1969, the General Assembly of the United Nations adopted Resolution 2396, requesting 'all states and organizations to suspend cultural, educational, sports and other exchanges with the racist regime and with organizations and institutions in South Africa which practice apartheid'. The cultural boycott now had the official endorsement of the United Nations. In 1983 the UN went a step further with the publication of a Register of entertainers, actors and others who have performed in apartheid South Africa. Supporters of the boycott were accused of practising censorship, of endangering academic freedom, cutting off the black population from the very contacts with the West they needed so badly, driving the white population into a corner and strengthening thereby the laager mentality, which would have a counter-productive effect. The UN Register was said to be a 'blacklist' of the same kind as Senator McCarthy's. The argument that the Whites could be changed by cultural exchange was repeated. In August 1988 Jonathan Demme of American Film Makers United Against Apartheid succinctly put together some of the arguments:

'Sometimes people tell us, you are really crazy not to let your films go to South Africa, because films are important information sources for the people down there. You will be depriving both the blacks and the whites of inspiration by not letting them see these movies. I find that attitude not offensive, but disastrously naive and patronizing. The idea that blacks in South Africa need any source of inspiration in their struggle to be drawn from seeing motion pictures is ludicrous. The idea of thinking that the whites who actively support and are fighting to keep apartheid in place are going to become emotionally overwhelmed by a motion picture and suddenly become anti-apartheid and change their views is again ludicrous.'

During a United Nations seminar on the cultural boycott in Athens in September 1988, Nobel Laureate Wole Soyinka explained: 'One of the curious defences the apartheid regime used for its policies was that it was one of the last bastions of civilization in Africa.'[5] However, he said, South Africa was not defending any white civilization but defiling the concept of the dignity of others. Universal rejection and isolation of the apartheid system was important not only for the victims but for the entire world.

Through the years, many European municipalities have accepted the UN Register and declared their platforms closed to boycott busters. This has been the case in the Scandinavian countries, Britain and Holland. Pressure by public opinion on governments to act has led to tentative measures in the European Community. Thus, in conformity with the United States and France, embarking on a policy of selective sanctions, in September 1985 the EC member states agreed to a ten-point programme of action to counter apartheid in South Africa. One issue among the ten half-heartedly formulated measures to be implemented dealt with the question of the cultural boycott. It reads that there should be no new cultural and scientific agreements, 'except those that are of a new nature, such as to contribute towards the elimination of apartheid and those that do not have a tendency to support it'.

The Federal Republic of Germany has sought to do away with the 23-year-old cultural treaty with South Africa. Its conservative government has proposed renegotiation with the apartheid regime to work out a newly defined cultural agreement, this time putting special emphasis on the needs and interests of the black population of South Africa. The intended talks have not yet taken place, but the broadly followed policy is still one of officially favouring cultural and academic ties with the minority regime. One should not have high hopes about the new West German policy: many contacts are continued and officially sanctioned. In this way the six German schools in South Africa and Namibia are still 60% subsidized by the German government and there is an exchange programme between the German Radio (Deutsche Welle) and Radio Windhoek.

Nonetheless the campaigns to deny apartheid propagandists a platform in Europe and elsewhere have been successful. After the boycott of the South African show **'Ipi Tombi'** – described by the ANC as 'a creation of the regime',because it was meant to show smiling black faces whose culture is preserved in the system of

apartheid[6] – it is no longer possible for explicitly racist and pro-apartheid theatre groups to tour openly abroad.

Even so, the pattern of measures at government level is very diverse so that Britain under Margaret Thatcher takes an entirely different stance from the Swedish or Norwegian governments. South Africa is seen almost everywhere as a pariah state, and it is widely recognized that no normal relations ought to exist with it. This is a challenge to the idea that the exposure to western cultural values will lead to an end to apartheid and means that South Africa's self-image as an accepted member of what it sees as the dominant international force – the civilized western world – has crumbled. The boycott is effective but it should not be forgotten that it is also meant as an instrument of liberation.

Alternative Culture

Paradoxically, the success and the effectiveness of the cultural boycott, in connection with the recent revival of the resistance movement in South Africa and of oppositional culture, has led to new dilemmas. The desire to support the resistance in all its aspects has given rise to a discussion about the concrete contents of alternative cultural relations. This was partly at stake at the conference 'The Cultural Voice of the Resistance', organized by the Dutch Anti-Apartheid Movement in 1982. Dozens of South African exiled artists gathered together in Amsterdam to talk with Dutch colleagues about an alternative for the by now cancelled Cultural Treaty and its replacement by an official link with the ANC. But the Dutch government was not ready for that. However, an official Cultural Treaty was established between the municipality of the Hague and the ANC.

The perception that an enormously vital oppositional culture was flourishing in South Africa, and the limited exposure of Europe to South African music, theatre and literature, gave rise to the need for further contacts. Conversely, many progressive South African artists felt excluded from these contacts. Where this was the case, it led to much confusion. Sometimes respectable bands from South Africa were met with picket lines in Britain. The question had to be asked whether the boycott had been applied too strictly, and was threatening to become negative. The boycott was meant to deny pro-apartheid followers exposure, not to make the 'alternative culture' invisible.

A major contribution to this debate was rendered by ANC president Oliver Tambo in a speech in London in May 1987. Here he indicated that the ANC had modified its thirty-year old commitment to a blanket boycott of all cultural and academic links with South Africa. The boycotts would be continued – but the ANC would become selective in its choice of targets. Tambo pointed out that inside South Africa there had emerged unmistakably an alternative democratic culture, a people's culture, which was doing justice to the aspirations of our people in the struggle. The moment had come to use the alternative structures brought about by the struggle and the sacrifice of the people. People's culture should not be boycotted, but should be encouraged and supported.

Several days after Tambo's speech, the UDF publicised its viewpoint in a resolution. This resolution reiterated its support for campaigns to isolate the apartheid regime and called on these to be intensified and strengthened, but pointed out the difference between isolating the regime and isolating the people of South Africa. The UDF formulated general criteria for selection. Tours both to and from South Africa would only be exempt from the boycott if they were supported by the democratic movement in South Africa, approved by overseas solidarity groups and contributed to the advancement of the national democratic struggle and the building of a future South Africa.

Medu 1982, Casa 1987

The development of these views of the cultural boycott did not come out of the blue. The issue was raised at the large Medu Conference in Botswana in 1982, and the ANC spokesperson told the participants of the conference, 'The Cultural Voice of Resistance' in Amsterdam:

'We welcomed the initiative taken by the National Museum of Botswana, Medu and cultural workers inside South Africa who correctly see that they have to use their talents to help liberate themselves and their country, and, consequently, unshackle the creative talents of the people. It should also be of interest to this gathering to know that even as cultural workers met in Botswana, they had to solve an immediate problem related to the issue of the cultural boycott. This matter arose in part because South African musical groups which had performed at home, together with visiting foreign artists, wanted to attend the festival and conference. Significantly, the hundreds of participants at the festival agreed that

these groups should be excluded because they had defied the call not to have anything to do with artists who come to South Africa in breach of the cultural boycott. . . . Indeed, we want that the voice of the cultural workers in the resistance should be heard clearly both by our people at home and by the international community. Obviously, we have no desire to isolate that voice within South Africa. . . . But we should be aware of the fact that the apartheid regime and its friends will naturally seek to use any opening it can get to breach the boycott wall surrounding it. We should therefore appeal that should anybody wish to relate to the cultural workers inside South Africa for the express purpose of encouraging these workers in their stand against apartheid, then that person should at least seek our opinion.'

All sensitive issues (how flexible ought the boycott to be? who determines the criteria and who controls them? what role ought culture to play in the struggle? what will the role of culture be in the future? and what is its relationship with politics?) were dealt with at the Casa Conference in Amsterdam in December 1987. It was a unique gathering: in its way, for some, a 'cultural Dakar'[7]; unique because it was the first time artists working inside South Africa, those in exile, and leaders and cadres from the liberation movement were brought together in such numbers. For the first time, people could talk together and come to a common stand about the cultural boycott. South African artists, individually and collectively, who travel and work abroad, could consult with the mass democratic movement and the national liberation movement.

Artists Against Apartheid

It was not just the boycott that mattered in those years. Everywhere, throughout the world, campaigns were started to give practical aid to both the ANC and to artists in the resistance in South Africa.

An exceptionally important role has been played by organizations established to coordinate the anti-apartheid activities of artists. The first such initiative was the creation in the United States of Artists and Athletes Against Apartheid in 1983, under the leadership of Harry Belafonte and Arthur Ashe. Stephen van Zandt took this co-operation a step further with the creation of United Artists Against Apartheid in 1985. In Britain in April 1986, Artists Against Apartheid was

established by Jerry Dammers and Dali Tambo to provide a similar co-ordinating role.

In Britain this resulted in co-operation with the Anti-Apartheid Movement in the famous Mandela Concert in the Wembley stadium in June 1988. Pop artists in Sweden and other countries also organized benefit concerts and sought ways to contribute their share. This was discussed at the Culture Against Apartheid conference organized by the UN in Athens. The Chairman of the Special Committee Against Apartheid, Joseph Garba, said 'it was not sufficient to refuse to perform in South Africa; artists and writers must use their talents and their imagination, their energy and their time and even funds, to do something which governments are reluctant to do. They have no secret agendas and they do not balance costs and benefits as, unfortunately, some governments have been doing for some years now'.

Also present was South African writer Nadine Gordimer who stressed the extension of the support to the resistance and the ongoing development of South African culture:

'The four-letter prefix anti (apartheid) stood for the world's conscience against racism. But we come here to assert together the positive; in the words of one of South Africa's freedom fighters, poet Mongane Wally Serote, we are here to 'help South Africa to sanity rather than just talk about her madness'. We want a new South Africa, a continuing organic growth of a culture that is already pushing up the paving stones of the academies, the state opera houses, and sweeping the dry rot of colonial cultural history into oblivion. . . . The new culture the people of South Africa are striving to build, under ugly and dangerous conditions, is based on the people's culture, a democratic culture, and is extended to everyone without exclusions by colour, race or class. For the people of South Africa, against apartheid, we must learn to use art for its true revolutionary purpose, the discovery and regeneration of the human world: which is freedom.'

We, the people of the Netherlands, in the West, or anywhere in the world, must be partners in the new 'other' culture and wish to know of it. We must enter into cultural relations and conclude new cultural agreements with the representatives of this new, 'other' culture.

180

Notes

1 Quoted in Chris Koppen, **En Zuid-Afrika**, postgraduate dissertation, University of Utrecht, 1981.
2 Ibid.
3 Quoted in accompanying text (White Paper) to the Netherlands–South Africa Cultural Treaty, 1951.
4 Ibid.
5 Jonathan Demme, Statement issued by **American Film-makers United Against Apartheid**, 5 August 1988.
6 Statement by British Anti-Apartheid Movement to the symposium on **Culture against Apartheid**, Athens, 2-4 September, 1988, p 9.
7 'Dakar' refers to the political breakthrough represented by the 1987 meeting between the ANC and white Afrikaner academics and politicians from inside South Africa.

prelude

When i take a pen,

my soul bursts to deface the paper

pus spills ——

spreads

deforming a line into a figure that violates my love,

when i take a pen,

my crimson heart oozes into the ink,

dilutes it

spreads the gem of my life

makes the word i utter a gasp to the world, —

my mother, when i dance your eyes won't keep pace

look into my eyes,

there, the story of my day is told.

Mongane Wally Serote

Beware of Dreams

The present is a dangerous place

to live. There were dreams once,

riding past and future alike; we

embraced the dream, drunk past

any look at the present in the face.

There were dreams once

and the illusion led

to the present.

There were dreams once,

gold, or red, / green & black,

but the present is here

like me and you. And is articulate.

And knows no peace; neither do you

nor me if we are friends

enough to have known the dream

Keorapetse Willy Kgositsile

Amsterdam Memories

An Amsterdam December
is foreign to our bones.
Yet here we are at home
surrounded by our own.
Here the photo album of my life
has been shuffled
and the selection dealt to me.
Some faded epidiascope slides,
some shiny Instamatics,
the hugs and pleasure of meeting.
Faces of my comrades
from almost all my life.
The faded sepia snapshots.
A comrade from Dorkay House
jazz men, writers, some of our leaders,
memories of finding our movement
in my picnic pre-prison days.
More recent photos,
Pentax sharp and clear.
Botswana, country of first exile
links us through Medu, friendship
and the struggle.
Angolan slides.
Comrades who help to bury exploded Jenny and Katryn,
we greet and hug and weep again.
Tanzanian shots, Zambian shots,
photos from whatever deployment has moved me.
Here in Amsterdam the Instamatic clicks.
Comrades just met.
New faces, new friendships
to be pasted in my album
when next the reality of meeting
puts flash upon the print
we will hug and laugh and remember.
Zooming in on our future
we will not long be forced apart.

15 December 1987

185 Marius Schoon

Soweto Road

On this spot rough

from cares of slow years

on these streets

muddy from torrents red

on these crooked roads

yawning for direction

here where like early spring

awaiting rain's seeds

young voices stormed horizons

how yet like summer streams

young blood flowed over

flooded flower

in the dead of winter

On this road here

here this road here

tingles and shudders

from acid taste

the snakeskin snakestooth whiplash road

 where snakes tongue flicker lick

broken glass children's park

road school for shoeless feet...

olympic track perfected

by daily daring sprints

against passes

and barbed wire nakedness...

this roads pressed soft

oozing like tear-falls

treeless show-ground for hard-ware

 processions

all the June sixteen festivals

and their mad array of hippos

muffling contrary anthems

with machine-gun chatter

naked greed and lust for blood in camouflage

Soweto road drunk

from rich red wine

this sweet arterial blood

for choice Aryan folk...

battlefield road here yes

Here

yes even here

where road-blocks to life pile

precariously

here we kneel

scoop earth raise mounds of hope

we oath

with our lives

we shall immortalize

each footprint left each grain of soil

 that flesh shed here

each little globe of blood

dropped in our struggle

upon the zigzag path of revolution...

Soweto blood red road

will not dry up

until the fields of revolution

fully mellow tilled

always to bloom again

Lindiwe Mabuza

Springtime in District Six (Zonnebloem)

The dust has settled
and unfailingly
the grass has pushed its way through,
covering the ugly
red scars
left by the bulldozers...

In fact
it looks quite pretty,
this empty patch
beneath the mountain,
in the heart
of the city
with empty churches
dotted here and there

The mosque stands
silhouette against the sky
as do the regimented chimney-pots
atop the black roofs
of the white
newly-painted white houses.

The area is pretty deserted, now
except a few brave white souls
who occupy
the white houses with their black roofs.

They slink about
with downcast eyes —
unsure, unsafe
They bar their windows
ears and eyes
against the voice of the Imam
who vainly calls the faithful
now long since shunted out...
They note the grasses
growing green
and hope that spring will never end
They double bolt
their doors at night
but strangely, at odd hours,
the voice of the Imam
still comes floating down their chimney-pots
calling
calling....

Mavis Smallberg

the stormtroopers are
in the streets

the stormtroopers are in the streets
the poets have buried their metaphors
the preachers are exiled prophets
the young boys are walled in
the young girls are violated

the stormtroopers are in the streets
the women wash dishes with their tears
the old women's knitting needles are broken spears
the men smash jugs of wine against pantzer
the old men forget their front stoop newspapers

the stormtroopers reign in the streets
they lob schoolboys from armoured car to armoured car
the streets are not empty
the stormtroopers reign in the streets

the writers die in exile
the preachers call to their gods in vain
the raped prime their barrels with thunder

the stormtroopers are in the streets
the youths carry spears

the stormtroopers are castrated in the streets
the girls carry spears

the stormtroopers are walled in
the children are in the streets

Hein Willemse

I am the Exile

I *am* the exile
am the wanderer
the troubadour
(whatever they say)

gentle I am, and calm
and with abstracted pace
absorbed in planning,
courteous to servility

but wailings fill the chambers of my heart
and in my head
behind my quiet eyes
I hear the cries and sirens

Dennis Brutus

release

already glistening I arrive the first day

with angel choirs: yonder the feathered folk sing psalms

and my countenance smells sweet and my hands

embalmed – did I not with all my years put aside

the final ointment precisely for this encounter?

quietly I'll recline with bated joy

so as not to move earth this last leg

dance dust my beloved – why are your eyes now so dull?

let our friends gather the laurel runners

and weave them into wreaths of green victory;

no one should mourn lest the bier be upset,

for I am yours now slaked of all dishonour,

yours where dolphins wind-softly wheel in the palms.

yours all freaked free in the boweries of night

Breyten Breytenbach

I took a trip down to the stream
En ek het daar 'n ronde klip gekies
And there I chose a smooth, round stone
And it was little; in a dream

Of all the height that was his own
Het Goliat die grond gevreet
The giant fell down. Hear him scream.

The people are a tiny stone
A pebble that will humble pride
The people are a mountain home.

You surround me with water.
I shall not drown myself.
I will drink the thirsty ocean
And sweat till my skin is leprous with salt in the sun
Whose beaks of rising and setting and noon eat out my guts,
 eat all of my being,
Whose cold eye cuts the wounds of the rocks on my body; the stones
I grind blind me.

You have stripped me completely.
I shall not hang myself. I cannot.
I shall not fall down the stairs of the air you have built here and have stripped bare
Until cold wet cement clamours to claim the steps off my feet.
I will stand forth naked in mirrors of lime pits and stand
Unashamed in my anger. Till all is accounted.

Cosmo Pieterse

Can I Get A Witness Here

How shall I tell them at home
That I met you at Grenoble
Beneath the slopes of the snow-capped Alps
Father Nelson Mandela

 Can I get a witness here
How can I make anyone believe
That the streets were full of you
In Grenoble outside the gates of Pollsmoor Prison
Father Nelson Mandela

 Can someone witness to this
Who can help tell everyone how your face
Loomed large in a city older than your country
Dressed warmly in a polo-neck jersey
Father Nelson Mandela

 Can I get a witness here
You stood far from the Koeberg nuclear station
Yet so very near the French nuclear power monster
Enclosed within the majestic towering Alps
Father Nelson Mandela

 Can someone witness to this
Up there on the slopes of the Alps
A thousand feet up the tumbling green slopes
I stood looking at the city below
Pondering the meaning of a place
Unwashed for centuries
A Roman abode in times past
At peace with itself
No fusses of centenary celebrations
Whose yield demeans the human heart
With such guilt as Operation Hunger
Amidst the glitter of gold and diamonds

I was standing where I could pluck off clouds

The air was a fresh green smell

Clean

Neat

Pure

All around there was the cherry-tree in bloom

With lily-white flowers

All around there was the apple-tree in bloom

With dazzling pink flowers

All around there was a mass of pine-trees

Stubbornly green all seasons

As defiant as the massive rocks

And the high peaks of the Alps

Wearing white caps all seasons

And then all at once I felt a moving spirit

My heart's pounding beat

In unison with the enthralling sights about me

The ring of rugged timeless mountains

The rolling green sides of these high sentinels

And oh! I saw the serene face of

Father Nelson Mandela

As if indifferent to the words scrolled

Over and below his sublime face

In a bleeding red colour

 LIBERER MANDELA

I asked

As if in between the tears and supplications

of a mother

 Why Lord

Why are the screams of men across the whole face of the earth

Unheard

Unheeded

Unmoving

Are you one or several

Sipho Sepamla

Reflections of an Old Worker

or

The Ballad of the Power over my Body

When I was a young man,

powerful and strong,

I had dreams:

I wanted soft pillows for my head

and to hear my children sing.

Those dreams never came true:

today I'm but an empty shell.

You reaped the harvest of my labour,

you became the power over my body.

I've worked this earth,

yet it offered me nothing.

My life partner

passed on through sickness and hunger,

my children all astray.

Why did I dig so deep?

I found nothing,

the hard work, the sweat.

You reaped the harvest of my labour,

you became the power over my body.

Man is born to work and toil,

but I've carried your load,

I've tilled the soil.

My black face is a concrete mask,

your buildings reach the sky,

your dreams fulfilled,

you smile victoriously.

Is it for this I bent my back?

A day's work done

I return to my shack.

You reaped the harvest of my labour,

you became the power over my body.

Long ago in my youth,

I was healthy and strong;

the dreams were there,

but now they're gone.

the hard work, the pain,

you stripped me of my strength,

but not in vain:

the power remained in my head.

You reaped the harvest of my labour,

you became the power over my body.

My children will return,

more powerful and stronger.

They will labour but demand their reward,

their dreams *will* come true,

their bodies fulfilled,

they will become new.

You reaped the harvest of my labour,

you were the power over my body.

Gladys Thomas

195

Mandela

Your spirit is visible throughout the land
from the Cape until Transvaal,
the wretched of the earth
have turned your name into a chant,
Mandela.
Free, in freedom, unfettered;
everywhere they sing praises in your name,
"I qhawe lama qhawe",
hero of heroes
whom they thought they could un-man,
by removing you
from the sight of your people;
but their cells
could not contain your spirit
Mandela.
Lauded in far-off lands;
a bridge near Jan van Riebeeck's town,
named after you;
the freedom of a city bestowed
upon you as a token of respect,
Mandela.
Unfree in your own land,
a 'demon' in the lives
of the boers
who nervously attempt
to keep you unfree.
Your spirit is visible throughout the land
from the Cape until Transvaal.
Even from within the confines of your fettered life
you pose a threat
to the jailers of this land
who – since time immemorial
have kept you and your people apart;
you – our dreams and hopes
personified,
a knight without horse or sword
taking up the cudgels
'gainst every form of inhumanity

in the South,
so paradisiacally blessed
with sun and mountains,
vineyards and gold,
reserved only for those
who called themselves the 'chosen of the Lord'
'Herrenvolk'
unrighteously so.
Mandela – father of the fatherland
whose spirit no bars
or stonewalls managed to contain,
nor dungeons, specially constructed
by the jailers
who rule by gun,
'sjambok'
and the 'gospel of Johannesburg'.
Your spirit is visible throughout the land
from the Cape until Transvaal,
and the sons and daughters
keep up the chant
"Mandela show us the way
to freedom"
like Moses
who did likewise,
and the troubadours sing
"free Nelson Mandela".
"Free Nelson Mandela",
a nightmare in the lives
of the Boers
who thought they could contain your spirit
forever – with bars and stonewalls,
Mandela
Rolihlahla
freedom fighter
your spirit is visible throughout the land
from the Cape until Transvaal...

15 July 1988, Nelson's 70th birthday, Transvaalquarter,
Luthulistreet, Amsterdam

Vernon February

Mother (fragment)

[...]
Who will be like a mother?
You were never a trained nurse, doctor
But in my infancy, before I could talk
she could live, feel and understand
the pain and suffering in my life.
She unselfishly gave me her breasts to feed
And today I have grown up, I am a man.
She taught me all the dangers in life
as well as those things good for my life.
I feel safe, still today your advice,
plans and wishes are planted and growing in me.
Even if I am in pain
my conscience reminds me of you.
And suddenly I hear that soft, echoing voice
guiding my way forward.
[...]

Alfred Temba Qabula

After All These years

— a letter to a friend wherever she may be —

Anger swells

Like an explosion

In the chest

But it is too late

To change lives now.

Love is a strange feeling

I left behind

In the disturbances of youth;

The tiger will not let me off

And the hyena cannot stop laughing

As the hippo rides the streets

Besides, we are too learned now

To go back to the source

After all these years

The emerald dazzle has softened,

Your eyes have black sediments,

And I have aged in my youth:

Oh how the years wasted our lives

How our tongues could not speak

The language of our hearts

How we barricaded

Behind the myths of our upbringings.

Farouk Asvat

That Courage May Come Again

For Zwelakhe Sisulu

In the fragile web of silence
your cries beat within the fractured heart
trodden eyes in waking dreams
the African soul unsung
lifts your crimson crown
against the dazzling flame

Sharpevilled again yet unsurrendering
booming blows for dignity
echo from our shaking drums
to mend your tears,
seal the grave of bondage
that courage may come again

19 December 1987

Don Mattera

The Day Shall Dawn

A new man is born
Full of strength and agility
To demonstrate conventional wisdom
In defence of the fatherland
Through cannons of criticism
His dragon force and enthusiasm
Shall perform a daring combat against fascism

Man shall initiate a campaign
Against genocidal crimes
Committed and perpetrated against beloved humanity
Today housing is another means of exploitation
And before the spirit of Hitler destroys man
Wake me up to join you in the march
To a people's kingdom

Man is swallowed by limited pleasures of time
Man is forsaken like a memory lost
Say it aloud
Justice is upset and democracies kneel
Say it aloud to counter state lie
Again shout it loud
The government is riding fast to a greatest fall
From one great defeat to another

Tuberculative bodies of young and old
Shall come to pass
Institutionalized violence is silent holocaust by design
However like a surprise the day shall dawn
And the world shall mourn
At the burial of fascism
For a threat to world peace shall be no more

The doors of Hell are golden
Possessed and displayed by Western powers
Self-interest is a vehicle to the graveyard
Hidden worms shall come to exposure
And collaborators like giant spiders
Shall belong to the dustbin of history
All this shall take root before dawn.

Shalom is the language of world peace
North. East. South. and West
The Nkomati Accords is not freedom but a deal.
No state power shall legislate me not to love man
do something to facilitate change in Africa
Do something to fling the doors of Pollsmoor and Robben Island Prison
 wide open

Do something favorable for the exiles to return back home
Oh! Africa, let this all be done before dawn
Oh! peace loving South Africans let it be done before dawn

I Will Wait

I have tasted, ever so often,
Hunger like sand on my tongue
And tears like flames have licked my eye-lids
Blurring that which I want to see,
I want to know.
But Oh! often, now and then, everywhere where I
have been,
Joy, as real as paths,
Has spread within me like pleasant scenery,
Has run beneath my flesh like rivers glitteringly sil-
ver;
And now I know;
Having been so flooded and so dry,
I wait.

Mongane Wally Serote

liberation

here I am this first day already shimmering bright
among angel choirs: afar the feathered folk sing psalms
my face smells of beauty my hands are embalmed
did I not store the leftover oil for years
with precisely this meeting mirrored in mind?
very still I will lie holding in my glee
so as not to rock the earth on this last lap

dance, raise the dust beloved – why are your eyes so grey?
let friends pick sprays of laurel leaves
and twist green victory garlands all entwined:
no one should sorrow so that the bier may be becalmed
for I am yours now picked clean of all disgrace
where wind-softly dolphins orbit in the palms
yours entirely released in the gardens of the night

Breyten Breytenbach

202

The CASA conference

Africa

Africa my Africa
Africa of the proud warriors in the ancestral savannahs
Africa that my grandmother sings of
On the banks of her far river.

I have never known you
But my gaze is filled with your blood
Your beautiful black blood spread over the fields
The blood of your sweat
The sweat of your labour
Your labour of slavery
The slavery of your children.

Africa tell me Africa
Are you the back that bends
That lies down under the burden of humiliation
That trembling back full of red slashes
That says yes to the whip on the roads to the south.

Then a voice answered me with earnest quietness
You fiery son this strong young tree
That tree there
Beautifully alone between white withered flowers
That is Africa, your Africa that is growing again
Patiently and stubbornly growing again
Bearing the fruits that slowly
Assume the bitter taste of liberty.

Ed van Thijn, Mayor of Amsterdam, recited this poem by the Senegalese David Diop at
the Grand Gala Opening Night of the CASA Festival.

Translation by Robert Dorsman
Photograph by Wilma Kuyvenhoven

'From Amsterdam with euphoria'

A Report of the CASA Conference and Festival

by Joost Divendal and Willem Campschreur

We want the world to know:
we have come a long way now.
we are not like spotless white shirts
we are khaki
it is the time, the road, the dust, the heat, the rain and the wind
which did it all

Within the resonance of the Renaissance New Church at Dam Square, the very heart of Amsterdam, in the building where Dutch kings and queens are crowned, these words sounded almost as a credo. On Sunday 20 December 1987, opening the exhibition *The Hidden Camera*, at the final event of CASA, *Culture in Another South Africa*, Barbara Masekela, head of the Department of Arts and Culture of the ANC, began her speech with these lines of poet Mongane Wally Serote.

As a *leitmotiv*, the lines were printed in large letters at the entrance to the exhibition. Forty-eight South African photographers had contributed specially to this collection — a portrayal of daily life in South Africa, showing both oppression and resistance, censorship notwithstanding, just as a group of Dutch photographers had done under Nazism in World War II *De verborgen camera* (The Hidden Camera). Here 300 South African artists and an audience of 1,000 gathered for the last time. In the afternoon

of the next day they would leave to travel back to Cape Town, Johannesburg, Soweto, Gaborone, Harare, Lusaka, Mazimbu, Ohio, Rio de Janeiro, Melbourne, Stockholm, Paris, London, Berlin, Warsaw and many other towns and villages.

On 6 December they had started arriving in groups of 80, of 30, as individuals in Amsterdam, hometown of South African colonialism and of the apartheid ideology of the *Boere* in the seventeenth century: but also the city that resisted Nazi anti-semitism and which now stands against the racism of the apartheid regime. Amsterdam, the Dutch capital and self-declared anti-apartheid city, had been symbolically proclaimed 'cultural capital of Europe'. And during the next two weeks, as Barbara Masekela put it at the closing session of the Conference, Amsterdam became the cultural capital of South Africa.

Aims

Culture in Another South Africa was the heading under which all events were staged. To become familiar with that 'other' culture was CASA's aim, and, more importantly, to give support to those 'other' cultural workers striving for a non-racial society. In the spirit of the United Nations Declaration of Human Rights and of the Freedom Charter adopted by the ANC, UDF and COSATU, culture belongs to the entire population of a country, to those who, as artists, create culture, and to those who participate in culture and enjoy culture. Right down to our times, in the declining years of the apartheid regime, South Africa's history is characterized by cultural oppression; consequently that 'other' culture has existed only in secret or in exile. Communication, exchanges, criticism, appreciation, free contact with other people: in South Africa today there is no room for such a confrontation, although it is a vital condition for the future.

CASA aimed at stimulating an open debate on the significance of culture in South Africa with regard not only to the future, but also to the significance of culture for the present. CASA was intended as a channel for the exchange of ideas and experiences that are already part of that cultural development of experiences and ideas both of South African artists-in-exile and of artists who have to work illicitly in South Africa at present.

This meeting between so many exiled artists and colleagues from inside South Africa itself was probably the most unique aspect of CASA. The arrival of the first group 'from inside' was a feast: the children of the Soweto-based Student Youth Drama Society, the grand old men of the Jazz Pioneers, the cultural workers of the mass democratic movement, COSATU and UDF, and other 'non-aligned' artists. Gradually

they mingled with exiled colleagues active in and around the national liberation movement, ANC, and with various non-aligned cultural workers.

Unknown writers and the world-renowned Nadine Gordimer from inside South Africa exchanged views with exiled writers Lewis Nkosi (based in Warsaw) and Breyten Breytenbach (based in Paris). Thabo Mbeki, head of the Department of Information and Publicity of the ANC, took part in discussions with many photographers, journalists, writers, visual artists and musicians such as Academy Award-nominated Jonas Gwangwa (exiled in London) and poet Vernon February (exiled in Amsterdam) as well as actors whose names cannot be mentioned for reasons of security.

Some artists devoted much of their time to rehearsals and performances because CASA was also the stage for the presentation of the culture from the 'other' South Africa: Dollar Brand (alias Abdullah Ibrahim, exiled in New York), the Earth Players of the Market Theatre in Johannesburg, and the actors of *You strike the woman, you strike the rock* from Johannesburg, and Basil Coetzee with his Sabenza band from Cape Town. Everywhere the response was favourable.

'Amsterdam, for two weeks the podium of a free South Africa' wrote the Dutch newspaper *De Volkskrant* (8 December 1987). 'CASA 1987: a reunion without fear', was the headline in Dutch quality paper *NRC Handelsblad* (21 December 1987). 'From Amsterdam with euphoria' was the headline in a two-page report in the South African *Weekly Mail* (15 January 1988). *South* (Cape Town, 14 January 1988) wrote of CASA that 'The Cream of South Africa's cultural community went to Amsterdam to give the world a rare glimpse of this country's talent', while *New Nation,* another South African weekly wrote: 'It is possible that many significant cultural developments in future years will ultimately be traceable to the historic Conference and Festival on Culture in Another South Africa' (23 December 1987).

One Step Further
Various cultural workers could not alas be present. Mzwakhe Mbuli, people's poet, was prevented from travelling to Amsterdam by the South African government (and he was held in custody without trial from January to July 1988); Zwelakhe Sisulu, editor of *New Nation,* already in custody without trial for more than a year, was honoured with the CASA Media Award in the CASA Colloquium on Journalism. Other absentees were the late James Madhlope Phillips, initiator of the CASA Choir of 300 Dutch singers singing South African freedom songs; poet and writer Mongane Wally Serote, who played a vital part in the preparation for CASA, but who received

his travel documents from the British government only after CASA was over: and fine artist Harry Thamsanqa Mnyele murdered in Gaborone, Botswana, by a South African commando unit. Thami Mnyele was, however, present at CASA in his painting of the huge backdrop against which Amandla the cultural ensemble of the ANC performed. He was present, too, in the minds of many as a symbol of those whose lives and works have been destroyed by the apartheid regime.

In 1976 Wally Serote and ten of his colleagues had taken part in a small conference in Amsterdam. This was the start of the cultural boycott of the apartheid system, and was held with the intention of breaking the Cultural Treaty between the Netherlands and South Africa. In July 1982 Thami Mnyele was present at the Medu conference in Gaborone, where discussions were held about culture as resistance, and in December 1983 in Amsterdam, at the 'Cultural Voice of Resistance Conference', where 50 South African artists in exile and their Dutch colleagues worked on a new filling-in of the cultural ties between Europe and (anti-apartheid) South Africa.

CASA 1987 was the next step: a great number of South African artists (exiles and non-exiles) were to exchange views about the cultural infrastructure of their country under apartheid and as a non-racial society.

To the Dutch public, Dutch anti-apartheid workers and passing tourists, the CASA festival was 'an exciting showcase of South African cultural work', as the *Weekly Mail* reported. For the South African delegates, CASA was 'the simultaneous conference, where assessment, discussion and forward planning took place'. From December 14 to 19, in spite of the heavy rehearsal, performance, workshop and press schedules, there were six days of prolonged conference sessions covering all cultural disciplines, from music and theatre to journalism and visual arts.

Discussions

At the end of the Conference, the discussions were summed up in a number of resolutions comprising 'one of the most comprehensive working documents on resistance culture'*(Weekly Mail)*, an impressive reflection of the issues debated and discussed by South African cultural workers in exile and from home. The CASA Preamble and Resolutions are not a blueprint ordained from above, not a doctrine for cultural life, not an 'ex-cathedra pronouncement from the ANC leadership' (Pallo Jordan, member of the National Executive Committee of the ANC, in his address to the Conference). They are guidelines to the culture of a democratic and non-racial South Africa, in which culture will be accessible to all.

The discussions at the Conference were characterized by a growing consensus on many major points. In Resolution 10 on language, for instance, it was agreed that all

the languages of South Africa, including Afrikaans and English, be accorded equal status, despite the fact that the latter two were associated with the tongue of the oppressor. However, 'noting that English and Afrikaans had taken on a disproportionate role in cultural production and communication because of their status as official languages', the resolution stressed 'multilingualism as a characteristic feature of South African society' and affirmed that 'all people shall have equal right to use their own language'.

The CASA Conference presupposed an 'implementation of the Freedom Charter' (Preamble and Conclusion), the policy declaration of the ANC and the mass democratic movement within the country accepted in 1955 as an alternative to the apartheid state by delegates from all over South Africa. However, the paragraphs in the CASA Preamble and Constitution sometimes had a clearer political composition than the general formulations of human values in the Freedom Charter. Thus CASA speaks of a 'vibrant people's culture' and stresses several times the importance of an 'anti-sexist culture'.

In the Conference sessions, prepared for with single statements and papers and open to delegates, observers and the press, there was room for marked differences of opinion, which could be aired in all frankness. Frequently the view was expressed that the political situation in South Africa requires that culture should serve the struggle. Often too, however, was the opposite view put forward, namely that culture should formulate its own objectives without self-denial, and that artists should be free to translate these objectives into militant politics.

The proposition that cultural workers bear responsibility for their accessibility to the mass of our people by speaking to them in a language and in symbols that they understand (I.5) and to work and develop collectively, while noting that the culture of the oppressors has encouraged a high degree of individualism amongst artists, was based on a political analysis rather than on strict conceptions of culture. In the political situation of South Africa such a point of view about collectivity does indeed have the force of words. All delegates at the Conference emphatically agreed on the formulation that 'cultural activity and the arts are partisan and cannot be separated from politics' (I.2). At the same time the words of Pallo Jordan were greeted with great approval: 'The ANC does not ask you to become political pamphleteers The ANC does not require poets to become political sloganeers'.

Considering the differences of opinion about collectivity and individualism for instance, it was all the more pleasing that the CASA participants agreed on a joint

statement. It was a hopeful feature of CASA that so many people with their own opinions and with a common objective entered into discussions in such an outspoken manner. An honest and free exchange of views is a pre-requisite for a flourishing cultural life, heterogeneous in nature and aiming to advance the quality of life.

Context

As stated earlier the texts of the 'Preamble and the Resolutions' must be read within the framework of the implementation of the Freedom Charter, that seeks to guarantee 'all the rights to speak, to organize, to meet, to print, to preach' and the 'free exchange of ideas'. In that sense, the CASA Preamble and Resolutions are first and foremost a working document, an addition to the more 'constituent document', the Freedom Charter.

Being a condensed expression of prolonged and intensive exchanges of views, resolutions can be summarized all too easily and interpreted wrongly, most certainly when explicitly formulated fragments are wrested from their context. Besides the Freedom Charter, the many discussions formed an important part of that context — the context of CASA — as indicated above in the debate about collectivity and individualism. A fine illustration of this was the contradiction between 'slogans as the purest form of poetry' and a passionate appeal for 'poems about our own inner being, we also must write love poems'! — an outburst during one of the Conference sessions. With reference to CASA, Pallo Jordan states, 'of course there are different opinions in the movement. Some people think that you can leave out of consideration everything that does not directly relate to the struggle. That is an extremely shortsighted and mechanistic idea of what struggle actually is. One of the objectives of our struggle is that people may enjoy the fullness of life.' *(Zuidelijk Afrika Nieuws* magazine of the Dutch Anti-Apartheid Movement, February 1988.) The *Weekly Mail* (15.1.88) summarized its report of CASA thus: 'What was the residue? A flexibility. Hard lines, rigid distinctions were few and far between. In discussions the *de facto* situation was understood: that community arts centres benefit from an input by professional artists, that there is space for fruitful interchange between proletarian theatre groups and actors and directors from the professional theatre, that progressive culture, though growing, is still in its infancy. Rather than a small exclusive purity, it needs the inclusion of a wide range of partisan artists' (15.1.88).

Significance

The CASA resolutions centred on real desires, such as the founding of a 'national democratic organization to represent the interests of all cultural workers'. Since the

CASA Conference in Amsterdam, various small CASA meetings have taken place within South Africa. In addition, activities of organizations such as the Congress of South African Writers (COSAW) seem to suggest an all-embracing cultural structure. Several resolutions were very explicit, but nonetheless principled, like the resolutions on copyright (II.8) and on funding (II.9). The explicitly formulated need for progressive journals and literature in the resolution on the performing arts (II.15) was inspired by the factual lack of such journals and literature in a situation marked above all by conflict. The word 'struggle', featured in the text regularly, is therefore not a cliché.

This reality of oppression by the apartheid regime and the struggle against it colour CASA totally. Thus, the resolution about the cultural boycott is of an actual political nature. CASA itself, as a historical meeting between artists from 'home' and from 'abroad', was a confirmation of the fact that this culture must be nurtured. The world at large, the CASA Conference concluded, must be able to become acquainted with the 'growing significance of democratic culture as an alternative to the racist, colonialist culture of apartheid (I.7) in furtherance of the national democratic struggle' (II.5) Again the importance was recognized of the 'total isolation of the apartheid regime. Among the tactics to be employed during this campaign, the academic and cultural boycott are crucial, and must be maintained' (I.7). However, it was recognized that the cultural boycott as a tactic in the struggle against apartheid must also leave room for cultural workers to enter South Africa and for South African artists to travel and work abroad, in consultation 'with the mass democratic movement and the national liberation movement'. (II.5).

The participants in CASA did not wallow in a romantic idea of a sort of *Volksgeist* formulated on paper. 'People's culture' is based on the universal principles of non-racialism and democracy, but exists because of the quality of equal cultural traditions and developments in all their diversity. CASA pledged 'to assert a humanist, internationalist but distinctly South African character of people's culture which draws upon the cultural heritage of all the people of the country' (II.2).

CASA expressly left it an open question as to what the 'distinctly South African character of culture' must be. The Conference sought ways to give room to the quality of culture of all the people of the country, in their diversity, on the basis of equality in a non-racial and democratic society. In such a society, with its past of colonialism and freedom, its present of apartheid and resistance, its future of democracy, culture thrives and in such a society the peoples of South Africa will show how 'distinctly South African' their culture is.

The CASA Preamble and Resolutions are remarkable historic moments in these latter days of apartheid South Africa. This holds too for the keynote address by Barbara Masekela, head of the Department of Arts and Culture of the ANC, the message from UDF and COSATU, and the address by Pallo Jordan on behalf of the National Executive Committee of the ANC. The press statement of the CASA Colloquium on Journalism and South Africa is an urgent address to the world, at a time when the apartheid regime still prevails, despite growing resistance to it. In view of the significance of the Freedom Charter, its text, along with the recently adopted ANC draft constitution, is included in this volume, a book which both commemorates a truly historic occasion and unveils to the world that rich 'other' culture which has flowered in South Africa, despite 40 years of apartheid oppression.

Preamble and resolutions of the CASA conference

I PREAMBLE

During the week of 14-19 December 1987, a conference of South African cultural workers organized by the Foundation *Culture in Another South Africa* (CASA) was staged in the anti-apartheid city of Amsterdam.

The CASA Arts Festival and Conference involved the participation of the Department of Arts and Culture of the ANC, the mass democratic movement in South Africa and the Anti-Apartheid Movement of the Netherlands (AABN).

After six days of extensive discussion, including thought-provoking papers covering every discipline of literary, graphic, visual and performing arts, the participants adopted the statement and recommendations below as their collective view of the place and the role of arts and cultural workers in the struggle for national liberation and democracy in South Africa:

1. That in the course of the struggle of our people against racist domination and exploitation there has developed a vibrant people's culture, rooted in South African realities and steeped in democratic values, in opposition to the racist culture associated with the apartheid regime. This democratic culture is characterized by a spirit of internationalism and a humanist perspective that derives from the best of the cultural heritage of the various peoples that make up the South African population.

214

2. That cultural activity and the arts are partisan and cannot be separated from politics. Consequently a great responsibility devolves on artists and cultural workers to consciously align themselves with the forces of democracy and national liberation in the life-and-death struggle to free our country from racist bondage.

3. That in order to play an effective role in the struggle, artists and cultural workers must create the appropriate organizational structures at the local, regional, national and international levels to enable themselves to take collective action, consult and coordinate their activities.

4. That within the developing democratic people's culture and the organized formations it creates, we must address all forms of oppression and exploitation, especially the triple oppression borne by the black women of our country as members of an oppressed gender, oppressed nationalities and exploited classes. Democratic culture should strive to be anti-sexist and consciously promote the norms of equality between men and women.

5. That the idiom of this democratic culture must strive for authenticity and be accessible to the mass of our people by speaking to them in language and symbols that they understand.

6. That to redress the scandalous discrepancies and disparities in skills, training and resources that are the direct consequence of racist policies, the democratic artists and cultural workers must promote a programme of affirmative action, both now and in the future, to enable black artists to take their rightful place in South African culture.

7. That the struggle for the total isolation of the apartheid regime must continue. Among the tactics to be employed during this campaign, the academic and cultural boycott are crucial, and must be maintained. However, in view of the growing significance of democratic culture as an alternative to the racist, colonialist culture of apartheid, the Conference recommends that South African artists, individually or collectively, who seek to travel and work abroad should consult beforehand with the mass democratic movement and the national liberation movement.

II RESOLUTIONS

1. On the role of culture and cultural workers in the struggle for a liberated South Africa

Recognizing
that culture is an integral part of the national democratic struggle;

the national democratic movement therefore asserts that the role of cultural workers is inseparable from the overall struggle against apartheid as well as the moulding of the future non-racial, non-sexist, unitary and democratic South Africa.

2. On people's culture

Recognizing
1. that apartheid culture is a tool of oppression intended to maintain the status quo and undermine the national democratic struggle; and
2. the emergence of a people's culture which expresses the social and political aspirations encompassing the artistic, intellectual and material aspects of culture in South African society;

we hereby pledge
to assert a humanist, internationalist but distinctly South African character of people's culture which draws upon the cultural heritage of all the people of the country.

3. On structures

Noting
1. the need for and desire of cultural workers to be organized into a national democratic organization to represent the interests of all cultural workers;
2. that the national democratic movement has a role to co-ordinate the formation and consolidation of cultural workers into local, regional and national structures in conformity with Resolution 1;

we hereby resolve
that a national democratic cultural organization be formed to cater for the cultural, social, political and economic aspirations of cultural workers in the national democratic movement; and

we hereby recommend
1. that this organization link up and liaise with existing organizations consisting of

South African cultural workers in exile which have similar aims and objectives;
2.1. that cultural workers represented at this conference consolidate and create organizations in their respective disciplines in consultation with the mass democratic movement;
2.2. that these organizations then meet to create a national organization of cultural workers.

4. On a collective approach to cultural work

Noting
the culture of the oppressors has encouraged a high degree of individualism amongst artists;

recognizing
that culture must be viewed in the context of people's struggle;

we therefore recommend
that cultural workers and artists be encouraged to work and develop collectively by sharing ideas, resources and skills with a view to enriching people's culture.

5. On the cultural boycott

Confirming
that apartheid South Africa must be totally isolated; and

noting
1. that the objective of the cultural boycott to isolate the regime is inviolate and needs to be pursued with even greater vigour;
2. the need to recognize and strengthen the emerging progressive and democratic culture in South Africa;
3. that the cultural boycott as a tactic needs to be applied with a degree of flexibility which takes into consideration the developing situation within the country;

we therefore resolve
1. that apartheid South Africa be totally isolated and that cultural workers and academics not be allowed to enter the country, save and except in those instances where such movement, after consultation with the national liberation movement, is considered to be in furtherance of the national democratic struggle;

2. that South African artists, individually or collectively, who seek to travel and work abroad should consult with the mass democratic movement and the national liberation movement.

6. On women and culture

Confirming
that women are integral to and have a vital role to play in our struggle; and

noting
1. that women are sexually and economically exploited;
2. that women are the victims of racist oppression and archaic patriarchal traditions and practices;
3. that South African women have historically waged a struggle against their triple oppression;

we demand
1. that progressive cultural organizations have a duty to accord equal status to women cultural workers and ensure their training and positioning;
2. that women assert themselves in all areas of cultural activity.

7. On religion and culture

Noting
the historical role of religion in the oppression of our people and the laudatory efforts of democratic theologians of various religions to play a meaningful role in the national democratic struggle;

we hereby resolve
1. to support the effort of all theologians struggling to find a meaningful way of expressing their faith in our struggle for a non-racial, non-sexist and democratic South Africa;
2. to call upon all those theologians to identify completely with the national democratic struggle of our people and to regularly consult with the national liberation movement and the mass democratic movement with a view to maintaining and strengthening the links between religion and the national democratic struggle.

8. On copyright

Noting
1. that our cultural workers have been and are economically exploited;

2. that our cultural workers have been kept in ignorance of the laws pertaining to copyright;
3. that plagiarism of our cultural heritage is increasing;
4. that the national democratic movement has a duty to document and preserve our cultural heritage; therefore,

we recommend
1. that our cultural workers organize themselves and act in concert whenever necessary to safeguard their interests;
2. that our cultural workers seek advice before committing themselves to contracts;
3. that the national democratic movement gives serious consideration to the concept of establishing alternative structures to secure the rights of cultural workers;
4. that the national democratic movement in conjunction with cultural workers commence with the documentation and preservation of our cultural heritage.

9. On funding

Noting
1. that organizations and structures within the national democratic movement require financial assistance in the pursuance of their cultural objectives;
2. that imperialist forces are continually attempting to undermine the national liberation struggle by, amongst other things, using funds to co-opt cultural workers, organizations and projects;

we hereby resolve
that financial assistance for cultural projects be solicited and obtained in consultation with the national democratic movement and that an art trust fund be formed to facilitate this process.

10. On language

Noting
1. that multi-lingualism is a characteristic feature of South African society;
2. that English and Afrikaans have taken on a disproportionate role in cultural production and communication because of their status as official languages;
3. that cultural workers have a special role to play in the preservation and development of all the languages of our country;

we hereby resolve
1. that all the languages of our country be accorded equal status;

2. that cultural workers be encouraged to use all the languages of South Africa in their work and that language training facilities be made available to spread the knowledge of South African languages.

11. On literature

Confirming
1. that writers play a role in shaping the cultural values of people;
2. that progressive writers are instrumental in the development of a democratic culture and political consciousness;

noting
1. the need to strengthen links between progressive writers within the national democratic movement;
2. that the recently constituted Congress of South African Writers (COSAW) is playing a vital role in the furtherance of our cultural struggle;
3. that poor educational facilities for the training of writers is a direct consequence of apartheid oppression and exploitation;
4. that the means of gathering, documenting and disseminating information and publications are almost exclusively controlled by the ruling class;

we hereby resolve
1. that links between COSAW and the national democratic movement be consolidated;
2. that links be formed between the progressive writers and the literacy programmes and that workshops be organized for the enhancement of training in creative writing skills;
3. that COSAW, in conjunction with the national democratic movement, establish libraries in both the rural and urban areas; the co-operation of publishers should be sought in this process.

12. On poetry

Confirming
that our people have a proud poetic tradition expressing their cultural values and norms, their history and aspirations;

we recommend
1. the continuing development of poetry as a mobilizing force in our people's struggle against apartheid exploitation, oppression and repression;

2. that competitions, workshops and symposia be organized to promote youth and children's poetry;

3. that our poets be encouraged to express themselves in their languages.

13. On media

Noting

1. the present assault on the democratic media by the apartheid regime;

2. the importance of informational media towards the development of a people's culture as well as the political mobilization of our people;

we hereby resolve

1. to internationalize the campaign to defend the progressive press in South Africa;

2. to build solidarity between South African media workers and those abroad;

3. to call upon governments and non-governmental organizations abroad to devise means to pressure the South African regime such as:

 a. reviewing the position of South African attachés in the light of repression in South Africa;

 b. curbing the practice of allowing foreign journalists to be used by the regime for its propaganda;

4. to call on the international community to insist on its rights to be informed and to evolve methods which ensure there is a constant flow of information into and out of the country;

5. that solidarity movements internationally should increase financial assistance to media projects within the national democratic movement;

6. that media workers should organize themselves into truly national and democratic structures;

7. that appropriate structures be set up in the country that will survive the state onslaught in the long term;

8. that media training be seen as a priority in all sectors and that women be incorporated fully into media projects.

14. On visual arts (incorporating graphics, film and video, photography, architecture, crafts)

Confirming
the importance of the role of visual arts in the democratic struggle;

noting
1. that posters and other graphics have made a significant contribution to advance
the national democratic struggle;
2. that architects and craftspeople are often inadvertently excluded from
conferences etc;
3. that craft is an essential part of our culture; and the erosion of our crafts'
traditions by, among other things, exploitation;
4. the power of film and television as a popular cultural medium and the need to
develop an authentic democratic film culture in South Africa, taking into account the
particular difficulties surrounding the financing of production and distribution of
film and television;
5. visual arts education in the black community is seriously undeveloped;

we call upon
visual artists to apply their skills and resources to further the national democratic
struggle; and

we recommend
1. that graphics directly associated with the democratic struggle, such as posters
and other art work, be further developed as our revolutionary art; and the resources
be allocated to this end;
2. that architects and crafts people be organized alongside other cultural workers;
3. that our cultural workers undertake the documentation and analysis of our
visual art in consultation with the mass democratic movement;
4. that archives be established and developed to record and preserve our work;
5. that cultural workers and the mass democratic movement urgently look into the
question of drawing crafts people into the cultural structures of the mass democratic
movement and into the production and distribution collectives;
6. that cultural workers commit themselves to the sharing of skills and resources in
the form of workshops and other progressive educational programmes in the
community.

15. On performing arts (incorporating theatre, music and dance)

Confirming
that the performing arts have been distorted and inhibited by co-option, censorship
and exploitation by the ruling class;

noting
1. historically the performing arts have been divided into two traditions — one
representing the interests of the apartheid regime and the ruling class, and the other

a true representation of people's culture and struggle;

2. that the performing arts have long been exploited by capital;

therefore we resolve

1. to restore the performing arts to their rightful role of both reflecting and being instruments of resistance to the apartheid regime;

2. to organize and unite the performing artists into national democratic structures which will, inter alia,

 a. protect performing artists against exploitation;

 b. conscientize and mobilize performing artists;

 c. produce progressive journals and literature;

 d. set up a progressive network of cultural products;

3. to secure funding towards providing training inside and outside the country, providing alternative venues, festivals and sponsorships;

4. to establish and develop archives to record and preserve traditional music, song and dance;

5. to secure as much performing space as possible by bringing existing venues into the fold of the progressive cultural organizations;

6. that the recommended structures urgently take steps to ensure the provision of adequate academic education for child performers and their protection against all forms of abuse and exploitation.

III CONCLUSION

The CASA Conference re-affirms that it is only through the implementation of the Freedom Charter by the mass democratic movement that we can fully realize a true Culture in Another South Africa.

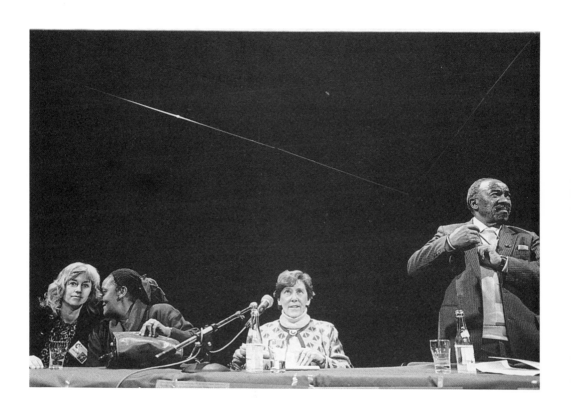

Minutes before the beginning of the CASA Conference. From left to right: Conny Braam
(president Anti Apartheid Movement Netherlands), Barbara Masekela (head Department of Arts
and Culture of the ANC), Mies Bouhuys (chairperson board of the CASA Foundation) and Alfred
Nzo (secretary general of the ANC). (Photograph by Lex van der Slot)

Minutes before the beginning of the Grand Gala Opening Programme of the CASA Festival,
Masters of Ceremony Surinamese singer and actress Gerda Havertong, who lives in the
Netherlands, and Dutch stage and film actor Jeroen Krabbé. (Photograph by Bertien van Manen)

Nkosi Sikelel' iAfrika (Pallo Jordan of the National Executive Committee of the ANC and others).
(Photograph by Fran van der Hoeven)

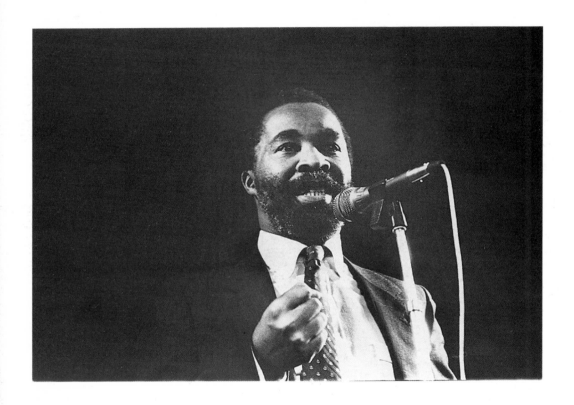

Thabo Mbeki (head Department of Information and Publicity of the ANC). (Photograph above by Pieter Boersma)
Faried Esack (representative of the UDF and Moulana of Johannesburg). (Photograph opposite by Wilma Kuyvenhoven.)

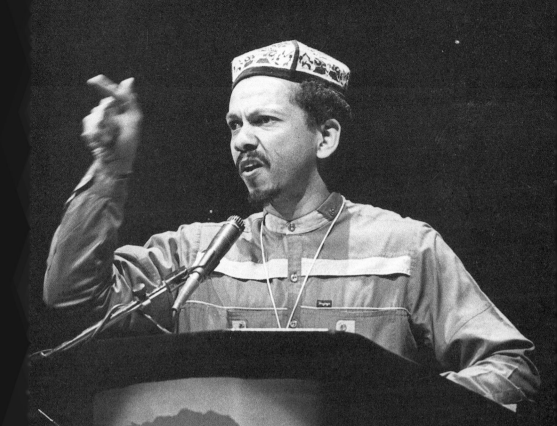

One of the many smaller CASA meetings: photographer Paul Weinberg opens a circuit of twenty exhibitions all over Amsterdam. (Photograph by Hugo Rompa)

CASA Exhibition in the Renaissance New Church at Dam Square in Amsterdam: 300 pictures that escaped the censor. (Photograph by Jan Voster)

CASA Colloquium 'South Africa and Journalism' in the City Hall of Amsterdam: presentation of the CASA Media Award to the South African weekly New Nation and its editor Zwelakhe Sisulu (in absentia). From left to right: Ed van Thijn (mayor of Amsterdam) and the two chairpersons of the Colloquium, Mono Badela (South African journalist) and Herman Bleich (Dutch journalist). (Photograph by Eduard de Kam)

Visit during CASA of the Achterhuis (the 'Secret Annex') of Anne Frank, symbol of the resistance against fascism, racism and antisemitism. From left to right: singer Mmabato Nhlanhla, poet Lindiwe Mabuza, poet Cosmo Pieterse. (Photograph by Eduard de Kam)

Religious service during CASA, with children of the Student Youth Drama Society (SYDS) from Soweto. (Photograph by Muriël Agsteribbe)

The children of SYDS singing during the CASA religious service. (Photograph by José Melo)

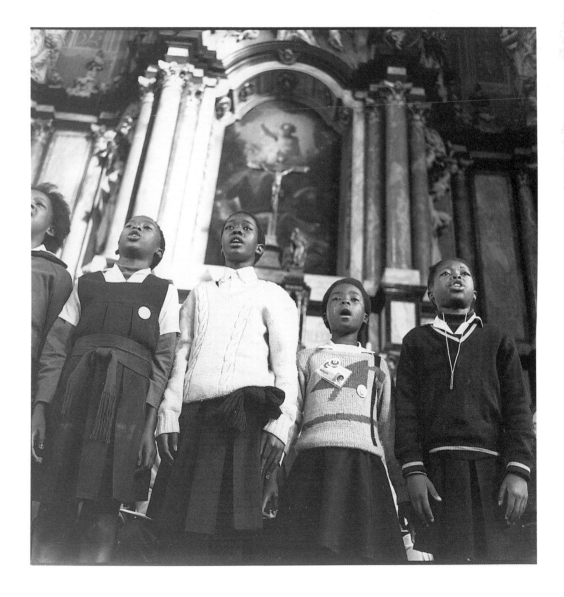

The children of SYDS from Soweto backstage in the Music Theatre, on their way to the performance. (Photograph by Bertien van Manen)

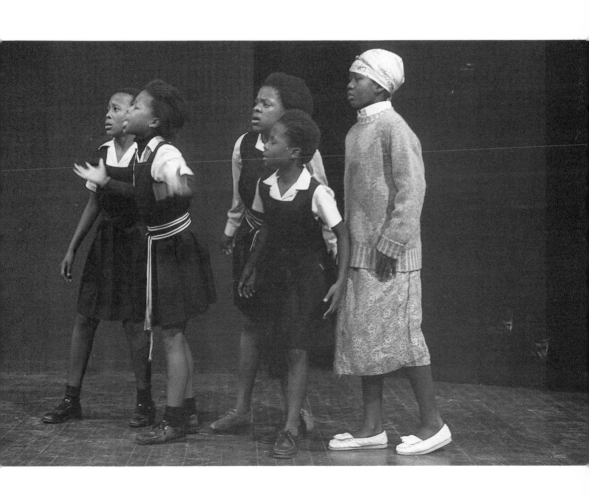

'Save the Children', by SYDS. (Photograph by Nicole Segers)

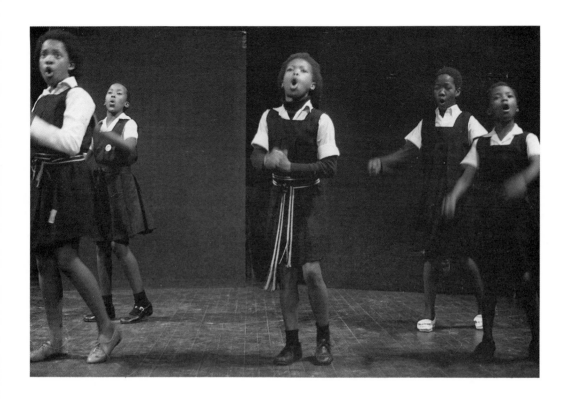

'**Save the Children**'. (Photograph by Nicole Segers)

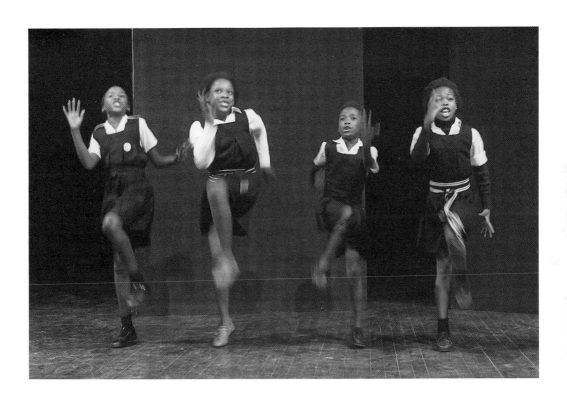

'Save the Children'. (Photograph by Nicole Segers)

'Save the Children'. (Photograph by Nicole Segers)

Freedom Charter

We, the People of South Africa, declare for all our country and the world to know:

that South Africa belongs to all who live in it, black and white, and that no government can justly claim authority unless it is based on the will of all the people;

that our people have been robbed of their birthright to land, liberty and peace by a form of government founded on injustice and inequality;

that our country will never be prosperous or free until all our people live in brotherhood, enjoying equal rights and opportunities;

that only a democratic state, based on the will of all the people, can secure to all their birthright without distinction of colour, race, sex or belief;

and therefore, we, the people of South Africa, black and white together — equals, countrymen and brothers — adopt this Freedom Charter. And we pledge ourselves to strive together, sparing neither strength nor courage, until the democratic changes here set out have been won.

The People Shall Govern!
Every man and woman shall have the right to vote for and to stand as a candidate for all bodies which make laws;

All people shall be entitled to take part in the administration of the country;
The rights of the people shall be the same, regardless of race, colour or sex;
All bodies of minority rule, advisory boards, councils and authorities shall be
replaced by democratic organs of self-government.

All National Groups Shall Have Equal Rights!

There shall be equal status in the bodies of state, in the courts and in the schools for
all national groups and races;
All people shall have equal rights to use their own languages, and to develop their
own folk culture and customs;
All national groups shall be protected by law against insults to their race and
national pride;
The preaching and practice of national, race or colour discrimination and contempt
shall be a punishable crime;
All apartheid laws and practices shall be set aside.

The People Shall Share In The Country's Wealth!

The national wealth of our country, the heritage of South Africans, shall be restored
to the people;
The mineral wealth beneath the soil, the banks and monopoly industry shall be
transferred to the ownership of the people as a whole;
All other industry and trade shall be controlled to assist the well-being of the people;
All people shall have equal rights to trade where they choose, to manufacture and
enter all trades, crafts and professions.

The Land Shall Be Shared Among Those Who Work It!

Restrictions of land ownership on a racial basis shall be ended, and all the land re-
divided amongst those who work it to banish famine and land hunger;
The state shall help the peasants with implements, seed, tractors and dams to save
the soil and assist the tillers;
Freedom of movement shall be guaranteed to all who work on the land;
All shall have the right to occupy land wherever they choose;
People shall not be robbed of their cattle, and forced labour and farm prisons shall be
abolished.

All Shall Be Equal Before The Law!

No-one shall be imprisoned, deported or restricted without a fair trial;
No-one shall be condemned by the order of any Government official;
The courts shall be representative of all the people;

Imprisonment shall be only for serious crimes against the people, and shall aim at re-education, not vengeance;

The police force and army shall be open to all on an equal basis and shall be the helpers and protectors of the people;

All laws which discriminate on grounds of race, colour or belief shall be repealed.

All Shall Enjoy Equal Human Rights!

The law shall guarantee to all their right to speak, to organise, to meet together, to publish, to preach, to worship and to educate their children;

The privacy of the house from police raids shall be protected by law;

All shall be free to travel without restriction from countryside to town, from province to province, and from South Africa abroad;

Pass Laws, permits and all other laws restricting these freedoms shall be abolished.

There Shall Be Work And Security!

All who work shall be free to form trade unions, to elect their officers and to make wage agreements with their employers;

The state shall recognise the right and duty of all to work, and to draw full unemployment benefits;

Men and women of all races shall receive equal pay for equal work;

There shall be a forty-hour working week, a national minimum wage, paid annual leave, and sick leave for all workers, and maternity leave on full pay for all working mothers;

Miners, domestic workers, farm workers and civil servants shall have the same rights as all others who work;

Child labour, compound labour, the tot system and contract labour shall be abolished.

The Doors Of Learning And Of Culture Shall Be Opened!

The government shall discover, develop and encourage national talent for the enhancement of our cultural life;

All the cultural treasures of mankind shall be open to all, by free exchange of books, ideas and contact with other lands;

The aim of education shall be to teach the youth to love their people and their culture, to honour human brotherhood, liberty and peace;

Education shall be free, compulsory, universal and equal for all children;

Higher education and technical training shall be opened to all by means of state allowances and scholarships awarded on the basis of merit;

Adult illiteracy shall be ended by a mass state education plan;

Teachers shall have all the rights of other citizens;
The colour bar in cultural life, in sport and in education shall be abolished.

There Shall Be Houses, Security And Comfort!

All people shall have the right to live where they choose, be decently housed, and to bring up their families in comfort and security;
Unused housing space to be made available to the people;
Rent and prices shall be lowered, food plentiful and no-one shall go hungry;
A preventive health scheme shall be run by the state;
Free medical care and hospitalisation shall be provided for all, with special care for mothers and young children;
Slums shall be demolished, and new suburbs built where all have transport, roads, lighting, playing fields, crèches and social centres;
The aged, the orphans, the disabled and the sick shall be cared for by the state;
Rest, leisure and recreation shall be the right of all;
Fenced locations and ghettoes shall be abolished, and laws which break up families shall be repealed.

There Shall Be Peace And Friendship!

South Africa shall be a fully independent state, which respects the rights and sovereignty of all nations;
South Africa shall strive to maintain world peace and the settlement of all international disputes by negotiation — not war;
Peace and friendship amongst all our people shall be secured by upholding the equal rights, opportunities and status of all;
The people of the protectorates — Basutoland, Bechuanaland and Swaziland — shall be free to decide for themselves their own future;
The right of all the people of Africa to independence and self-government shall be recognised, and shall be the basis of close co-operation.

Let all who love their people and their country now say, as we say here:

**'These Freedoms We Will Fight For
Side By Side, Throughout Our Lives,
Until We Have Won Our Liberty.'**

Adopted at the Congress of the People, Kliptown, on 26 June 1955.

Draft constitution of the ANC

The State

(A) South Africa shall be an independent, unitary, democratic and non-racial state.

(B) Sovereignty shall belong to the people as a whole and shall be exercised through one central legislature, executive, judiciary and administration. Provision shall be made for the delegation of the powers of the central authority to subordinate administrative units for purposes of more efficient administration and democratic participation.

(C) The institution of hereditary rulers and chiefs shall be transformed to serve the interests of the people as a whole in conformity with the democratic principles embodied in the constitution.

(D) All organs of government, including justice, security and armed forces, shall be representative of the people as a whole, democratic in their structure and functioning, and dedicated to defending the principles of the constitution.

Franchise

(E) In the exercise of their sovereignty, the people shall have the right to vote under a system of universal suffrage based on the principle of one person one vote.

(F) Every voter shall have the right to stand for election and to be elected to all legislative bodies.

National Identity

(G) It shall be state policy to promote the growth of a single national identity and loyalty binding on all South Africans. At the same time, the state shall recognise the linguistic and cultural diversity of the people and provide facilities for free linguistic and cultural development.

Bill of Rights and Affirmative Action

(H) The Constitution shall include a Bill of Rights based on the Freedom Charter. Such a Bill of Rights shall guarantee the fundamental human rights of all citizens, irrespective of race, colour, sex or creed, and shall provide appropriate mechanisms for their protection and enforcement.

(I) The state and all social institutions shall be under constitutional duty to eradicate race discrimination in all its forms.

(J) The state and all social institutions shall be under a constitutional duty to take active steps to eradicate, speedily, the economic and social inequalities produced by racial discrimination.

(K) The advocacy or practice of racism, fascism, nazism or the incitement of ethnic or regional exclusiveness or hatred shall be outlawed.

(L) Subject to clauses (I) and (K) above, the democratic state shall guarantee the basic rights and freedoms, such as freedom of association, thought, worship and the press.

Furthermore, the state shall have the duty to protect the right to work and guarantee the right to education and social security.

(M) All parties which conform to the provision of (I) to (K) above shall have the legal right to exist and to take part in the political life of the country.

Economy

(N) The state shall ensure that the entire economy serves the interests and well-being of the entire population.

(O) The state shall have the right to determine the general context in which economic life takes place and define and limit the rights and obligations attaching to the ownership and use of productive capacity.

(P) The private sector of the economy shall be obliged to cooperate with the state in realising the objectives of the Freedom Charter in promoting social well-being.

(Q) The economy shall be a mixed one, with a public sector, a private sector, a co-operative sector and a small-scale family sector.

(R) Co-operative forms of economic enterprise, village industries and small-scale family activities shall be supported by the state.

(S) The state shall promote the acquisition of management, technical and scientific skills among all sections of the population, especially the blacks.

(T) Property for personal use and consumption shall be constitutionally protected.

Land

(U) The state shall devise and implement a land reform programme that will include and address the following issues:

Abolition of all racial restrictions on ownership and use of land.

Implementation of land reform in conformity with the principle of affirmative action, taking into account the status of victims of forced removals.

Workers

(V) A charter protecting workers' trade union rights, especially the right to strike and collective bargaining, shall be incorporated into the constitution.

Women

(W) Women shall have equal rights in all spheres of public and private life and the state shall take affirmative action to eliminate inequalities and discrimination between the sexes.

The Family

(X) The family, parenthood and childrens' rights shall be protected.

International

(Y) South Africa shall be a non-aligned state committed to the principles of the Charter of the OAU and the Charter of the UN and to the achievement of national liberation, world peace and disarmament.

Adopted by the National Executive of the ANC, 1988

Keynote address

on behalf of the Department of Arts and Culture of the ANC

by Barbara Masekela

In this year of the 75th anniversary we salute you in the name of the ANC and congratulate you for all the risks, sacrifices and varied contributions you have made towards the *Advance to People's Power* in our beloved country. This, a conference and festival for anti-apartheid cultural workers, comes five years after two historic cultural festivals, namely *Culture and Resistance* organized by the Medu Cultural Ensemble in Gaborone in July 1982, and the *Cultural Voice of Resistance* — Dutch and South African Artists Against Apartheid in December 1982.

Among cultural activists who were the key participants in these festivals are some who are no longer with us: Thami Mnyele, our magnificent people's artist, whose life is a monument and example of the best we can attain, cut down by the murderous SADF commandos in Botswana 1985; James Madhlope Phillips, Johnny Dyani and Kingforce Silgee, to mention a few. We remember them now for their illustrious contribution and take a minute's silence in honour of their spirit which can never be vanquished.

This festival opening is an occasion for paying tribute to the meritorious work done to achieve our common ideals. It is also necessarily a time for humble assessment of the objective we have set ourselves of eradicating the apartheid monster which feeds so greedily on diversion, division and manipulation. This effort is a powerful reminder of our own potential as cultural activists and solidarity workers, hand-in-hand. We must express our deep appreciation for

this chance of reunion and discussion with our Dutch counterparts and the all too brief but enormous opportunity to embrace our brothers and sisters, our compatriots who come from the frontline of politico-cultural resistance, who in their daily confrontation with apartheid, are still decorated with the scars and stars of courage, determination and sacrifice displayed daily by all our people in struggle. Comrades, your example is an inspiration to us and your patriotic performance strengthens our own dedication to our joint just cause and the task we have set ourselves to create a united, democratic, non-racial South Africa.

We can never be exiled from our homeland because daily your songs, your poems, your plays, your paintings and films — magnificent manifestations — keep our attention riveted to our inevitable freedom. Through your excellent work the reality of the ANC presence is now even acknowledged by our enemies.

We would rather that the scene of this festival had been closer to the battlefront and indeed, for some of us here, it may have been cause for concern that we must meet in the Netherlands from whence the ships of colonialism sailed to exploit our people 335 years ago.

Notwithstanding, this meeting confirms our conviction in the oneness of the human race and that colonialism is not of the Dutch people in general, that the resistance against apartheid is not of black South Africans only. Rather, that colonialism and the support of apartheid is designed by specific groups that sought and still seek to gain from exploitation, oppression and other forms of barbarity.

Thus, we are here, because our friends and supporters in The Netherlands, in common with the majority of humankind, have taken a principled stand against apartheid and have constituted themselves into a significant component of the pillar of international solidarity. Nonetheless, the major thrust is on the shoulders of the South African people, who value the complementary efforts of international solidarity.

Our gathering here, to share in and have discourse on the burgeoning alternative culture in the making of South Africa, is also an acknowledgement of the integral contribution made and still to be rendered by cultural workers in the bitter struggle ahead. It constitutes part of the seeding that will bring about 'another' South Africa.

The theme of CASA underlines the dichotomy of apartheid South Africa, which, in its dying fits, is vainly struggling to throttle the birth of a democratic, united, non-racial South Africa, refusing to yield to the inevitable.

But that which is already fully formed and shaped will emerge against all odds. It is the law of nature and as one of our poets has sung, 'To every birth its blood'. The real South Africa, struggling to be born, is represented by the fighters of freedom, the popular spirit of resistance and self-affirmation. That real South Africa is seen in the strong emergence of the mass democratic movement that straddles every aspect of South African life and culture today. So that in education, the workplace, the churches, even in the enemy camp, there is today evidence of this encompassing, inclusive culture of liberation. The dying social system which seeks to pull everyone into the murky bottoms of antiquity, which does not represent the best of South Africa or Africa, is an inhumanity which has been progressively rooted out. That the two South Africas are not defined by geography or skin colour is daily becoming a vindication of the ANC position that South Africa belongs to all who live in it. While the overwhelming majority of the oppressed have chosen to fight for and build a new South Africa, the spirit of resistance is also filtering into the former strongholds of white supremacy. Reality dictates that ultimately those who have enjoyed the privileges of white South Africa must cast their lot unequivocally with the oppressed, in word and deed. Unarguably this will hasten the demise of apartheid and the establishment of a new order.

We are a generation that has witnessed the birth in the sub-region of Angola, Mozambique and Zimbabwe. We know of the apartheid efforts to nullify the hard-won independence and sovereignty of these states because of what they represent and because they support our cause. Certainly we are also products of an era when economic and political destabilization, when military aggression is commonplace. We are also familiar with the impunity with which apartheid causes mass hunger and famine, massacres, and dislocation. The apartheid tactics of divide and rule, paternalism, promotion of negative traditional customs and the co-option of collaborators as a buffer system — all these are carried out in a 'constructive engagement' with those Western powers who bolster and support them. Indeed, it is a wonder and achievement, that in the face of such concentrated racist sway we have never succumbed to racial solutions. The challenge of these grim conditions of necessity dictates that we cultural workers are freedom fighters first, that political reality be the mirror in which we reflect our creativity. Thus, we are an integral part of the overall struggle, not artists who merely contemplate on the cataclysms of our era. Our art springs directly from the experiences that have been moulding our national consciousness over the centuries to the present. Now, at the brink of the dawn of our freedom, in the process of becoming, it is essential

that, as our President has stated when dealing with the role of cultural workers in his 8 January 1985 address: 'Let the arts be one of the many means by which we cultivate the spirit of revolt among the broad masses, enhance the striking power of our movement and inspire the millions of our people to fight for the South Africa we envisage'.

As the tactics of our enemies become more refined and also more brutal, so must we call on all our reserves of strength and creativity to make the day of triumph come sooner. Our resistance today is built on the cumulative experience of our forebears from the ancient Khoi-khoi and Nama to Sekhukhune, Moshoeshoe, Makana, to the giants of the present, Mandela, Sisulu, Kathrada and our other political leaders in the resurgent mass democratic movement. Recently we have witnessed the release, after 23 years of imprisonment, of Govan Mbeki. Last Friday Govan Mbeki was placed under a strict banning order by the racist regime. The banning of Govan Mbeki makes a mockery of his supposed unconditional release. Clearly, the welcome accorded him on his release by the people has frightened the racists.

However, it is not an accident that Plaatje, a writer, or Vuyisile Mini, a composer, were also political activists. It is in the tradition of our history of resistance. We have not invented revolution and we have never imitated (nor shall we ever imitate)

the presumptiousness of the unwashed voyagers of the colonial era who claimed to have discovered what was already there and commonplace to the owners of the land. That is why it is customary in our culture that on great days of celebration or observance, the *mlbongi* always praised the ones who charted the path before them. The performances, exhibitions, discussions at this festival are in no small way a praise song to our predecessors. They are also an encouragement and spur on the long and difficult journey ahead.

At the present moment there are various organizational forms for progressive people's artists. We need to address the question whether they are reaching the people, whether they represent the majority of patriotic artists and serve to accommodate the needs of groups at various levels of consciousness. It is pertinent that in the late sixties and early seventies it was the Black Consciousness cultural awakening which emphasized the building of self-confidence and the national spirit of the oppressed. The positive contribution of this movement has been acknowledged by the ANC. In a statement issued after the Second Session of the ANC's National Executive Committee meeting in 1973, our Secretary-General pointed out that:

'The assertion of the revolutionary identity of the oppressed black peoples is

not an end in itself. It can be a vital force of the revolutionary action involving the masses of the people, for it is in struggle, in the actual physical confrontation that the people gain a lasting confidence in their own strength and in the inevitability of final victory — it is through action that the people acquire true psychological emancipation.'

Happily, we can now say with confidence that with the workers, students and many other sectors these words have become true. Is this also a fact for the cultural sector? Of course we are aware of our own traditional attitudes towards artists as well as the apartheid regime's monopoly and control of culture that have impeded the development of an authentic 'people's culture'. But we are greatly encouraged by the fine work of the relatively young UDF Cultural Desk and the COSATU Cultural Structures. The formation of COSAW (Congress of SA Writers) is also a happy addition to these forces. We hail these efforts and have confidence in their strength. The work of organizing cultural workers is on its way but a major part of the tasks still lies ahead of us. To break down certain assumptions about artists, we have to guard against sometimes raising our own consciousness to a fetish. We must eschew exclusivism or arrogance lest we alienate potential activists. We also need to guard against relegating to irrelevance the contribution of our white democratic compatriots. We must

encourage the trend of Afrikaner cultural workers of the past and present, take cognizance of and support their efforts to identify with the national democratic struggle.

Cultural workers being of and for the people cannot merely assume the role of teaching or prescribing for the people. We can learn from the overall activity of the people and, on occasions when they seem slow to respond, then we must exercise patience and persuasion because mobilization, political education and involvement differs and it takes more time than the coercion that is the overwhelming characteristic of the enemy.

As comrade Alfred Nzo, Secretary-General of the ANC, has pointed out:

'The speed of a column on the march is determined by the pace of the slowest and weakest soldier and not the fittest and fastest. The most advanced sections should therefore at all times seek to advance the least developed ones, keeping in the fore-front the principle of the greatest and highest unity of the people and at all times fighting against all tendencies of seeking to "go it alone" through impatience and contempt for the less developed forces of the revolution.'

Logically this statement infers that the advance contingent of cultural workers — many of whom are here today — should of necessity move at the pace of our people.

254

The work of an artist is mirrored in the popular response of the masses and the latter would gain a lasting confidence in their own strength and in the inevitability of final victory.

People's culture, born of cross-pollination among the artists and the people themselves in the democratic mainstream of socio-political and economic change, is a growing dynamic process which is defined by subjective and objective circumstances. It is a scientific growth in the conduct of struggle that determines and paves the way towards the assumption of people's power. For instance, *marabi, mbaqanga, micathamiya, kwela,* are today universally accepted as authentic South African peoples' art forms, but it was not always the case. Their practitioners were at one time despised and shunned, and at other times completely 'buried' by the notorious Gallo and other institutionalized capitalist-orientated recording companies. It is precisely due to the development of the struggle, the involvement of the masses of our people that these art forms have now been given their rightful place in our people's culture.

Given what our President has referred to as the changing balance of strength in our country and the shift of strategic initiative into our hands, there is, therefore, a sense in which the apartheid forces are becoming the opposition by unleashing indiscriminate violence upon the ascendant democratic movement, rather than the other way round. The advancing forces of a new social order in our country — of which you are part — as against the degenerating and collapsing machinery of apartheid, are moving at a pace apartheid finds difficult and impossible to reverse. We must, as President O.R. Tambo exhorts, 'move from a position of an indestructible force to a conquering force'.

It is a critical situation which requires vigilance on our part against complacency and arrogance. The gains made must be guarded and augmented. Among these gains has been the success of the cultural boycott of apartheid South Africa. Due to the emergence of alternative structures which are actively implementing the boycott inside our country, and the complementary actions from the international anti-apartheid movement, there are relatively very few foreign artists at the moment coming into South Africa to perform. The few mediocre artists prepared to earn bloodstained money are still lured by the lucrative contracts offered. There is no doubt as to the origin of this collaborative funding. However, it can no longer be concealed that a fully fledged democratic culture is in place in South Africa, as stated by our President, 'a definable democratic culture — the people's culture — permeated with and giving expression to the deepest

aspirations of our people in struggle immersed in the democratic and enduring human values'. Referring to the cultural boycott issue, President Tambo in his recent ground-breaking analysis at the Canon Collins Memorial Lecture stated that:

'The core of cultural workers engaged in creating this people's culture are simultaneously engaged in developing our own institutions and structures which are aligned to the mass democratic organizations in our country.'

He therefore concludes that:

'This is our position that those who belong to the category of dedicated fighters of a genuine and democratic culture should not be boycotted but should be encouraged and be treated as democratic counterparts within South Africa and similar institutions and organizations internationally.'

What this conference urgently needs to consider are the methods and means to realize the fullest achievement of our revolutionary cultural objectives which are at the core of our overall struggle. Let us exhaust ourselves in the service of all our people as cultural workers with a vision of another South Africa, a united, non-sexist, non-racial South Africa. Let us work tirelessly for a new South Africa.

Amandla!

Message

From COSATU and the UDF

Comrades and combatants,

It is only two days since one of our major cultural workers, Zwelakhe Sisulu, completed a year behind bars. It is also two days since comrade Govan Mbeki was banned. From what we have gathered he is now restricted to Port Elizabeth and cannot be interviewed even by the foreign media.

However, we the cultural workers would like to reiterate our stand that all such panic-stricken efforts cannot stop our struggle for justice and peace.

Comrades and combatants, the CASA Conference could not have come at a better time, when the mass democratic movement at home has identified culture as one of the remaining terrains from which to pursue our fight against racism, imperialism and sexism.

For years back, in South Africa, the role of cultural workers has been left in the hands of unscrupulous, exploitative elements who have used it to manipulate, hoodwink and divide the people.

However, with the strong emergence of COSATU's Cultural Unit and the UDF's Cultural Secretariat, there is a good basis for a Freedom Charter Cultural Secretariat which will hasten the demise of apartheid culture. This secretariat will encourage and enhance culture on all levels, from the factory floor, educational institutes, townships, hostels, mines and wherever our people are. Because it is the people in those areas who for years have been pushing at the doors of learning.

It is these people who have witnessed the brutality of oppression by the ruling-class culture — a culture that kills and maims, as witnessed both at home and in the neighbouring states; a culture which has turned the wombs of South African women into factories to produce cannon fodder for the fascist regime; a culture which has immunized our children from

the gory nature of violence; a culture which denies the people the right to know the truth; a culture which breeds rapists and gangsters among the oppressed; a culture which enhances and reinforces a feeling of subservience. This is a culture which idealizes imperialism, oppresses the mind and is leaving our creativity in chains.

It is the above-mentioned which has driven the people of South Africa to obliterate fascist culture and substitute it with popular people's culture. This is reinforced by the slogan 'people's education for people's power'.
Cultural workers at home see popular culture as a vehicle, not to dominate or exploit, but to liberate the mind. It is culture to create a new person in a new society with democratic values — a culture which espouses non-racialism, anti-imperialism and non-sexism as cornerstones of a just South Africa; a culture which respects our forebears, our heroes both fallen and alive; a culture which is not alienated from the peace-loving people in other parts of the world.

While apartheid culture continues to divide and isolate the people — not only inside South Africa but from the rest of the international community — the mass democratic movement is making immeasurable gains in its efforts to create a unitary, non-racial and democratic South Africa. It is the mass democratic movement which will continue to

relentlessly resist the apartheid regime with its fascist allied forces in the western world and those African states who up to today have failed to take a progressive stand against fascism. Such resistance and determination will continue despite the scores of our warriors who are languishing in jail.

Comrades and combatants, our tree of liberation grows stronger with the blood of every martyr that waters it. And the lions of the mass democratic movement have bravely adopted the slogan: 'freedom or death — victory is certain'. And so long as that slogan stands, the justice-loving people of South Africa will continue to defend what is right, consolidate their ranks and advance towards the total eradication of the fascist regime and its culture.
Comrades and combatants, your sacrifices and support, wherever you are, have strengthened and continue to strengthen our endeavours for an alternative South Africa. The date of the birth of a South Africa we are aspiring for shall be brought closer by all our collective efforts, as witnessed by this historical CASA Conference.
This Conference is testimony to us that the international community loathes apartheid and its perpetrators and has identified an alternative to an illegitimate government.

Forward to people's culture and people's power!

Keynote address

on behalf of the National Executive Committee of the ANC

by Pallo Jordan

Comrades and friends,

We are pleased to be here in Amsterdam today, a city which has such close historic links with our country. These links in the past were occasioned by the Dutch settlement set up by van Riebeeck some 300 years ago — they were links of oppression. Increasingly today we have begun to forge new links not only with the city of Amsterdam, but with the people of the Netherlands as a whole — links based on our common commitment to the struggle for liberation, social justice and democracy. The hosting of this CASA Conference and Festival by the city of Amsterdam is a concrete expression of these new links; as is the Dr Govan Mbeki Fellowship whose seat is the University of Amsterdam. We greet the anti-apartheid city of Amsterdam and wish to place on record our profound appreciation of the hospitality it has shown us.

I speak today on the subject of culture, not in order to lay down an 'ANC line on culture'. My remarks today should rather be read as part of continuing dialogue amongst cultural activists, committed to the national democratic struggle in our country, to define jointly more clearly the role we would like culture and cultural workers to play in that struggle. If a 'line' has to be pronounced, it is our hope that such a 'line' will emerge from our collective endeavours here and not as an *ex-cathedra* pronouncement from the ANC leadership.

The topic I am presenting here today has been the subject of many conferences in the past, and will probably continue to exercise the minds of others after today. I therefore make no apology for having to repeat what others have said before me. I will beg your indulgence, Comrades, while I recount two tales which I think are most

259

instructive with respect to the topic we are examining. The first of these tales is drawn from our indigenous literary traditions, the second derives from the ancient Greek tradition.

The African tale is called *Sikhamba-nge-Nyanga* (She-Who-Walks-by-Moonlight). According to this tale, there lived in a village a very beautiful maiden, whose beauty was so extraordinary that when she was abroad during the day, the herd boys would not drive the cattle to pasture; the men and women would be so enraptured by her beauty they would not go to the fields to hoe. She was therefore forbidden to come out during the day and was only permitted to go abroad at night, 'by moonlight', when the day's tasks had been completed.

The Greek tale is derived from Homer's *Odyssey*. Odysseus, one of the Greek kings returning from the sack of Troy, had to sail his ships past the islands inhabited by the Sirens. It was said that the Sirens, mysterious women, sang such a disarmingly beautiful song, so distracting the sailors from their responsibilities aboard ship that their ships drifted into the treacherous reefs surrounding the islands. Odysseus had fortunately been warned of these dangers. In order to pre-empt them he ordered his men to stop up their ears with wax. He, however, wished to hear the Sirens's song. He therefore instructed his men to tie him fast to the mast. The upshot was that the sailors rowed steadily past the islands of the Sirens. Odysseus, tied to the mast, heard the song, was overcome and called to his men to untie him. But of course they could not hear him. When the danger had passed, they released him.

Both these tales derive from societies that no longer exist. The first was composed in the pre-colonial African societies of South Africa. The second comes from the ancient Greek societies, but both tell us something about how culture and cultural activity were regarded by both. Both see culture and cultural activity as an important human activity, which despite its importance was an activity which needed to take second place in the affairs of humanity. First place was accorded to the essential tasks relating to securing the means of livelihood. Cultural activity had thus to be deferred until these tasks had been completed. Hence, the extraordinary beauty of *Sikhamba-nge-Nyanga* could only be contemplated at night.

The Greek tale, however, has a second dimension of which we must not lose sight. Unlike pre-colonial African societies in South Africa, ancient Greek society was dominated by a class of slave masters, from amongst whom were drawn their kings, nobles and statesmen. Being owners of slaves, these men, like Odysseus, were exempt from labour because others worked for them. On his ships Odysseus, as king, was exempt from

rowing. He was, therefore, in a position to listen to the song of the Sirens. But this was a privilege he could enjoy only if first rendered powerless to interfere with the priority task of rowing the ship to safety. And so he was tied to the mast. Odysseus could then enjoy the music of the Sirens, but at the expense of his men whose stopped up ears enabled them to row the ship, Odysseus aboard, to safety.

The significance of the social relations between Odysseus and his sailors will become more evident later in the course of my contribution. Suffice it to say for the present that in societies divided into superordinate and subordinate classes, access to culture and the product of cultural activity are inequitably distributed.

The ANC and its allies classify South Africa as a Colonialism of a Special Type in that the colonial power and the colonized people occupy the same territory. As a result of this historical fact, two perspectives have grown up in South Africa regarding the solution of the national question. The one, associated with the apartheid regime, and to one degree or another, the various white political parties, regards the diversity of South African society as a source of conflict, which conflict can only be resolved by the white minority exercising domination over the majority black population.

Pursuance of this perspective has required successive white regimes to corrupt, distort and suppress the cultural heritage of the oppressed for purposes of domination. Simultaneously they have been compelled to denude the cultural traditions deriving from Europe of what is best in them and reduce them to parochial horizons as the exclusive property of persons of European descent. I do not feel it is necessary to expand on the effects of these practices to this audience.

The opposing perspective, which is historically associated with the national liberation movement, accepts that history has brought together on the territory of South Africa people who trace their roots to three different continents — Africa, Asia and Europe. The national liberation movement has consistently held to the view that it is not only impossible, but also undesirable, to try to unscramble this historical omelette. We say that the very fact of sharing a common territory has set in train an irreversible historical process — whose consequences are Black and White engaged in a common economy and therefore creating a common society. This is the true meaning of the preamble to the Freedom Charter . . . *that South Africa belongs to all who live in it . . .*

We argue that, though our people came from differing ethnic and racial backgrounds, having been thrown together on South African soil, they are

collectively engaged in creating something qualitatively new. This emergent quality, we say, is a South African people. The national liberation movement has therefore advocated the nurturing and development of a common spirit of South African patriotism which is rooted not in ethnic, racial, religious or linguistic identity, but rather in the variety and diversity of South African society. As opposed to the overt and covert white supremacists, we regard this variety not as a source of conflict but as a source of immense strength and cultural wealth. That these two perspectives are irreconcilable is self-evident. Indeed their irreconcilability lies at the heart of the life and death struggle between freedom and oppression.

Speaking in this same theatre in 1976, the late Comrade Alex La Guma said, *inter alia,* that 'life is the criterion through . . . which the artist's imagery and literary observations are evaluated . . .' Central to the life of the human race has always been the struggle of humankind to change its social, economic and political life. 'Life', therefore, embraces the struggle for liberation — to liberate humankind from the forces that inhibit its development. If we accept as a virtue the diversity and rich variety of South African culture, the realization of its potential has become inextricably bound up with the struggle for freedom and democracy. During the past days,

especially during the Gala Opening Night, we have all seen how great that potential is. This culture of the other South Africa is the culture of democracy, the wave of the future.

No one can dispute the extreme elegance, grace and beauty of this democratic culture. Yet we must say, it is not a hothouse plant. It is a gnarled, tough, stubborn, though very beautiful plant, rooted in the richness of our African soil. It has over generations been lovingly tended by thousands of artists and cultural workers, sprung from the loins of our people. They have watered it with their tears, their sweat and their blood. It is tough because it has grown up in and as part of the struggle.

This emergent democratic culture, though it is distinctly South African, is not now nor has it ever been animated by a spirit of shallow chauvinism. It openly acknowledges its debt to other cultural traditions and prides itself not only on its capacity to absorb and learn from others but also its capacity to teach others. It is infused with an internationalist spirit and a humanist perspective. For inspiration it draws as much from Sipho Sidyiyo, John Knox Bokwe, Mackay Devashe as from Mozart, Ravi Shankar, Charlie Parker and Duke Ellington; its writers display the influence of Shakespeare and Samuel Mqhayi, of Victor Hugo and Richard Dhlomo, of Maxim Gorky and Sol Plaatje;

its graphic and plastic artists blend indigenous traditions and schools with those from abroad. Nothing human is alien to it. By weaving all these bright and vivid threads into the already rich tapestry that is our South African culture, they change them while further enriching our own.

Yet, much as this is the culture of all South Africans, the numerical preponderance of the African majority has left an indelible stamp on it, both in terms of the artists who have contributed to its growth and the aesthetic values to which it subscribes.

The institutions of apartheid colonialism would indeed be easy to overthrow if they were sustained by ideology alone. The power of the system of racist domination is vested in and entrenched through the ownership and control of productive property. It is in this context that we can more clearly discern the relevance of the tale of Odysseus recounted at the beginning of this contribution. Control over financial resources, over industrial plant, over technical inputs, access to theatres and studios is the real moral of the so often told tragic story of the musician, poet and playwright who dies in the gutter, having been milked dry by the modern day Odysseuses. It is my contention that, in order to deliver on the Freedom Charter's promise that 'The Doors of Learning and Culture Shall be

Opened' it requires that we address the inordinate power wielded by a tiny handful of corporations over the wealth of our country.

In apartheid-dominated South Africa it is those who own and control the mines, the banks, the commercial farms, the factories, the newspapers, the publishing houses, the recording studios and theatres who monopolize and determine the main direction of cultural production. In this sense culture is very much a terrain for political and social struggle. In the words of Maxim Gorky, it is a partisan weapon that 'can be wielded for or against injustice'.

In the struggle for liberation the democratic cultural worker and artist occupy a singularly important position in our ranks. In the words of Comrade President O.R. Tambo, they must:

'use their craft to give voice not only to the grievances, but also to the profoundest aspirations of the oppressed and exploited. In our country a new social and political order is being born. Our artists have to play an even bigger role as midwives of this glorious future.'
'Let the arts be one of the many means by which we cultivate the spirit of revolt among the broad masses, enhance the striking power of our movement and inspire the millions of our people to fight for the South Africa we envisage.'

The task of the democratic artists is to define, through their art, the political and social vision of the democratic majority. In order to do this, they must fuse with the democratic movement and the concerns of the mass of our people.

Over the past four years we have witnessed the transfer of the strategic initiative from the hands of the regime to the democratic forces. As we have seen, in many instances this has assumed a quite palpable form in the shape of alternative institutions of popular power. This changed balance of forces has driven the regime into a reactive posture — unable to determine the direction of events. The cultural sphere must increasingly also begin to reflect this change as well through the creation of alternative cultural centres, reinforcing and complementing the work of the UDF and COSATU Cultural Desks. We commend the writers and musicians who have already constituted such bodies in their respective disciplines. We would urge the coalescence of these into a federation of artists and cultural workers nationwide.

We need to address also the issue of the cultural and academic boycott. From the time when Chief Luthuli called upon the international community to impose sanctions against apartheid South Africa, the cultural and academic boycotts were conceived as instruments for the isolation of the racist regime. In effect, the democratic movement fighting for freedom

in our country was calling upon the rest of the world to join us in isolating the regime internationally, just as we were seeking the regime's total isolation within the country. This objective — the total isolation of the regime and its supporters — remains unchanged.

Yet there is intense debate today about the validity and the wisdom of the cultural boycott. Ironically, this comes at a time when the Pretoria regime stands more isolated than at any other. This paradox is occasioned by precisely the advances the democratic forces have made inside the country. The emergence of a definable democratic culture — permeated with and giving expression to the aspirations of our people in struggle — is one of the features of these advances. It is development that occurs in the midst of the emergent institutions of popular power, whose duty includes drawing on the academic and cultural resources of the entire world to strengthen the cause of democracy in our country. In the words of Comrade President Tambo, in his Canon Collins Memorial Address:

'Without doubt the developing vibrant culture of our people in struggle and its structures need to be supported, strengthened and enhanced. In the same way as apartheid South Africa is being increasingly isolated internationally, within South Africa this people's culture is steadily isolating the intellectual and cultural apologists of apartheid.

'Indeed the moment is upon us when we shall have to deal with the alternative structures that our people have created and are creating through struggle and sacrifice, as genuine representatives of these masses in all fields of human activity. Not only should these not be boycotted, but more, they should be supported, encouraged and treated as the democratic counterparts within South Africa of similar institutions internationally.'

Comrades and friends,

Permit me to make so bold as to propose that this CASA Conference act as the first forum at which South African artists and cultural workers, in conjunction with the mass democratic movement, the ANC and elements of the international solidarity movement, hammer out a common approach as to how we apply these principles.

In conclusion, permit me to address a special word to the family of South African artists and cultural workers, both those in the frontline trenches of the struggle at home and those who have been forced into exile to pursue their craft. The ANC does not ask you to become political pamphleteers. There are a number of those, though we need more. The ANC does not require poets to become political sloganeers, the walls of South Africa's cities testify to our wealth in those and the mastery they have of their craft. While we require propaganda art, we do not demand that every graphic artist and sculptor become a prop artist. We would urge our artists to pursue excellence in their respective disciplines — to be excellent artists and to serve the struggle for liberation with excellent art. But let us remember also that the future imposes grave obligations on us all — artists and non-artists alike. These obligations can be best expressed in the worlds of a poet, Cosmo Pieterse:

'I sometimes feel a cold love burning,
Along the shuddering length of all my
 spine;
It's when I think of you with some kind
 of yearning,
Mother, stepland, who drop your litter
 with a bitter spurning.'

Press statement of the CASA colloquium on South Africa and journalism

We, the South African journalists gathered at this CASA Colloquium, consider that the picture of South Africa presented to the world by the South African and international media is not the true picture.

It is a picture distorted intentionally by the South African state and sometimes unintentionally by the media itself.

The state's interest in distorting the picture is obvious. We believe the international media distorts the picture of South Africa by giving undue weight to the interpretations and perspectives of the state — the very people responsible for perpetuating minority racist rule. The opinions of the Pretoria government are not entitled to the weight conventionally and correctly given by journalists to the opinions and attitudes of democratic governments — opinions and attitudes which have the weight of majority support behind them.

South Africa is a complex society, but not a unique one and we ask that journalists covering the 'South African story' embody within their work the values and norms they would expect in journalism in their home countries. South Africa and its people are entitled to be judged and interpreted by journalists in terms of accepted democratic principles.

The South African story is not a set of sensational events concerning what Pretoria calls 'black-on-black violence' and 'reform'. Nor is it a series of body counts. It is a

story of a repugnant society and attempts to transform that society. It is an ongoing story requiring consistent coverage and analysis.

This is not a call for journalists throughout the world to practise biased, skewed or advocacy journalism. It is precisely the opposite. It is an appeal for unbiased and undistorted coverage guided by those democratic principles adhered to in their own countries.

These principles include:
— the right freely to inform and to be informed
— the right to live peacefully in a non-racial democratic society based on universal franchise.

As journalists we believe we are entitled to live and work in a society based on those principles. And we believe that only in a society based on those principles is a truly free South African press possible.

We would also like to take this opportunity to thank those responsible for organizing this colloquium enabling us to meet and discuss these issues freely. Our discussions were limited by the absence of some of our colleagues prevented by Pretoria, in various ways, from attending.

Amsterdam, December 11, 1987.

Resumé

Afrikaans

'The doors of culture shall be opened','Die deure van kultuur sal geopen word' is die uitdrukking wat sedert 1955 in die Vryheidshandves (Freedom Charter), die manifes van die African National Congress, die Suidafrikaanse bevrydingsbeweging, gebruik word. Kultuur speel 'n baie belangrike rol in die daaglikse stryd wat die ANC, UDF, COSATU, die kerke en talle kunstenaars teen apartheid voer. In die gees van die Verenigde Volke se Universele Verklaring van Menseregte en in die gees van die Vryheidshandves, behoor kultuur aan 'n land se hele bevolking, afgesien van ras, kleur of geloof. Op grond van hierdie basiese beginsel het die instituut 'Culture in Another South Africa (CASA) en die Hollandse anti-Apartheidsbeweging in Desember 1987 'n konferensie oor kultuur in 'n ander, nierassige Suid-Afrika georganiseer. Driehonderd kunstenaars, van binne en buite die land, het die huidige kulturele ontwikkelinge en die kulturele infrastruktuur van 'n demokratiese en nierassige Suid-Afrika, sonder apartheid, bespreek.

In 'n reaksie op die CASA-konferensie, en veral vir hierdie boek, het verskeie auteurs artikels oor die 'ander' Suid-Afrika geskryf; oor die betekenis daarvan ten opsigte van teater, musiek, prosa en poësie, fotografie, films en video, beeldende kunste en die media. Die kulturele boikot van Suid-Afrika was ook bespreek.

CASA was 'n unieke uitwisseling van idees oor die verhouding tussen kultuur en verset teen apartheid en daar is beklemtoon dat kunstenaars nie bloot produseerders van pamflette of slagspreuke is nie. Die artikels vorm gesamentlik 'n kleurvolle versameling van Suid-Afrikaanse kultuur en dokumenteer verder die CASA-Konferensie as 'n geskiedkundige gebeurtenis.

Danish

'Kulturens Fder skal blive åbnede' står dø skrevet siden 1955 i Freedom Charter, begyndelsesprogrammet fra The African National Congress, befrielsesfboevagelsen i Sydafrika.

Kultur spiller en vigtig rolle i striden mod apartheid som den dagligt føres af ANC, United Democratic Front. The Congress of South African Trade Unions, kirkerne og

talrige kunstnere. Ifølge de Forenede Nationers menneskerettighedserklaering, ifølge Freedom Charter, tilhører kulturen hele befolkningen i et land ufden forskel på grund af hudfarve, afstamning eller overbevisning.

Med dette princip som udgangspunkt organiserede stiftelsen 'Culture in Another South Africa' (CASA) og Anti-apartheids-bevægelsen i Holland i december 1987 en konference om kulturen i det 'andet' Sydafrika uden raceforskelle. Trehundrede kunstnere, som enten lever i Sydafrika eller i landflygtighed, udvekslede ideer om den kulturelle udvikling og om den kulturelle infrastruktur i et demokratisk Sydafrika uden apartheid. I anledning af CASA-konferencen skrev forskellige forfattere artikler specielt for denne bog om de 'andet' Sydafrika og betydningen af teater, musik, prosa, poesi, fotografi, film og video, skabende kunst, medierne. Den kulturelle boycot af apartheidens Sydafrika bliver oqså omtalt.

CASA var en unik tankeudveksling om relationen mellem kultur og modstand imod apartheid, hvor vaegent blev lagt på at kunstnere ikke kun må vaere 'løbesseddelskribenter' eller 'sloganråbere'. Foruden artiklerne, som tilsammen danner et farverigt udvalg af Sydafrikansk kultur, er CASA-Konferencen som historisk mode udførligt dokumenteret i denne bog.

Dutch

'De deuren van cultuur zullen geopend worden' staat sinds 1955 in het Freedom Charter (Handvest van de Vrijheid) geschreven, het beginselprogramma van het African National Congress, de bevrijdings beweging Zuid-Afrika, Cultuur speelt een belangrijke rol in de strijd tegen apartheid, zoals die dagelijks gevoerd wordt door het ANC, door het United Democratic Front (Verenigd Democratisch Front) en het Congress of South African Trade Unions (Congres van Zuidafrikaanse vakbonden), de kerken en talloze kunstenaars. In de geest van de Verklaring van de Rechten van de Mens van de Verenigde Naties, in de geest van het Freedom Charter, behoort cultuur toe aan de gehele bevolking van een land, zonder onderscheid op basis van huids kleur, afkomst of overtuiging. Met dit principe als uitgangspunt organiseerden de Stichting 'Culture in Another South Africa' (CASA) en de Anti-Apartheids Beweging Nederland in december 1987 een conferentie over de cultuur van het 'andere' non-raciale Zuid-Afrika. Driehonderd kunstenaars, die in Zuid-Afrika of in ballingschap leven, wisselden van gedachten over de hudige culturele ontwikkelingen en over de culturele infrastructuur van een democratisch en non-raciaal Zuid-Afrika, zonder apartheid. Naar aanleiding van deze CASA-conferentie schreven verschillende auteurs speciaal voor dit boek artikelen over het 'andere' Zuid-Afrika en de betekenis daarvoor van theater, muziek, proza, poëzie, fotografie, film en video, beeldende kunsten, en de media. Ook de culturele boycot van het Zuid-Afrika-van-de-apartheid komt aan de orde. CASA zelf

was een unieke gedachtenwisseling over de relatie tussen cultuur en verzet tegen apartheid, waarbij benadrukt werd dat kunstenaars niet zo maar 'pamfletschrijvers' of 'sloganroepers' moeten zijn. Naast de artikelen, die samen een kleurrijke bloemlezing van Zuidafrikaanse cultuur vormen, is in dit boek de CASA-conferentie als historische bijeenkomst uitvoerig gedocumenteerd.

French

'Que les portes de la culture s'ouvrent'

Depuis 1955 ce texte figure dans le 'Freedom Charter', la déclaration de base de l'ANC (Congrès National Africain), le mouvement de libération de l'Afrique du Sud. L'ANC, le United Democratic Front (Front démocratique uni) et le le Congress of South African Trade Unions (Congrès des syndicats de l'Afrique du Sud) s'efforcent chaque jour à combattre l'apartheid; dans cette lutte la culture joue un rôle important.

Comme l'affirmè la déclaration des droits de l'homme des Nations Unies et le 'Freedom Charter', la culture appartient à toute la population d'un pays sans faire de la distinction à base de couleur de la peau, d'origine ou de conviction. En prenant ce principe comme point de départ en décembre 1987, la foundation 'Culture in Another South Africa' (CASA, culture dans une Afrique due Sud différente) et le mouvement anti-apartheid des Pays-Basont organisé une conférence sur la culture de cette 'autre' Afrique du Sud non-raciale.

Trois cents d'artistes en Afrique du Sud ou en exile ont échangé des idées sur le developement de la culture et sur l'infrastructure culturelle d'un Afrique du Sud démocratique non-racial et sans l'apartheid. Autour de la conférence de CASA plusieurs auteurs ont écrit des articles, spécialement pour le théâtre et la musique, la prose et la poésie, la photographie, le cinéma, le vidéo, les beaux arts et la presse. Ce qu'on a mis en évidence encore, c'est l'importance du boycottage culturel de l'Afrique du Sud de l'apartheid.

La fondation CASA elle-même est la résultat d'un échange d'idées sur la relation entre la culture et l'opposition contre l'apartheid. Dans ce procès on a souligné que les artistes ne devaient pas être de pamphlétaires' ou de 'crieurs de slogans' quelconques. Ce livre dont les articles forment une riche anthologie de la culture sud-africaine, comprend aussi un compte rendu du fait historique qu'a été la conférence de CASA.

German

'The doors of culture shall be opened' ('Die Türen der Kultur werden geöffnet werden') steht seit 1955 im Freedom Charter (Freiheits-Charta), dem Grundsatzprogramm des

African National Congress (Afrikanischer Nationalkongreß, ANC) der
Befreiungsbewegung in Südafrika. Die Kultur spielt eine wichtige Rolle im Kampf gegen
die Apartheid, wie er täglich vom ANC, von der United Democratic Front
(Demokratische Einheitsfront) und dem Congress of South African Trade Unions
(Kongreß südafrikanischer Gewerkschaften), von den Kirchen und von zahllosen
Künstlern geführt wird. Im Sinne der Erklärung der Menschenrechte der Vereinten
Nationen, im Sinne der Freiheits-Charta ist Kultur das Gemeingut der gesamten
Bevölkerung eines Landes ohne Unterschiede aufgrund von Hautfarbe, Herkunft oder
Weltanschauung. Mit diesem Prinzip als Ausgangspunkt organisierten die Stiftung
Culture in Another South Africa (CASA, Kulture in einem anderen Südafrika) und die
Anti Apartheids Beweging Nederland (Niederländische Anti-Apartheids-Bewegung) im
Dezember 1987 eine Konferenz über die Kultur des 'anderen' Südafrika ohne
Rassentrennung. Dreihundert Künstler, die in Südafrika oder im Exil leben, trafen sich
hier zum Gedankenaustausch über kulturelle Entwicklungen der Gegenwart und über
die kulturelle Infrastruktur eines demokratischen, nicht nach Rassen zersplitterten
Südafrika ohne Apartheid.
Aus Anlaß dieser CASA-Konferenz schrieben mehrere Autoren speziell für dieses Buch
Beiträge über das 'andere' Südafrika und seine Bedeutung für Theater, Musik, Prosa,
Poesie, Fotografie, Film und Video, bildende Kunst und die Massenmedien. Auch der
kulturelle Boykott des Apartheidsstaats Südafrika wird behandelt. Die CASA-
Konferenz selbst war ein einzigartiger Austausch von Stellungnahmen zu dem
Verhältnis zwischen Kultur und Widerstand gegen die Apartheid, in dem hervortrat,
daß Künstler nicht bloße Pamphletisten oder Sloganrufer sein sollten. Neben den
Beiträgen, die zusammen eine vielfarbige Anthologie der südafrikanischen Kultur
darstellen, enthält dieses Buch eine ausführliche Dokumentation der CASA-Konferenz
als einer historischen Versammlung.

Greek

"The doors of culture shall be opened", "Οι πόρτες του πολιτισμού θα ανοίξουν"— αυτό
είναι από το 1955 γραμμένο στον Καταστατικό Χάρτη περί Ελευθερίας, δηλαδή στο
Πολιτικό Πρόγραμμα του Εθνικού Συνεδρίου της Αφρικής (African National Congress),
του απελευθερωτικού κινήματος της Νότιας Αφρικής. Ο πολιτισμός παίζει σημαντικό
ρόλο στον καθημερινό αγώνα εναντίον του apartheid (εναντίον του πολιτικού συστήματος
που βασίζεται σε φυλετικές διακρίσεις) που διεξάγεται από το Εθνικό Συνέδριο της
Αφρικής, το Ενωμένο Δημοκρατικό Μέτωπο (United Democratic Front), το Συνέδριο των
Εργατικών Συνδικάτων της Νότιας Αφρικής (Congress of South-African Trade Unions), τις

εκκλησίες και αναρίθμητους καλλιτέχνες. Κατά την Οικουμενική Διακήρυξη των Δικαιωμάτων του Ανθρώπου των Ηνωμένων Εθνών και κατά τον Καταστατικό Χάρτη περί Ελευθερίας ο πολιτισμός ανήκει σ' ολόκληρο τον λαό χωρίς διακρίσεις βάσει του χρώματος, της καταγωγής ή των πεποιθήσεων. Με αφετηρία αυτή την αρχή το Ίδρυμα "Πολιτισμός σε μια άλλη Νότια Αφρική" (Stichting "Culture in another South-Africa", CASA) και το Ολλανδικό Κίνημα κατά του apartheid (Anti Apartheids Beweging Nederland) διοργάνωσαν το 1987 μια διάσκεψη με θέμα τον πολιτισμό της "άλλης", μη-ρατσιστικής Νότιας Αφρικής. Τριακόσιοι καλλιτέχνες, μερικοί από τους οποίους ζουν σε εξορία, αντάλλαξαν απόψεις για τις τρέχουσες εξελίξεις στον τομέα του πολιτισμού και για την πολιτιστική υποδομή μιας δημοκρατικής και μη-ρατσιστικής Νότιας Αφρικής, μιας Νότιας Αφρικής χωρίς apartheid.

Με αφορμή αυτή την διάσκεψη του Ιδρύματος "Πολιτισμός σε μια άλλη Νότια Αφρική" διάφοροι συγγραφείς έγραψαν άρθρα, προκειμένου να δημοσιευθούν σ' αυτό το βιβλίο, για την "άλλη" Νότια Αφρική και για την σημασία για την "άλλη" Νότια Αφρική του θεάτρου, της μουσικής, της ποίησης, της πεζογραφίας, της φωτογραφίας, της ταινίας, του βίντεο, των εικαστικών τεχνών και του τύπου. Επίσης αναφέρεται στον πολιτιστικό αποκλεισμό της Νότιας Αφρικής του apartheid. Η διάσκεψη-CASA υπήρξε μια ασύγκριτη ανταλλαγή απόψεων για την σχέση πολιτισμού-αντίσταση εναντίον του apartheid όπου τονίστηκε ότι ο ρόλος του καλλιτέχνη δεν πρέπει να περιορίζεται στο να γράφει φυλλάδια ή να φωνάζει συνθήματα. Στο βιβλίο αυτό ντοκουμεντάρεται εξονυχιστικώς η ιστορική συνάντηση που ήταν η διάσκεψη-CASA και περιλαμβάνονται άρθρα που στο σύνολό τους αποτελούν μια πολύχρωμη ανθολογία του πολιτισμού της Νότιας Αφρικής.

Italian

'Le porte della cultura saranno aperte' è scritto dal 1955 nel Freedom Charter, la dichiarazione fondamentale dell'African National Congress (Congresso Nazionale Africano), il movimento di liberazione del Sud Africa. La cultura ha assunto un ruolo importantissimo nella lotta contro l'apartheid, lotta quotidiana dell'ANC, del United Democratic Front (Fronte Democratico Unito), del Congress of South African Trade Unions (Congresso dei Sindacati Sudafricani), delle chiese e di numerosi artisti. Secondo lo spirito della Dichiarazione dei Diritti dell'Uomo delle Nazioni Unite e secondo lo spirito del Freedom Charter, la cultura appartiene a tutta la popolazione, senza alcuna discriminazione dovuta al colore della pelle, all'origine o al credo. In base a questo principio la fondazione 'Culture in Another South Africa' (CASA, Cultura in un Sud'Africa Diverso) e l'Anti Apartheids Beweging Nederland (Movimento Olandese Contro l'Apartheid) hanno organizzato nel dicembre del 1987 un congresso sulla cultura di questo Altro Sud Africa non razziale. Trecento artisti che vivono sia in Sud Africa che in esilio hanno scambiato le loro idee sugli attuali sviluppi culturali e sull'infrastruttura culturale di un Sud Africa democratic e non-razziale, senza

apartheid. In occasione di questo Congresso di CASA diversi autori hanno scritto specialmente per questo libro articoli sull'Altro Sud Africa e sul suo significato per il teatro, la musica, la prosa, la poesia, la fotografia, il film, il video, le arti figurative, i mass-media. E stato messo in evidenza il boicottaggio culturale del Sud Africa dell'apartheid. La stesso fondazione CASA è il risultato di uno scambio di idee sul rapporto tra cultura e opposizione all'apartheid. Con questo processo si è voluto sottolineare il fatto che gli artisti non dovrebbero nè essere 'panflettisti', ne 'gridare semplici slogan'. Questo libro, i cui articoli costituiscono un'antologia variopinta della cultura sudafricana, contiene anche un resoconto di quel fatto storico che è stato il congresso di CASA.

Norwegian

'The doors of culture shall be opened' - kulturens dører skal åpnes. Dette har siden 1955 stått i Freedom Charter (Frihetserklaeringen), programmet til African National Congress (Den afrikanske nasjonalkongress), den sør-afrikanske frigjøringsbevegelsen. Kultur spiller en viktig rolle i striden som hver eneste døg føres mot apartheid. Striden som føres av ANC, United Democratic Front (Den forente demokratiske front), Congress of South African Trade Unions (Den sør-afrikanske fagforeningskongress), kirken og utallige kunstnere. Ifølge FNs menneskerettighetserklaering og Freedom Charter tilhører kulturen hele landets befolkning; unansett rase, klasse eller religion, Med utgangspunkt i dette prinsippet organiserte stiftelsen 'Culture in Another South Africa' (CASA, Kultur i det andre Sør-Afrika) og Anti Apartheids Beweging Nederland (Den nederlandske bevegelsen mot apartheid) i desember 1987 en konferanse om det 'andre' Sør-Afrika uten raseskille. I anledning av CASA-konferansen, og spasielt til denne boken, skrev flere forfattere artikler om det 'andre' Sør-Afrika. Forfatterne går bl.a. inn på betydningen av teater, musikk, prosa, poesi, fotografi, film og video, bildende kunst og media for dette 'andre' Sør-Afrika, Den kulturelle boikotten av 'apartheidens Sør-Afrika' blir også behandlet. Selve CASA var en unik mulighet til å utveksle tanker om forholdet mellom kultur og striden mot apartheid, og det ble presisert at kunstnerne ikke uten videre må vaere 'løpeseddel-skrivere' eller 'slagord-ropere'. I tillegg til artiklene, som tilsammen utgjør en fargerik antologi om den sør-afrikanske kulturen, blir CASA-konfraensens historiske betydning utbredt dokumentert i denne boken.

Portuguese

'As portas da Cultura serâo abertas pode ser lido desde 1955 na Freedom Charter (Carta da Liberdade), o programa-base do African National Congress (Congresso Nacional Africano), o movimento de libertacâo da Africa do Sul.

A Cultura desemphenha um papel importante na luta contra o 'Apartheid'. Uma luta que o A.N.C. efectua diariamente em conjunto com o Congress of South African Trade Unions (Congresso dos Sindicatos Sul-Africanos), as congregacões religiosas e inúmeros artistas.

Dentro do espírito da Declaracâo dos Direitos Humanos das Nacóes Unidas e da Freedom Charter a Cultura pertence a toda à populacâo de un país, sem fazer distincâo em cor, origem ou conviccâo. Tendo este princípio como ponto de partida a fundacâo 'Culture in Another South Arica' (CASA, Cultura numa outra Africa do Sul) e o Anti-Apartheids Beweging Nederland (Movimento Holandês Contra o Apartheid) organizaram em Dezembro de 1987 uma conferência sobre a Cultura da 'outra' Africa do Sul nâo-racial. Trezentos artistas, que vivem na Africa do Sul ou no exîlio, trocaram ideias sobre os desenvolvimentos actuais no campo da Cultura e a infra-estrutura de uma Africa do Sul democrática e nâo-racial, sem Apartheid.

Tomando esta conferência como ponto de partida vários autores escreveram, especialmente para este livro, artigos sobre essa 'outra' Africa do Sul. Sobre o significado do teatro, da música, da literatura (prosa e poesia), da fotografia, do cinema e do vídeo, das artes plásticas e dos média nessa transformacâo. O boicote cultural da Africa do Sul-do-Apartheidé é um dos tópicos tratados neste livro.

CASA foi uma boa oportunidade para trocar ideias sobre a Cultura e a resistência contra o Apartheid. A conferência deixou bem acentuado que os artistas nâo podem ser meros 'escritores panfletários' ou simples 'reprodutores de slogans'.

Além de artigos, que em conjunto constituem uma antologia bastante diversificada da Cultur Sul-Africana, este livro contem também documentação detalhada sobre CASA como conferência histórica.

Sepedi

'Dikgoro tsa setšo di tla bulwa', ke fokontšu leo le šomišitswego ka gare ga 'Freedom Charter' go tloga ka ngwaga wa 1955 maikemišetšo a African National Congress, e lego mokgatlo wa tokologo go la Afrika Borwa. Karolo ya setšo ke ye bohlokwa go lwantšha kgethologanyo, yeo e lwantšhwago letšatši le ka letšatši ke United Democratic Front (UDF), Congress of South African Trade Unions, dikereke le dibapadi tšeo di sa balwego.

Ka moya wa boikano wa 'United Nations Declaration of Human Rights' le ka moya wa 'Freedom Charter' setšo ke sa setšhaba ka bophara nageng, go sa lebelelwe morafe, mmala goba ditumelo. Ka thekgo ya se kgopolong, 'Culture in Another South Africa' (CASA) le Dutch Anti-Apartheid Movement ka Disemere 1987 ba biditše kopano ka ga setšo go Afrika Borwa ye nngwe, ye e se nago kgethologanya ya merafe. Dibapadi tsě makgolo a mararo go tšwa ka gare ga Afrika Borwa le bafaladi, ba ahlaahlile diphetogo tša bjale tša setšo go Afrika Borwa ya batho yeo e sa tsebego karologanyo ya merafe.

Go tšwe kopanong ya CASA, kudukudu go puku ye, bangwadi ba ba fapanego ba ngwadile ka ga Afrika Borwa ye nngwe le tema ye e ka kgathago ke theatre, mmino, direto, bostantshi, diswantšho le bidio, mešongwana ya go bonwa le boraditaba. Go ngala setšo sa Afrika Borwa ya kgethologanyo le gona ile gwa ba tsikinya maikutlo.

CASA ka bon yona e be e le kabelano ya dikgepolo ka ga tswalano magareng ga setšo le go gana kgethologayo, e gatelela gore dibapadi ga se boramatlakala goba boradikapolelo. Go tlaleletsa go dingwalwa tseo ka moka di dirago kgobokanyo ye botše y setšo sa Afrika Borwa, puku ye e bontsha ka botlalo gore kopano ya CASA ke ya histori.

Spanish

'Las puertas de la cultura seran abiertas', esta escrito desde 1955 en el Freedom Charter, las bases del programa del ANC el movimiento de liberación del Sud Africa.

La cultura juega un importante rol en la lucha contra el Apartheid, (como el) que realize diariamente el United Democratic Front (Frente Democratico Unido) y el Congres of South African Trade Unions (El congreso sindical Sud Africano), las iglesias y un numero incontable de artistas.

En la idea de las declaraciones de los Derechos Humanos de las Naciones Unidas, en la idea, del Freedom Charter, la cultura le pertenece a toda la población de un país, sin ninguna discriminación racial, de descendencia o de creencias. Con este principio como punto de partida, organizaron la Asociación Culture in Another South Africa (CASA) y el Movimiento Anti Apartheid Holandés en diciembre de 1987 una conferencia sobre la cultura de la otra South Africa, la no racista. Trescientos artistas que viven en Sud Africa y en el exilio intercambiaron pensamientos sobre el desarrollo actual de la cultura y sobre la infrastructura cultural de una Sud Africa democrática y non racista sin apartheid.

A continuación de la conferencia de CASA escribíeron diferentes autores, especialmente para este libro, artículos sobre 'La Otra Sud Africa' y el significádo que tiene para esta otra Sud Africa el teatro, la música, la prosa, la poesía, cine y video, las artes plásticas y los medios de comunicación.
Tambien el boycot cultural de Sud Africa del Apartheid se trata como tema.

CASA fue por sí misma un intercambio único de pensamientos sobre la relación existente entre cultura y resistencia contra el Apartheid, en el cual se le puso acento a que los artistas no deberian ser solamente creadores de pamfletos y/o consignas.

Junto a los articulos que forman una colorida antología de la cultura sud africana esta en este libro la conferencia de CASA ampliamente documentada como una reunión historica.

Sesotho

'The doors of culture shall be opened' 'Dikgoro tsa meetlo ya setho di tla buleha' ana ke mantswe a sebedisitsweng pampiring ya tokoloho (Freedom Charter), ya Mokgatlo tsa Setjhaba tsa Afrika (African National Congress), o lwanelang tokoloho. Meetlo ke thebe ya bohlokwa khahlanong le apartheid. Mekgatlo a tshwanang le bo United Democratic Front (UDF), ANC le 'The Congress of South African Trade Unions' (COSATU), dikereke le mekgatlo e meng, e thabela ho sebedisa meetlo, khahlanong le Apartheid.

Ho ya ka Dishwanelo tsa Botho (Human Rights), tse ngotŝweng ke Mokgatlo wa Machaba a Kopanong (United Nations), le ho ya ka moya wa toka wa Freedom Charter, Moetlo wa setho, ke wa sechaba sohle se ahisaneng naheng e le ngwe.

Ngokuphathelele kule nkomfa ye-CASA, mgakumbi malunga nale ncuadi, ababhali abahluka-hlukeneyo babhala imihlathi ethile ngo Mzantsi Afrika omtsha nangokubaluleka kwako kwithiyetha, emculweni, kwimibongo, kwiphotography, kimiboniso we bhanya-bhanya nakwi videyo, kwi visual arts njalonjalo. Ukukwaywa komcimbi wezithethe zacalu-calulo yaba yenye into eyathi yathathelwa ingqalelo.

I CASA ngokwayo njengombutho waba yindlela eyodwa yokutshintshana kweengcinga malunga nonxubelelwano phakathi kwezithethe (culture) nokuchasa ucalu-calulo ugxininisa ekubeni abantu abachubekileyo abanga bantu abenza izinto ezitsala amehlo kephela. Ukongezelela kule mihlathi yaba bhali ethi yenze ukuqokelelana kwezithethe zom Mzantsi Afrika, lencuadi ye-CASA isisiganeko sembali.

Ke ka lebaka leo, mokgatlo wa CASA (Culture in Another South Africa) le mekgatlo ya Netherlands e kgahlanong le kgatello le apartheid ileng ya mema setjhaba sa Afrika Borwa ho tla kopanong ka Tshitwe, 1987. Ho tla buisana ka Meetlo ya Setho ya Afrika Borwa e se nang kgatello, e kopaneng, e sa khetholleng mmala kapa tumelo, e sa kgetholleng monna kapa mosadi.

Batho ka ho thabela kopano ya mofuta ona, le ho phephetswa ke buka ena e ngolwang, bangodi ba bangata ba ile ba qala ho ngola bukana tsa mefuta yohle ho tsa mmino, ditshwantsho le dithothokiso, le tse ding.

Kopanong ya CASA, batho ba buile ka kamano ye teng pakeng tsa meetlo ya sechaba, le mekga ya ho fedisa kgahlanong le Apartheid.

Jwale, ka hodimo ha tse seng di ngotswe, buka ena e kopanya ntho tsohle tse ntle tse etsahetseng kopanong ya CASA, le diketsehalo tsa meetlo ya sechaba ya Afrika Borwa. CASA e bile kopano ya hostori.

Swedish

'The doors of culture shall be opened', kulturens dörrar kommer att öppnas, står sedan 1955 skrivet i Freedom Charter (frihetens stadga), principprogrammet för African National Congress (Afrikanska Nationella Kongressen), Sydafrikas befrielserörelse. Kultur spelar en stor roll i kampen mot apartheid, som dagligen förs av ANC, av United Democratic Front (Förenade Demokratiska Fronten) och Congress of South African Trade Unions (Sydafrikanska Fackföreningars Kongress), kyrkorna och otaliga konstnärer, Enligt FN:s Allmänna Förklaring om de Mänskliga Rättigheterna, enligt Freedom Charter, tillhör kulturen ett lands totala befolkning, utan skillnader på grund av hudfärg, härkomst eller övertygelse, Med denna princip som utgångspunkt organiserade stiftelsen 'Culture in Another South Africa' (CASA, Kultur i ett annat Sydafrika) och Anti Apartheids Beweging Nederland (Nederländsk rörelse mot apartheid) i december 1987 en konferens runt kulturen i det 'andra' Sydafrika utan rasåtskillnader. Trehundra konstnärer som är bosatta i Sydafrika eller som lever i landsflykt, utbytte tankar om nuvarande kulturella utvecklingar och om den kulturella infrastrukturen av ett demokratiskt Sydafrika utan rasåtskillnader, utan apartheid. Med anledning av denna CASA-konferens har olika författare särskilt för denna bok skrivit artiklar om det 'andra' Sydafrika och betydelsen för landet av teater, musik, prosa, lyrik, fotografi, film och video, plastiska konster och massmedierna. Även den kulturella bojkotten av apartheids-Sydafrika behandlas. CASA själv var ett unikt tankeutbyte om förhållandet mellan kultur och motstånd mot apartheid, vid vilket betonades att kostnårer inte utan vidare skulle vara 'pamflettister' eller 'parollropare'. Förutom artiklar, som tillsammans bildar en färgrik antologi av sydafrikansk kultur, har CASA-konferensen som historisk sammankomst i denna bok utförligt dokumenterats.

Xhosa

Minyango ephathelele nechaphazelela izithethe yovulwa. Nomlathi ucatshulwe kuludwe lweenjongo zenkululeko (Freedom Charter) kususela ngomnyaka ka 1955. Olu ludwe lwezinjongo ezichaphazela umbandela wezithethe ufumaneka kwi manifesto ye African National Congress engumbutho olwela inkululeko yase Mzantsi Afrika.

Indawo edlalwa zizithethe ibalulekile kwi dabi lokulwa ucalu-calulo. Elidabi liliwa yonke imihla yo ANC, United Democratic Front (UDF) iinkongolo zomanyano lwabasebenzi base Mzantsi Afrika (South African trade unions) iinkonzo nakuye nabadlali aba balulekileyo abaninzi.

Ngokommongo we United Nations Universal Declaration of Human Rights nakunye nangokommongo woludwe lweenjongo zenkululeko (Freedom Charter), izithethe ziyinto

yoluntu lonke belo lizwe nokuba bangabantu abanjani ma ngokwebala nangobuhlanga. Ukuphuhlisa ukubaleka kwemibutho efana ne *Culture in Another South Africa* (CASA) kwakunye ne Dutch Anti-Apartheid Movement ngo Disemba ka 1987 yaququzelela ukwenza ubukho benkomfa enjongo zayo yayikukuxoxa ngemicimbi yezithethe zomzantsi Afrika omtsha nongomnye ongena banjululo labuhlanga. Malunga namakhulu amathathu abantu abachubekileyo abahlala e Mzantsi Afrika nangaphandle nabazumbacu, abathi baxoxa baphicotha ngemeko ekuyiyo ngoku malunga nezithethe ku-Mzantsi Afrika Omtsha wolawulo lomntu wonke apho kungekho mithetho yabuhlanga nalucalu-calulo.

Zulu

'The doors of culture shall be opened', 'Iminyango ye mihlobo izo vulwa', loehu esi ku iFreedom Charter yango 1955, incwadi ye iAfrican National Congress, ye inqubo ye we inkululeko ya bantu ba se umzantsiAfrika.

Isigawu se mihlobo yinto e funekayo ku le mpi e ku si lungula ku iApartheid, yona le si ilwisayo wonke amalanga ukuze si ihlule; si ngabaye ANC, iUDF, iCosatu, e masontweni noma phakathi kwe izibongi ezi ningi.

Ngo mthetho we i-United Nations eya bhala ukuthi bonke abantu emhlabeni ba ya fana, futhi akufuneki ba yalelwe, ku thwi ukuthi imihlobo e ya bantu bonke ba se mhlabeni, nga phandle kwe kuthi ungu mhlobo uphi, no mbala uphi, no ma uthemba luphi; ka njalo, i-Dutch Anti-Apartheid Movement ngo December 1987, iye ya ma uku beka umhlangano we mihlobo ya ma-artist noma izibongi zonke e zi nga phandhle kwe South Afrika. Izibongi e zi mashome-shome kathatu, zi hlangene noma se zi kudi na se khaya; za khulumisana nge ndaba yo ku bumba i ntlanganiso ye izo enza ukuba sonke se be ne-democracy; ku le i-South Afrika e zo ba me thando la bantu bonke.

Ukuba si sebenzise umoya we United Nations ngo nqobo, futhi uKuba si phendule imisebenzi ye CASA Conference, futhi-futhi nge ndaba yo ku phendulela le ncwadi, ababhali aba ningi, ba ye bathi, nabo bonke ba se South Afrika, ba ye ba bhala nge izingoma, o-imidhlalo, imibhalo, nayo inthlabelelo, nayo futhi imfanekiso ye imihle, izithombe, izifilimi, ne zi-video, zonke izintu eziboyayo, konke loku ku fanele ku qithe i-Apartheid ya se South Afrika, ngoba yi into ye imbi. I-CASA yona, yi into yo mhlanganiso we zinqondo. Inqondo lezi zi zo lungisa ukuphilisana kwa bantu, futhi zi qhite i-Apartheid, zi qinise ukuthi ababali a si nje ababalayo ngo gu dhlala, mhlambe aba zi khulumela nje. Futhi, le zimbalo, nge mibhalo e miningi i funa ukuthi si velise inkundhla yethu; incwadi ye yi bhaliwe nje, yona le, a hlaganiphisa ukuthi si yi-mihlobo e yi hlangene ukuthi si fumane i-Nkululeko ngo msebenzi we intlhangano ye-CASA ngoba isikhathi sethu sonke ukuthi si fumane inkululeko yo ko-philisana singabantu.

Contributors

Anthony Akerman is a playwright and author of **Somewhere on the Border, A Man out of the Country**, and **A World Elsewhere**. He was born in South Africa in 1949 and now lives in exile in The Netherlands.

Farouk Asvat is a poet and journalist, and author of **The Time of our Life** and **A Celebration of Flames**. He lives in South Africa.

Fulco van Aurich is a journalist and specialist on African music, and spokesperson for the Dutch Anti-Apartheid Movement. He was born in The Netherlands in 1951.

Mono Badela is a journalist and South African correspondent for such international newspapers and journals as the *New York Times, Utrechts Nieuwsblad* (Holland) and *Der Stern* (Germany). He was born in South Africa in 1937 and spent several years in prison for 'political activities'.

Conny Braam is the chairperson of the Dutch Anti-Apartheid Movement and Secretary-General of the board of the Culture in Another South Africa Foundation. She was born in The Netherlands in 1948.

Breyten Breytenbach is a poet, writer and painter, and author of, *inter alia*, **A Season in Paradise, The True Confessions of an Albino Terrorist, Mouroir** and **Judas Eye,** a collection of poems. He was born in South Africa in 1939 and spent several years in prison for 'political activities'. He now lives in exile in France.

Dennis Brutus is an academic and poet, and author of, *inter alia*, **Letters to Martha** and **Stubborn Hope**. He is Professor of English at the University of Pittsburgh and lives in exile in the United States. He was born in 1924 in what was then Southern Rhodesia (Zimbabwe).

Willem Campschreur was one of the organizers of the CASA Festival. He is an active member of the Dutch Anti-Apartheid Movement and works as a

publisher for the Dutch section of Amnesty International. He was born in 1955 in The Netherlands.

Joost Divendal was the Director of the CASA Conference and Festival. He is active in the Dutch Anti-Apartheid Movement and works as the General Editor of the arts section of the Dutch newspaper *Trouw*. He was born in 1955 in The Netherlands.

Vernon February is a poet and academic, and author of **Mind Your Colour** and **And Bid Him Sing**. He is at present the Senior Research Fellow at the Africa Studies Centre, University of Leiden. He was born in South Africa in 1938 and lives in exile in The Netherlands.

Barry Feinberg is a painter, film-maker and poet and the Director of the International Defence and Aid Fund. He has edited a collection of South African poetry entitled **Poets to the People** (South African Freedom Poems). He was born in South Africa in 1938 and lives in exile in England.

Patrick Fitzgerald is a poet and full-time worker at the Department of Arts and Culture of the ANC in Lusaka. He was born in South Africa in 1954 and lives in exile in Zambia.

Fons Geerlings is the Secretary-General of the Dutch Anti-Apartheid Movement and a member of the board of the Dr Govan Mbeki Fund at the University of Amsterdam. He was born in The Netherlands in 1946.

Nadine Gordimer is a writer and author of several novels, including **The Lying Days, The Conservationist, Burger's Daughter, July's People, A Sport of Nature** and a number of collections of short stories. She is a co-founder of the Congress of South African Writers. She was born in South Africa in 1923.

Jonas Gwangwa is a musician and Director of the **Amandla** Cultural Ensemble of the ANC. He

composed and arranged the music for the film **Cry Freedom** for which he was nominated for an Academy Award (Oscar). He was born in South Africa in 1937 and lives in exile in England.

Abdullah Ibrahim (formerly Dollar Brand) is a world-renowned musician and composer. He has produced numerous records and musical scores, including **Mannenburg – 'Is Where It's Happening'**, and **Blues for a Hip King**, a tribute to the late King Sobhuza of Swaziland. He was born in South Africa in 1934 and lives in exile in the United States.

Pallo Jordan is a member of the National Executive Committee of the ANC and head of the ANC's Research Department. He has a Masters Degree in History from the University of Sussex. He was born in South Africa in 1942, and lives in exile in Zambia.

Keorapetse Willy Kgositsile is a poet and academic, author of **Spirits Unchained, The Present is a Dangerous Place to Live**, and the Editor of **The Word is Here**, an anthology of modern African poetry. He lectures in literature at the University of Dar Es Salaam. He was born in South Africa in 1938 and lives in exile in Tanzania.

Lindiwe Mabuza is a poet and diplomatic representative of the ANC in the United States. She was born in South Africa in 1938 and lives in exile.

Miriam Makeba is a musician and writer. She has made numerous records, including most recently **Sangoma**. She is also the co-editor, with James Hall, of her autobiography **Makeba: My Story.** She lives in exile in the Republic of Guinea.

Barbara Masekela is a poet and Head of the Department of Arts and Culture of the ANC. She was born in South Africa in 1941 and lives in exile in Zambia.

Don Mattera is a poet and writer, author of the poetry collection **Azanian Love Song** and of an autobiographical study, **Gone with the Twilight: A Story of Sophiatown.** He was born in South Africa in 1935.

Mzwake Mbuli is a poet and political activist. Some of his poetry has been released on tape and record entitled **Change is Pain.** Formerly a member of the performing arts group, **Khuvangano** (Solidarity), he is now working with the group, **Wasamata.** He was born in South Africa in 1958.

Njabulo S. Ndebele is a writer and poet, author of the short story collection **Fools and Other Stories,** as well as numerous articles. He is Professor of English at the National University of Lesotho. He was born in South Africa in 1948 and now lives in Lesotho.

David Niddrie is a journalist working freelance for a number of South African and overseas newspapers. He was born in South Africa in 1953.

Cosmo Pieterse is a poet and academic, author of, *inter alia,* **Five African Plays, Seven South African Poets,** and with George Hallett, **Present Lives, Future Becomings.** He teaches African Literature at Ohio University. He was born in Namibia in 1930 and lives in exile in the United States.

Alfred Temba Qabula is a poet and activist. He is a member of the COSATU Workers' Cultural Group. He was born in South Africa.

Steven Sack is an academic and photographer and organized the prominent photographic exhibition entitled 'The Neglected Tradition: Towards a New Tradition of South African Art (1930–1988)'. He was born in South Africa in 1951.

Marius Schoon is the diplomatic representative of the ANC in the Irish Republic. Formerly an academic in South Africa, he spent 12 years in prison for 'political activities'. He was born in South Africa in 1937 and now lives in exile.

Sipho Sepamla is a teacher and writer, author of the novels **The Root is One** and **A Ride on the Whirlwind** and a number of poetry collections including **Hurry Up To It!** and **The Blues is You in Me.** He is at present Director of the Federated Union of Black Arts in Johannesburg. He was born in South Africa in 1932.

Mongane Wally Serote is a poet and writer, author of, *inter alia,* **To Every Birth Its Blood,** and poetry collections including **A Tough Tale, The Night Keeps Winking, Tsetlo, Behold, Mama, Flowers.** He is a member of the board of the CASA Foundation and works for the Department of Arts and Culture of the ANC. He was born in South Africa in 1944 and lives in exile in England.

Mavis Smallberg is a teacher and poet, and Vice-President of the Congress of South African Writers. She was born in South Africa.

Gladys Thomas is a poet and writer, author with James Matthews of the poetry collection, **Cry Freedom,** and of several short stories and children's stories. She was born in South Africa in 1935.

Paul Weinberg is a photographer and a member of the photographic collective Afrapix in South Africa. He was born in South Africa in 1956.

Hein Willemse is a poet, journalist and academic. He is a member of the National Executive of the Congress of South African Writers, and a lecturer in Afrikaans Literature at the University of the Western Cape. He was born in South Africa in 1957.

Index